WITHDRAWN

W9-DBI-863

Adam, "New Born and Perfect"

Adam, "New Born and Perfect"

The Renaissance Promise of Eternity

GIANCARLO MAIORINO

Indiana University Press

Bloomington and Indianapolis

This book was brought to publication with the aid of a grant from the Andrew W. Mellon Foundation

© 1987 by Giancarlo Maiorino
All rights reserved

No part of this book may be reproduced or utilized in any form or by any means, electronic or mechanical, including photocopying and recording, or by any information storage and retrieval system, without permission in writing from the publisher. The Association of American University Presses' Resolution on Permissions constitutes the only exception to this prohibition.

Manufactured in the United States of America

Library of Congress Cataloging-in-Publication Data

Maiorino, Giancarlo, 1943–
 Adam, "new born and perfect".

 Bibliography: p.
 Includes index.
 1. Aesthetics. 2. Renaissance. 3. Creation
(Literary, artistic, etc.) I. Title.
BH39.M355 1987 111'.85'094 86-46144
ISBN 0-253-30405-9

1 2 3 4 5 91 90 89 88 87

To Rome,
whose forms of eternity
I
bear in my heart

CONTENTS

IV
A Modern Epilogue

Illustrations

Acknowledgments

At different stages in the writing of this book, I have been helped by the criticism and support of Willis Barnstone, Eugene Eoyang, Harry Geduld, James Halporn, Terence Martin, Frank Warnke, Ward Bissell, and the students—Aaron Baker, Lu Hsiao-peng, Dawn Marsh, Michael Milan, Thomas Mussio, Amy Rose—of my seminar on Classical and Renaissance Humanism (1984). Back in Madison, Wisconsin (1969–1981), exchanges of ideas with Paolo Barucchieri and Ward Bissell on the life of Mediterranean forms started it all.

At crucial stages of my intellectual growth, Maria Caprioli (Rome), Cyrena Pondrom (Madison), and Newton P. Stallknecht (Bloomington) have been my teachers.

For plates and permissions, I recognize the following: Archivi Alinari, Art Resource, Gazette des Beaux-Arts, the Museum of Modern Art (New York), National Gallery of Art (Washington, D.C.), National Gallery (London), and The Walters Gallery (Baltimore).

The epigraphs are from Friedrich Schiller's *On the Aesthetic Education of Man* and from Giulio Carlo Argan's *Salvezza e caduta nell'arte moderna*.

G.M.

Adam, "New Born and Perfect"

PART I

The Architecture of the Ego

Introduction:
Within Eternity's Reach

*In the eyes of a Reason which knows no limits, the
Direction is at once the Destination, and the Way is
completed from the moment it is trodden. . . .*

*Surround them, wherever you meet them, with the
great and noble forms of genius, and encompass them
about with the symbols of perfection, until Semblance
conquer Reality, and Art triumph over Nature.*

Friedrich Schiller

1

As one of the most representative images in the tradition of the West,
Michelangelo's *Creation of Adam* (1511) on the ceiling of the Sistine Chapel in
the Vatican (plate 1) presents an exemplary vision of "the potential nobility
of man," who awakens to adulthood at the moment of creation.[1] While it
remains exceptional insofar as humans normally come to life, the archetypal
image calls to mind Athena's birth from the head of Zeus in an ideal state of
being. Through the centuries, in fact, the symbolic value of perfection at
birth has made a formidable impact on literature and the arts.

In the figurative language of fifteenth-century Neoplatonism, which
shouldered much of the philosophical thrust of Renaissance culture,
Adam's harmonious proportions implied a commensurate maturity of
mind. Marsilio Ficino explained that beauty "is a certain attitude, vivacity
and grace, which radiates in the body from the infusion of the Idea." Since
God "could bestow nothing better on a man than a complete likeness of his
own divinity," our body "most resembles heaven, the substance of which is
harmonious."[2] The idea belongs to superior minds lodged in beautiful
forms. Similarity therefore extends Godlike attributes to man, and, by
extension, to the artist himself.

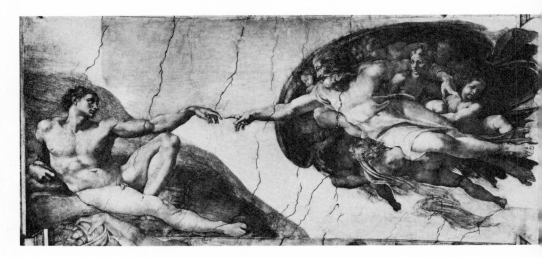

Plate 1. Michelangelo, *Creation of Adam,* 1511. Sistine Chapel, Vatican, Rome (Alinari, 7516)

In terms of analogical transfers, many of the metaphysical images associated with Neoplatonism are aesthetic in nature. Baldassare Castiglione voiced a standing assumption when he wrote that "beauty springs from God and is like a circle, the center of which is goodness. And hence, as there can be no circle without a center, there can be no beauty without goodness."[3] Visually, the young Michelangelo made physical beauty central to his concept of human dignity. Adam therefore magnified the *qualitative proportion* that body and mind share.[4]

Whatever its shortcomings, such an idealizing frame of mind inspired an age which often wasted much of its best energies in the snares of ruthless greed, insatiable ambition, and social unrest. While the Florentine chancellor and historian Leonardo Bruni searched for the texts of Plato with renewed eagerness whenever threats to peace were most serious,[5] the *Creation of Adam* was painted in the very heart of Catholicism just when papal authority was entering a new period of crisis. By 1500, the "myth of the Renaissance" peaked, and Italy retained leadership over the cultural life of Europe in spite of its economic decline.[6] Although it would be unreasonable to scale down concerns with *fortuna, sperienza,* and catastrophic visions (Leonardo, Savonarola) that affected even Leon Battista Alberti's faith in the unlimited powers of the human will, we still cherish the Renaissance as a culture embedded into aloof images of human excellence.

To that extent, the archetypal simile of creation is not merely illustrative, but constitutive. For Jacques Derrida, analogy "makes possible and homogeneous the passage from one place of discourse to another." Since it is "itself

the unity of the method," analogy can help us to "select, interpret, and systematize" the facts of art.[7] The *Creation of Adam* therefore can provide a focus for a hermeneutic study of a mode of creation thriving on potential maturity and theoretical perfection. As a pivotal "figure of thought," the concept of similarity made it possible for the Renaissance mind to face the dialectic of originality and tradition with confidence. I submit that the "analogical approach" was crucial for ground-breaking concerns with *imitatio* and *aemulatio*, birth and *re*-birth, myth and history within the secure boundaries of a frame of order that courted the hypothetical.

In a fundamental sense, the structure and meaning of the Vatican fresco mirrored an early phase of the Renaissance that was nurtured in the late fourteenth century, blossomed throughout the *Quattrocento* (particularly in Florence, Urbino, and Mantua), and finally grew to maturity at the beginning of the *Cinquecento* in Rome. To narrow the historical span (diachronic) and geographical scope (synchronic), I shall restrict the cultural range of this study to Humanism (literature and philosophy) and to the Early and High Renaissance in central Italian art. Because of its broad lifespan and semantic vagueness, the notion of "Renaissance culture" has come to encompass a plethora of definitional "isms" (Humanism, Mannerism), "anti," "counter" (Antirinascimento, Counter-Renaissance), and early-high-late period-frames (Renaissance, Baroque) extending from Petrarch and Masaccio to Milton and Poussin across Europe and despite such antithetical experiences as the Reformation and the Counter-Reformation. Within our restricted trajectory, however, the term *umanista*, which surfaced during the late fifteenth century to define teachers of the classically oriented *studia humanitatis* (grammar, rhetoric, poetry, history, and often ethics), promoted the representation of ideal images of man.[8] From Bruni and Alberti to Raphael and Castiglione, culture thrived on a convergence of assumptions in artists, philosophers, historians, and men of letters who pursued a shared ideal of perfection. My approach to such an outstanding goal will highlight artforms symbolic of an epoch at its virtual best.[9]

It is the aim of this study to link the *Creation of Adam* to the concept of "new born and perfect," which Leon Battista Alberti put forward at the end of his treatise *On Painting* (1435–36). Both of them sustained the epoch's faith in the validity of exemplary images of man (Michelangelo), his family (Alberti), city (Pius II), history (Bruni), and culture (Raphael, Castiglione), which were largely conceived in a state of theoretical maturity. Such a focus will encompass aspects of the broader world view of the age only insofar as they fall within the conceptual province of Michelangelo's central image.

This is not a study of the anatomy or the history of the Renaissance, but rather an in-depth probing into a single "motivational impulse" that spear-

headed a most daring ideal in the life of the Western mind. Bypassing experience, artistic likenesses in the Adamic mode of "new born and perfect" drew the map of a perfective outlook on the utopian potential of man.

So formulated, my thesis tests the heartbeat of a culture that produced flawless images in most fields of human endeavor. I would describe my effort as an interpretative essay that bears on one of the most salient aspects of the Renaissance. I hope that my critical inquiry will stir debate about an age so central to a tradition which still insists on writing essays on, and defenses of, Humanism.

2

The first part of this study centers on the emergence of analogical and geometric models of maturity (Chapters One and Two) on the Sistine ceiling and in the treatises of Leon Battista Alberti, the master builder of the Renaissance architecture of the Ego.

The second part develops a more comprehensive analysis of the impact that the humanist ideals of adult birth and potential accomplishments had on artists whose self-confidence voiced a "constant sacrament of Praise" (Chapter Three). As representative as the pictorial Adam, Michelangelo's *David* (1501–3, plate 2) raised the competitive drive of *aemulatio* to conceptual heights (Chapter Four) edging on a transhistorical monumentality. These chapters trace what is perhaps the central path (via Athens, Rome, Florence, Urbino, and back to Rome) in the development of the "Mediterranean experience,"[10] which has consistently projected its highest aspirations toward an exemplary *moi universel*.

The components of the Adamic simile take on a cultural dimension in the third part of this study, where the rebirth of *paideia* as an educational ideal (Chapter Five) brought forth an unprecedented synthesis of beauty, faith, and knowledge in art (Raphael's *School of Athens*, 1510–11, plate 3) and literature (Castiglione's *The Courtier*, 1516–18). In Chapter Six, the analogue man-God comes to bear on the very concept of creativity in art ("image") and language ("word"). By leading us toward the shift from representational to nonrepresentational forms of expression, stylistic analogies between Piero della Francesca and Piet Mondrian in the last chapter set up a modern epilogue to the "geometrizing" nomenclature of perfection.

Taken together, literary and artistic forms of hypothetical perfection shed light on the unity of a cultural field wherein poets, artists, philosophers, and scientists freely mingled in *piazze*, *botteghe*, and *accademie*. Interactions across the arts thrived on common experiences that fostered eclecticism (Brunelleschi, Alberti, Michelangelo). My interdisciplinary approach, therefore, reflects the historical reality.

Throughout, I have dealt with the creational analogue in a way that

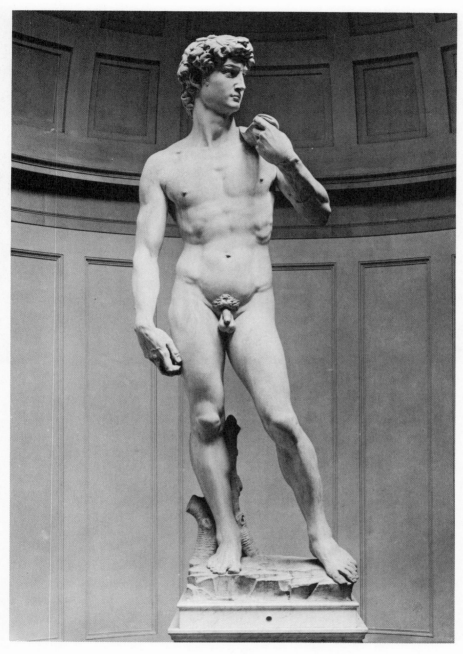

Plate 2. Michelangelo, *David,* 1501–3. Accademia, Florence (Alinaria, 1689)

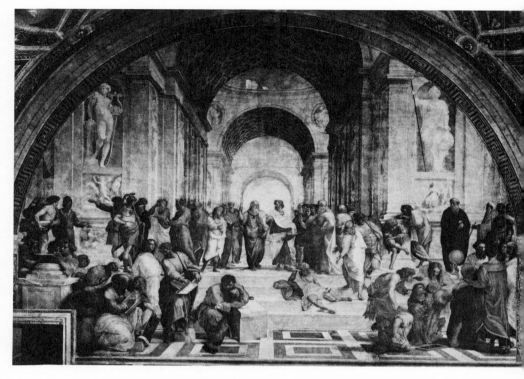

Plate 3. Raphael, *School of Athens,* 1510–11. Stanza della Segnatura,
Vatican, Rome (Alinari, 7892)

comparisons between ancient and modern concepts of humanism sharpen
the interplay between heritage and originality, *imitatio* and *aemulatio.*
Through the ages, the Graeco-Roman tradition has perpetuated what
Hayden White has called "an attitude of mind that places man at the center
of the world-picture and defines humanity's purpose as the creation of a
culture dedicated to serving the needs, interests, and aspirations of man
alone. . . . Insofar as we honor classical civilization as a still living force
today, we honor it for its Humanism."[11] In spite of Copernican revolutions
and moon walks, we have maintained a Ptolemaic perspective on man's
sphere of action. For all intents and purposes, much of the Western mind
still "knows" reality as man-measured, cherishes the invariants of life, and
worships the axiomatic validity of clarity and certainty.

<div align="center">3</div>

If we agree with Michael Baxandall that "the style of pictures is a proper
material of social history," and each offers "necessary insight into the
other,"[12] we might surmise that the cognitive style of Michelangelo's fresco

gave form to the highest aspirations of Renaissance culture. As a result, it would be feasible to translate the monuments of art into the language of knowledge. In studying such relations, we can advance the critic's knowledge of, and commitment to, the progress of creation.

At the turn of the nineteenth century, Friedrich Schlegel opened his study on the philosophy of history by recognizing that "the most important subject, and the first problem of philosophy," was "the restoration in man of the lost image of God."[13] Thoughts of a similar kind probably weighed on an earlier restoration in the Sistine Chapel. From our own point of view, we should take comfort in the Renaissance heritage, for it could help us in shaping our own promises of eternity.

1

Michelangelo's *Creation of Adam* and the Analogy of Perfection

The whole figure reposes and dwells in itself, a creation completely self-contained, and, as if existing beyond space, neither yielding nor resisting; here is no force to contend with force, no frailty where temporality might break in.

Friedrich Schiller

1

Perfection at birth in Michelangelo's *Creation of Adam* stems from the analogical assumption that man is made in the image of God. Maturity "in the beginning" therefore mirrors a transcendental model. For a better understanding of the Sistine fresco, modern viewers should divest themselves of an ingrained familiarity with postclassical patterns of novelistic growth.

The ancient contention that "nothing is completed at the beginning" (Seneca, *Naturales Quaestiones*) was rooted in the natural condition of things, and stood against epic forms of heroic maturity. Undoubtedly, Alberti was aware of such a twofold heritage when he formulated a new concept of reality:

> I was pleased to seize the glory of being the first to write of this most subtle art. If I have been little able to satisfy the reader, blame nature no less than me, for it imposes this law on things, that there is no art which has not had its beginnings in things full of errors. Nothing is at the same time new born and perfect— *nulla si truova insieme nato e perfetto—.*[1]

The humanist statement paraphrased a Ciceronian axiom: "Nothing has ever yet been invented and perfected at the same time—*nihil est enim simul et inventum et perfectum—*" (*Brutus*). Since it comes at the very end of *On*

Painting (*De pictura*), acceptance of the natural process could not be taken literally without undermining the theoretical model that has just been set up. On the contrary, the treatise is built on a measure of self-confidence averse to belated confessions of inadequacy. Rhetorical concessions aside, Alberti undermined the classical precept at the very beginning of the treatise: "I believe the power of acquiring wide fame in any art or science lies in our industry and diligence more than in the times or in the gifts of nature" (*O.P.*, 39). Like other humanists, he took an emulative stand toward the limits ("has ever yet") that the external world places on human potential.

By the turn of the sixteenth century, even the gods contributed their best talents to the forging of Machiavelli's Ideal Ruler. Moreover,

> in that earth mingled with water such a spirit Minerva put as time or labor never produces.
> (*On Ambition*, 82–83)

At birth, the Renaissance Athena bestowed her flawless maturity on man. At death, Pietro Bembo so phrased Raphael's epitaph:

> *Hic ille est Raphael, metuit quo sospite vinci rerum magna parens, et moriente, mori*
> (Here lies Raphael, in whose lifetime the great Mother of things feared to be outdone, and at his death, feared to die)

While nature endures through art, only the artist stands at the threshold between time and eternity,[2] where the Albertian treatises on the the arts and *On the Family* (*I libri della famiglia*, 1437–41) set up canons of a utopian geometry. Growth and experience yielded to a body of artistic rules "worthy of consuming all our time and study." Painting truly "makes the dead seem almost alive." An aesthetic ideal aimed at "building anew an art about which nothing . . . has been written in this age" (*O.P.*, 63–65) was to reconstruct life on a Parnassian mountaintop where the ego shaped images of its own making.

Alberti regrets at the very outset of *On Painting* that "so many excellent and superior arts and sciences from our most vigorous antique past could now seem lacking and almost wholly lost" (*O.P.*, 39). The implication is that art ought to rely on theoretical definitions as much as on the survival of artworks. In a rather revealing sequence, the introductory attention paid to the ruins of antiquity gives way to Filippo Brunelleschi's majestic cupola of S. Maria del Fiore, which in turn frames the treatise's own architecture. Likewise, the writer first refers to Pliny and Greek epigrammatic eulogies in which nature gave its best in bringing to life "geniuses or giants," but then turns to contemporary talents capable of accomplishing "every praiseworthy thing" (*O.P.*, 39). At the end of the book, exceptional efforts make room for a Florentine progeny whose theoretical knowledge could indeed "make

painting absolute and perfect" (O.P., 98). It is indicative that the treatise celebrates the works of artists (Masaccio, Donatello, Luca della Robbia, Ghiberti, and Brunelleschi) at the beginning, but ends with a statement of faith in theoreticians. If at all needed, Alberti's "successor" is a theorist who would be "helpful to painters" by making "this noble art well governed" (O.P., 98). As expected, art overshadowed nature.

2

Inevitably, archetypal modes of imitation had to come to terms with primeval images of lost plenitude. Even at this introductory stage, the creational simile Adam-God must be qualified, and several questions come to mind. Can the analogical link claim any kind of meaningful equality in spite of Christian falls and pagan oblivion? Does analogy imply parity or subordination? In other words, how similar is similar?

The past is better than the present on epic grounds, where reality is shaped by memory rather than by knowledge.[3] Consequently, patterns of similarity harking back to that time would have to presume loss. Because of an Olympian privilege, Athena enjoys perfection at birth. Common mortals, however, are bound to accept the limits of similarity: like means other, which is less in an epic sense. Analogical inequality governs classical relationships—Platonic and Aristotelian alike—between the ever-changing world of the senses and the universal telos. Since it measures a distance that is qualitatively unbridgeable, analogy points to either reduction or approximation.

Under Christian skies, Godlike resemblances do not warrant equality. Although he would later use "image" and "likeness" to qualify the relationship between father and son (Genesis 5:13), the theological author made it clear that God brings man close to him without confusing difference with identity. While securing a self-contained frame of reference, analogy set up a hierarchical gap between the human (relative) and the spiritual (absolute).[4]

In Genesis (1:26–31), God said:

Let us make man in our image after our likeness. . . .

It would seem that "image" and "likeness" are more than a simple reiteration, for they bring to the fore the unity-duality of the analogical model. Image implies a sharing in identity, whereas likeness connotes the conscious act of drawing a resemblance between two forms. In Augustinian terms, "image" determines a specific relationship between creator and creature, while "likeness" weighs on formal concerns. From a representational standpoint, "likeness" makes of "image" the subject of mimesis, which in turn transfers the theological analogy to art. At the same time, the preposition

"after" bears on a conceptual "distancing" that heightens judgment. And the emergence of artistic consciousness gains strength in the lines that follow:

> God created man in his image.
> In the image of God he created him.

Since "he" is the creative agent standing midway between "image" and "likeness," the second line confirms God's reflection on his own creation. At last,

> God saw that all he had made was very good.

The whole universe is new born and perfect ("very good") the moment man appears. The distancing of the temporal "after" gains spatial presence through the verb "saw," which sets up a visual standard of evaluation. In a sequence, God carries out his plan ("makes," "speaks") through the agreement between work and forethought ("sees").

Aesthetic concerns became predominant when Pico della Mirandola linked creation to the Renaissance praise of man's dignity:

> But, when the work was finished, the Craftsman kept wishing that there were someone to ponder the plan of so great a work, to love its beauty, and to wonder at its vastness. Therefore, when everything was done (as Moses and Timaeus bear witness), He finally took thought concerning the creation of man. But there was not among His archetypes that from which He could fashion a new offspring, nor was there in His treasure-houses anything which he might bestow on His new son as an inheritance.[5]

Since "imitation" of divine resemblances and Platonic archetypes stood side by side, Pico nestled the concept of beauty in the gap between "image" and "likeness." No simple being "is beautiful; not God himself; this begins after him."[6] This statement sheds light on the biblical reiteration ("God created man in his image/In the image of God he created him"). While legitimizing the creative act, the repetition seems to mark a pause that allowed God to become aware of himself as an anthropomorphic subject of imitation. Set against the literary passage, the Sistine fresco captures the Creator's first exposure to the appearance of beauty. His awesome glance hovers over the new form of his "likeness" just before Adam awakens to consciousness.

Beyond prelapsarian and Olympian prerogatives, birth to adulthood became a model which Renaissance artists set out to impose on their own age. In the process, they disengaged the analogical mode from notions of original perfection at bay of history. Man is made by God; in turn, it is his destiny to transform himself into a Godlike nature. For the Greek Fathers,

the word for man's "similitude" to the Creator was *homoiosis*, which described the dynamic process of becoming like God.[7] Marsilio Ficino later assumed that transcendental longings are innate in man: "Whoever understands the divine, and loves it, is divine by nature."[8] As such, analogy propagates along a creational chain whose rungs are a created analogue of God, who has made all things. By extension, the world of art mirrors its *artifex*, who could project himself into a better Other. Birth to maturity unveiled man's inherent ability to fulfill his own ideals. Yet, while Adam was the past of mankind, the family leader and the Courtier belonged to the historical present of Alberti and Castiglione. The modern Adam was to take an emulative stand toward creation, for he invested nostalgia with hope.

3

According to Nietzsche, the Socratic love of knowledge led to the delusion "of being able thereby to heal the eternal wound of existence."[9] In spite of millennial ruins and unrelenting disappointments, the man of the Renaissance steadfastly believed that art could prevent injuries. He therefore set the experience of facts against images symbolic of what man would have liked to attain. His ideals of art, education, and culture bore a panacea that could have healed even the wounds of history.

2

The Geometry of Perfection:
L.B. Alberti and the Treatise as a
Symbolic Form

*To strive after autonomous semblance demands higher
powers of abstraction, greater freedom of heart, more
energy of will, than man ever needs when he confines
himself to reality . . . The reality of things is the work of
things themselves; the semblance is the work of man;
and a nature which delights in semblance is no longer
taking pleasure in what it receives, but in what it does.*

Friedrich Schiller

1

Like Michelangelo's Adam on the Sistine ceiling, images of perfection had
to be placed in suitable environments. The Renaissance therefore set up
paradigmatic forms that removed the whim of fortune from its framework
of order.

Familiar as he was with classical precedents, Alberti modeled the gram-
mar of art after anthropomorphic standards: "Since man is the thing best
known to man, perhaps Protagoras, by saying that man is the mode and
measure of all things, meant that all accidents of things are known through
comparison to the accidents of man" (*O.P.*, 55). By disengaging the notion
of 'whole' and 'one' from myths of cosmic inclusiveness, Protagoras intro-
duced (or at least popularized) the concept of humanism in the West. That
change has been illustrated through the parable of an artist who set out to
paint a picture of the universe. At first, he accidentally left man out of his
endeavor, but he then painted himself in the act of making the celebrated
picture. The insertion of a human point of view validated Protagoras'
contention that "man is the measure of things; of things that are that they

are; and of things that are not that they are not" (Diogenes Laertius, *Lives and Opinions*, Protagoras, III). Since the mind determines the existence of objects, the philosopher called the things that man measures *chremata*, which underline our use of, and relation to, a thing, not what the thing may be in itself.[1] Emphasis on the *homo mensura* doctrine lets the Self-Knower claim priority over the perception of external reality.

Minds, not things, are essential to any system based on harmonious proportions,[2] and the fragmentary statement of the sophist probably led Alberti to read greater meaning than the language itself contained. As such, his spatial construct was supposed to be viewed by measuring all objects and relationships in proportion to the man in it. Not exactly Protagoras, but not completely opposed to him either.[3] Whatever the borrowings, the discordant world of phenomena yielded to a utopian image of life tailored to man's size.

In a preliminary essay on the concept and metaphor of perspective, Claudio Guillén writes that "*perspectiva* or *ars perspectiva* derives from the Latin verb *perspicere*, meaning 'to see clearly,' 'to ascertain.' "[4] As a source of philosophical enlightenment, sight is the greatest good "given by the gods to mortal man" (Plato, *Timaeus*); to know means to have seen (Aristotle, *Metaphysics*). And the Greek word for truth was *aletheia* (Heraclitus, Fragment B 16, "How can one hide himself before that which never sets?"), which means "to come to light," "to be unconcealed." In the fifteenth century, Lorenzo Ghiberti confirmed that sight leads to knowledge, and the authoritative Cajetan (Tommaso de Vio) sanctioned that "to see by corporeal vision and by intellectual vision are indicated by the common term to see, because just as to understand presents something to the mind, so to see presents something to the animate body."[5]

Whether it be Brunelleschi's experiments with architecture or sculptural-pictorial (Donatello's *Feast of Herod*, 1420; Ghiberti's *Gates of Paradise*, c.1435; Masaccio's *Trinity*, 1427–28; Paolo Uccello's *Deluge*, 1445–47) artworks, the new system of spatial representation paved the way for the Albertian treatises on art and the family. A common emphasis on order and self-confidence unveiled the mental framework of a society whose paramount commitment to art mirrored the divine geometry of the universe.[6]

2

To the extent that they are hypothetical rather than actual images of life, the system of linear perspective and the treatise do justify a theoretical correlation; they do not represent life as it is, but as it ought to be. In both instances, objective measures enforced a subjective notion of reality.

Intellectual procedures emerge in the opening pages of Alberti's *On Painting*: "Among the ancients there was no little dispute whether these

rays came from the eye or the plane. This dispute is quite useless for us. It will not be considered." Likewise, "the function of the eye in vision need not be considered. It will be enough in this commentary to demonstrate things that are essential" (*O.P.*, 46–47). To avoid the flaws of peripheral vision, the surface of the eye had to be flat rather than curved. Focal uniformity and the vanishing point also did away with perceptual distortions. Furthermore, the painter had to "postulate beforehand a single point from which his painting" would be viewed.[7] Mental constructs "redeemed" experience, and Brunelleschi set out to

> rise above corruptible matter
> And gain the strength of clearest sight.[8]

Reason, not optics, could gain the clearest sight. Beyond the medieval heritage of spiritual heights and empirical details, the new standard of clarity was more a matter of interpretation than imitation, of knowledge rather than perception.

Since antiquity, measurement has equated beauty with patterns of proportional relationships. In that tradition, the system of linear perspective set up a geometric microcosm based on the height of a human model. Almost every artist searched for an ideal size (or golden section) governing human and architectural proportions. Donatello and Brunelleschi often wandered through the ruins of ancient Rome without paying "much attention to what they ate and drank, or how they were dressed or where they lived, as long as they were able to satisfy themselves by seeing and measuring."[9] For Piero della Francesca, the system of linear perspective provided "a correct representation of the distance between things and a correct spatial recession (*degradare giustamente*)."[10] The correctness of vision was translated into mathematical values that guaranteed aesthetic perfection.[11]

At first, Alberti still related art to nature, experience, and training. He could not excuse those who, "presumptuous of their own intellect and without any example from nature to follow . . . study by themselves to acquire fame in painting" (*O.P.*, 93). Once created, however, the artistic whole imposes rational laws even on its perceptual components. Later, Castiglione found it necessary for man to "bring into his thought so many adornments that, by putting together all beauties, he will form a universal concept and will reduce the multitude of those to the unity of that single beauty which sheds itself on human nature generally. And thus he will no longer contemplate the particular beauty of one woman, but that universal beauty which adorns all bodies" (*The Courtier*, 352).

Since there is no merit in being "more careful to make things similar to the natural than to the lovely" (*O.P.*, 92), Alberti endorsed an intellectual

approach to form. Accordingly, the movements of the human body are "partly learned from nature and partly fabricated by the mind" (*O.P.*, 78). Moreover, "the parts of the body ugly to see and in the same way others which give little pleasure should be covered with draperies, with a few fronds or the hand. The ancients painted the portrait of Antigonos from the part of the face where the eye was not lacking" (*O.P.*, 76). Piero della Francesca updated that procedure when he painted Federigo da Montefeltro (blind in one eye because of a battle wound) in profile (plate 4). Mimesis conformed with intellectual criteria even in the case of a genre as intrinsically realistic as portraiture. While Donatello wavered between graphic realism (bust of *Niccolò da Uzzano*, 1460–80) and semi-idealized images (*Gattamelata*, c.1450), Alberti sculpted his own profile in a classical guise (plate 5). It was generally agreed that the beauty of art could not be realized in actuality.[12]

On matters of composition, Alberti found it "useful to take from every beautiful body each of the praised parts" so as to express "much loveliness" (*O.P.*, 92). Selection governed physical proportions: "To measure an animate body take one of its members by which the others can be measured. . . . This one member is taken which corresponds to all the other members in length and width" (*O.P.*, 73). Statements of that sort updated the classical concept of organic unity, which served as a the ladder rising from the multiplicity of nature to the unity of an intellectual concept of beauty.[13] Alberti based such a mechanism of transcendence on congruity, whereby different members "conspire to form a beautiful whole."[14] Phrased in the language of Neoplatonic philosophy, "beauty in general is a Harmony resulting from several things proportionably concurring to constitute a third." At that point, the artistic synthesis of the organic construct was analogous to God's "pure uncompounded Unity."[15]

Still on the subject of idealization in art, Albrecht Dürer wrote that "the Creator fashioned men once for all as they must be." The perfection of form is contained "in the sum of all men," and beauty presumes that no single individual "can be taken as a model of a perfect figure, for no man liveth on earth who uniteth in himself all manner of beauties."[16] Later, Goethe made a similar distinction between "common" and "noble" nature in classical art. One is nature in the raw, while the other proclaims a higher degree of beauty which alone can reveal *la belle nature* or *refined nature*. Michelangelo surely fell back on a similar kind of naturalistic idealism[17] when he painted a nude "that could not be found in nature" (Alberti, *O.P.*, 93) on the Sistine ceiling.

Inevitably, even nature fell prey to geometric standards of beauty. Alberti recommended planting "many, many trees in good order and in rows, for they are more beautiful to look at if so planted." Arrangement prevailed over randomness:

Nature herself also seems to have bonded and incorporated in things, from the first day that they see the light, clear indications and manifest signs by which they fully declare their character. Men are able, therefore, to recognize and use them according to the uses for which they were created. In the mind and intellect of mortal man, nature has placed the seed and kindled the light of knowledge, and insight, into the remotest, most secret reasons for the clear and present causes of things. He knows whence and from what end things were born. To this nature added a divine and marvelous capacity for distinguishing and discriminating between what is good and what is harmful, between injurious and salutary, useful and useless.[18]

The literary statement echoed the artistic practice of an age that eventually inspired the geometries of the Boboli gardens and their French descendants.

In Leonardo Bruni's *Panegyric to the City of Florence* (*Laudatio florentinae urbis*, 1403–4), the city stands at the center of the Tuscan landscape, "like a guardian and lord. . . . Just as on a round buckle, we see the regions lying like rings surrounding and enclosing one another. Within them, Florence is first, similar to the central knob. The city herself is ringed by walls and suburbs."[19] Geometric figures (ring, circle) and human artifacts (buckle, knob, walls, suburbs) are the relevant—if not exclusive—signposts of a landscape patterned after Aelius Aristides' description of ancient Athens in his *Panathenaicus*.[20] Yet, Greek reconciliations between the urban and the natural underwent forceful alignments in the Tuscan valley, where "the two banks of the river are joined by four bridges magnificently constructed of squared blocks, and these are placed at such convenient intervals that the river never seems to interrupt the several main streets that cross Florence. Hence you can walk through Florence as easily as though it were not even divided by a river."[21] At least in literary descriptions, nature adjusted itself to the architectural setting.

Laudatory exaggerations aside, Brunelleschi did view the river Arno as the structural axis of a new urban plan. Within fifteen years, the construction of almost all his major buildings was under way. Like the pivot of a perspectival grid radiating from the city toward the countryside, his *cupola* (1420–36) of S. Maria del Fiore towered at the center of a concentric system of hills and suburbs. Nobody "could fail to praise Pippo the architect on seeing here such a large structure, rising above the skies, ample to cover with its own shadow all the Tuscan people" (Alberti, *O.P.*, 40). Likewise, the Palazzo Vecchio "dominates all the buildings nearby and its top stands out above those of the private houses." Nothing in the city is "ill-proportioned, nothing improper, nothing incongruous, nothing vague; everything occupies its proper place, which is not only clearly defined but also in right relation to all the other elements."[22] While Giotto's *campanile* marked the

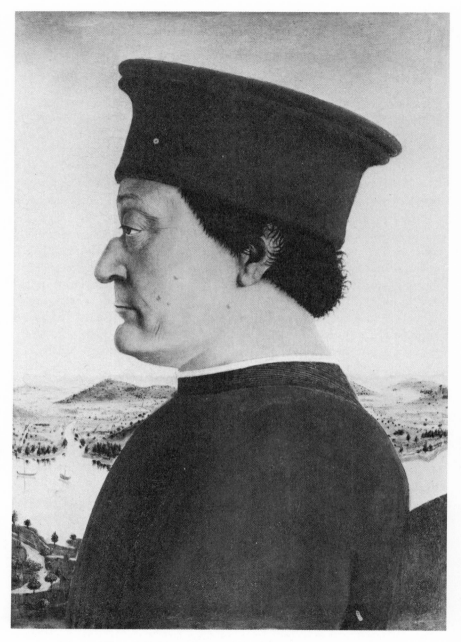

Plate 4. Piero della Francesca, *Federigo da Montefeltro*, 1465. Uffizi, Florence (Alinari, 874)

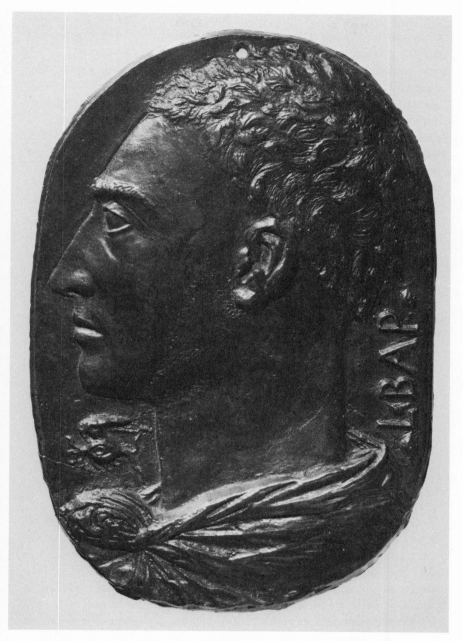

Plate 5. Leon Battista Alberti, *Self-Portrait*. Samuel H. Kress Collection, National Gallery of Art, Washington, D.C.

center of a working community of artisans enclosed within the ancient walls, the majestic *cupola* became the symbol of a city whose financial and cultural prestige had expanded far beyond the urban perimeter.[23]

Throughout Italy, artists set out to order life by planning *piazze* (Brunelleschi's SS. Annunziata in Florence), ideal towns (Filarete's *Sforzinda*), and architectural perspectives (Luciano Laurana, Piero della Francesca). At Pienza, Bernardo Rossellino combined several buildings into a tight unit centered around the square, an idea repeated in *piazze-salotti* (San Marco, Venice) and *città-palazzi* (Urbino). Pride in those achievements led the humanists to declare that the world "had been made more beautiful and perfect by man."[24]

Etymologically, perspective means "to set at a distance," a procedure whereby the Renaissance Ego replaced mimesis with construction. Such a shift occurred when the workshop tradition yielded to art theory, which stood side by side with the literary treatise.[25] Aware of abstract fallacies, Alberti conceded that "mathematicians measure with their minds alone the forms of things separated from all matter. Since we wish the object to be seen, we will use a more sensate wisdom" (*O.P.*, 43). Yet, optical vision was sacrificed to the geometry of perspectival space, and efforts to draw a line between painters and mathematicians implicitly confirmed their proximity. The theory of art and the theory of science complemented each other.[26]

3

The system of linear perspective denied space as an empirical reality. Likewise, the treatise on the family was to stabilize a mercantile society often torn by misguided alliances between greed and power. To keep those eruptive energies under control, Alberti set up norms of conduct for enlightened merchants out to conquer a higher *raison d'être*. At least theoretically, art, science, and society would form a cohesive whole under the authority of the human mind.

On the Family presents a hypothetical figure whose excellence stems from a selective distribution of knowledge. Having confronted the whole spectrum of society, Alberti focused on—as Max Weber would say—an ideal type: the *pater familias*. His image of the successful merchant shed the brightest light amid a constellation of civic and intellectual models who renovated what the ancients called a typology of higher men.

Alberti assumed that man's *virtù* is all-powerful because it alone can tame *fatum*, *fortuna*, and *vanitas*. Consequently, success was the only measure of human endeavors: "If you persevere, if you labor to master whatever lies before you and to make yourself by far the best, you will not . . . find it hard to take all the prizes of honor and fame. . . . In the race of human life and the general contest for honor and glory, likewise . . . the first step is to

choose an appropriate, manageable vessel for your powers and talents, then to strive hard for first place. One must surpass entirely that obscure and forgotten crowd behind" (*O.F.*, 139–40). Only competitive postures of that kind could stand up to the destructiveness of political unrest. Through the centuries, "many families in Italy and elsewhere have been seen first at the height of fortune and honor, then lying prostrate." By contrast, the Albertis have "been able to throw off or endure with constancy bitter misfortunes and furious blows from a cruel fate . . . fortune has too often been unjustly blamed . . . many who have fallen on evil days by their own folly have accused fortune" (*O.F.*, 25–26). Man alone had to be blamed for his own fallacious *virtù*.

Emulative comparisons were infectious. Although art had not achieved any "greater perfection" after the classics (Ghiberti's first *commentario*), one could find in Florence artists superior to those of ancient Greece (second *commentario*). Writing a few decades after Alberti, Filarete poured out pride, irreverence, and critical acumen in his treatment of the ancients, who never "understood perspective. Even though they exercised good judgment in their works, they did not locate things on the plane in this way and with these rules."[27] At all levels, the present had to excel over the past. While Petrarch competed for his poetic laureateship (a three-day examination), Alberti sanctioned excellence in the vernacular (*volgare*) through a literary contest, the *Certame Coronario*. Within the tradition of ancient and medieval "outdoing," the modern writer was better than Homer. "Were he alive today," Erasmus wrote in his eulogy of Dürer, "Apelles would as an honest and candid man concede the glory of this palm to our Albrecht."[28] That claim soon became a commonplace amid artists whose "strong" reading of the classics was innovative rather than gregarious.

Inherent in the Albertian treatise is the assumption that discipline is value, and both of them lead to excellence. Hence, an "orderly routine (*modo e ordine*)" must govern the family, and several opportunities are found for "casting disapproval on disorder of any kind" (*O.F.*, 218, 225). At the top of the social ladder, the family leader inspires the community. Through the voice of old Giannozzo, experience does contribute to shaping man's character, even though "in human life generally reason is more powerful than fortune, planning more important than any chance event" (*O.F.*, 30). At least hypothetically, *virtù* could invalidate the Platonic concession that "a mortal man cannot expect to have everything in his own life turning out according to his will" (*Menexenus*, 247).

It was imperative that the family leader be linked to the community, wherein he would love "not so much his own tranquillity as that of other good men. . . . He desires the unity, calm, peace, and tranquillity of his own home, but much more those of the country and of the republic" (*O.F.*, 178).

For Alberti, excellence itself is collective, since "fame is not born in the midst of private peace but in public action. Glory springs up in public squares" (*O.F.*, 178). Classical references (Anaxagoras, Protagoras, the Stoics, Plato, and Chrysippus) call attention to the task of preserving "the friendship and society of men. . . . Plato, in a letter to Archytas of Tarentum, declared that men were born to serve their fellow men, and that we owe a part of ourselves to our country, a part to our kinsmen, and a part to our friends" (*O.F.*, 134). The individual was part of a socioeconomic network as tightly planned as its perspectival counterpart, and the very titles of *On the Family*, *The Courtier*, and *The Prince* emphasize societal relationships (family-court-princedom) woven in the *città*, the only place where the Platonic myth of *philadelphia* (communal harmony) could be pursued. Instead of educational journeys to faraway places, the Florentines readily accepted the Aristotelian precept (*Politics*, I, 1, 6) that man grows in the family but achieves maturity in the *polis*, an idea which Augustine transferred to Christianity (*Sermo de urbis excidio*, vi, 6). Mindful of the ancient axiom that goodness yearns for education and citizenship, Machiavelli wrote that "the greatest honor possible for men to have is that willingly given them by their native cities; I believe the greatest good to be done and the most pleasing to God is that which one does to one's native city."[29]

Although "every difference of life, of customs, habits, age, and occupation troubles" communal life, Alberti insists that "any resemblance . . . greatly attracts men and invites them to love" (*O.F.*, 275). The analogical mode again leads to a superior fellowship, which in turn produces "a cultured way of life, worthy ways and habits suggesting humaneness and readiness for friendship—*el modo del viver civile, e gesti degni e aspersi di umanità e parati a grazia*" (*O.F.*, 276). Because it implies attraction and concord, similarity generates love. In a Greek sense, analogy stands at the very root of the harmonious and the heroic, which Plato considers "a slight alteration of *Eros*, from whom the heroes sprang . . . they were born of love" (*Cratylus*, 398).

As a literary figure, the family leader exists only through the words spoken by the interlocutors. Rather than an actual character in the flesh, he is the image of an idea, and the dialogues set up his conduct-to-be. It is significant that the action of *On the Family* dates back to 1421, when the interlocutors met in Padua to attend the dying Lorenzo Alberti. His lifetime experience was added to Lionardo's hopes, which in turn became part of a character as intangible and hypothetical as the Prince and the Courtier.

Vis-à-vis Olympian analogues, ancestry provides sources which ought to be emulated. Zeus' majesty is not inherited; in a paradoxical way, he bears his dynasty regressively as well as progressively.[30] Translated into the Renaissance cast of mind, merchants and courtiers were the ancestors of the

family leader and the Courtier, who bodied forth a higher sense of purpose.

Because of his virtual nature, the Albertian hero would never travel the backroads of novelistic vicissitudes, since the writer had done all the growing and learning for him. And the treatise was instrumental in offering one of the safest shortcuts to sudden maturity. On the main road of empirical growth, even Castiglione found it problematic to reconcile development with achievement: "For if the Courtier is so young as not to know what we have said he ought to know, then we are not speaking of him, since he is not the Courtier we presuppose, nor is it possible that one who must know so many things can be very young" (*The Courtier*, 330). Only a much older man could reach such intellectual heights; in turn, he no longer could perform the deeds and "practice the accomplishments" ascribed to him (*The Courtier*, 331). On novelistic grounds, the Courtier is a contradiction in terms.

Like actors in a theater, or figures enacting a story on the stage of perspectival paintings, the family leader would make his entrance at the last moment, after audience, setting, and program had been put in place. He was thus ready for the premiere performance in a role which only needed to play out the treatise-script. In the Plutarchan manner of characters who neither grow nor change, but are simply filled in, the family leader (like the Courtier) was endowed at first appearance with all the categories of knowledge he would ever need. The world stage had been ordered before the protagonist entered it; and before entering it, he was given a story to follow, a space to operate in, and values to be inspired by.

Birth, growth, and old age have involved "untold discomforts" since Plato, whereas the satisfactory part of human life "is generally held to form a kind of breathing-space in the middle years of life" (*Epinomis*, 974). The Renaissance reconstructed that blissful condition in the theoretical habitat of the *città*. At the other end of the social spectrum, and strong of his empirical bent, old Giannozzo maintained that "a man wants to live for himself, not for the community. . . . Do not abandon your private concerns to guide public affairs. . . . Public honors will not feed the family" (*O.F.*, 177, 179–80). Obviously, such an egoistic stand was incompatible with public responsibility. Blending pure (Greek) and practical (Roman) reason, the family leader would value the distribution more than the accumulation of wealth. In actual life, Giovanni Rucellai confessed that he enjoyed spending for others more than earning for himself. Although less than typical, statements of that kind brought to light a new sense of "civic wealth."[31]

Tensions between economic and civic spheres often were conflictive amid the thriving economy of Florence. In shops and market places, too many people agreed with Cecco Angiolieri that "florins are the best of kin," and "can turn to facts all your desires." Even the epic theme of the voyage

took on mercantile overtones in some of the less scholarly statements of Coluccio Salutati: "A great thing is the journey, but greater is justice; even greater, we think, is business, without which the world would not prosper."[32] One need only mention that the Italian *repubbliche marinare* (Genoa, Pisa, Amalfi, and Venice) weighed their power on maritime trades. As a symbol of the new mercantile Florence, the eagle had set its voracious wings to fly back in Dante's days (*Inferno*, xxvi), when a new enterprising Ulysses began to conquer the commercial markets of Europe in the name of God and profit.[33] Long after Petrarch had complained that children were educated at great expense of the family but with "the hope of a much greater financial return,"[34] Alberti foresaw a break between business and culture in a society where "every discussion seems to concern economic wisdom, every thought turns about acquisition, and every art is expanded to obtain great riches" (*O.F.*, 56–57). Personal in tone, this statement betrays the writer's longing for an ideal family more receptive to the new learning than his own.[35] The foundations were thus laid for a juxtaposition of Platonic flights and business trips, learning and *ragion di mercatura*.

Whereas the conservative time of the Church was synchronized with the immobile space of the feudal world, the new dynamics of mercantile commodities led Giannozzo's empirical "plan" to "make as good use as possible of time, and never to waste any." Using it on "praiseworthy pursuits," he would "spend no more time on anything than is needed to do it well" (*O.F.*, 171). Juxtaposed to it, there stood the atemporal dimension of scholarship. Such antithetical energies were buttressed between the *homo oeconomicus'* financial power and the learning of the artist-scholar, between a Gilded (wealth) and a Golden (art) Age.[36]

Instead of mirroring the way things were, *On the Family* called for the amelioration of a society which could reform itself from within. Lionardo already embodied a higher stage of economic consciousness, and the very writing of the treatise set up a corrective program under the banner of an aesthetic-moral ideology.[37] At its best, the literary artifact envisioned a community purged of inequities and inspired by what it might have become. Even the language of business broke free of utilitarian restrictions:

> We shall ever give ground to honor. It will stand to us like a public accountant, just, practical, and prudent in measuring, weighing, considering, evaluating, and assessing everything we do, achieve, think, and desire. With the help of our honor we shall grow if not wealthy in goods at least abundantly rich in fame, in public esteem, grace, favor, and repute. All these things are to be preferred over any degree of wealth (*O.F.*, 150).

On balance, honor should have outweighed profit.

4

Within the realm of art, the system of linear perspective was as prescriptive as its literary counterpart. "All things are known by comparison" in the homogeneous space of the pictorial construct. Comparison immediately demonstrates in objects "which is more, less or equal" (*O.P.*, 55), forcing them to share function, definition, and significance.[38] Alberti demanded that painters and architects compare things according to *concinnitas universarum partium* (*On Architecture*, iv, 2). Even the splendor of Florence could not be appreciated in isolation: "Only those who have been away for some time and return to Florence fully understand how much that flowering city excels beyond all the others."[39]

Uniformity and contextuality were central to literary and artistic wholes. Alberti called a figure "anything located on a plane so the eye can see it" (*O.P.*, 43). As the object was placed in a preexistent space to which it had to conform, so was the individual placed in the theoretical environment of the treatise. As a matter of fact, the *pater familias* was introduced after the family had been set "on the road to success" (*O.F.*, 154). The contextual nature of the perspectival grid was reflected in that of "fatherland," "whole," "community," and "State." Determined to *vivre méthodiquement*[40] in the manner of the Greeks, Alberti molded behavior into given structures of order.

Dedication to collective ideals nurtured greatness in the city, whereas self-interest instigated anarchy. History taught that "as soon as the Macedonian kings began to pursue only their private good and to care not for the public empire" decadence settled in. Similarly, Roman might endured "as long as concern for the public good outweighed with them the pursuit of private ends" (*O.F.*, 26–28).[41] Alberti was not alone in believing that Cicero considered *prudentia*, the virtue of contemplation and scholarship (*De officiis*), inferior to *iustitia*, *fortitudo*, and *moderatio*, the virtues of active life and public commitment.[42]

To strengthen the link between context and construction, Alberti compared the family leader to a spider: "You know the spider and how he constructs his web. All the threads spread out in rays." Placed at the center, it "keeps so alert and watchful that if there is a touch on the finest and most distant thread he feels it instantly, instantly appears, and instantly takes care of the situation. Let the father of a family do likewise" (*O.F.*, 206). The treatise represents such a web, and its dialogues weave relational threads in a communal space (family-clan-State) where the *pater familias* is to enforce a network of rules he has been equipped with. Furthermore, the spider's ability "to feel and see everything" (*O.F.*, 206) parallels *virtù*'s mastery of a world "full of human variety, differences of opinion, changes of heart, perversity of customs, ambiguity, diversity, and obscurity of values. . . .

One has to be far-seeing, alert, and careful in the face of fear, traps, and betrayals" (*O.F.*, 266). Turning toward reality, however, Alberti himself wondered "what father could manage to supervise so many activities." By the same token, "what son could ever be induced to learn all the things you have indicated to us?" (*O.F.*, 84). At a closer scrutiny, the similitude is nothing more than a rhetorical device that cannot disguise complex interactions. However intriguing, the analogy is an oversimplification.

In spite of pedagogical claims, *On the Family* fails to be prescriptive in a practical sense. It outlines, but without precision; it inspires, but does not explain. Teaching is problematic for everybody except the family leader, who is blessed with the artist's "divine dispensation." At the very end of the treatise, Adovardo notes that the prince could "win affection" and "be less feared than loved" by doing "one action, and that a highly pleasurable one." Yet, princes neglect "this means to acquire immortal love and admiration." Lionardo: "I am waiting to hear what that one action is." Adovardo: "Well, then—I'll answer you tomorrow" (*O.F.*, 316–17). At the contextual apex of social relationships, the answer is not given, and the treatise slips into the void of wishful thinking.

Actually, *On the Family* fixes the interlocutors into given roles; they are instruments of a postulated ideology. In the Socratic sense, Mikhail Bakhtin comments, the dialogic means of seeking truth is counterposed "to official monologism, which pretends to possess a ready-made truth." That ambiguity is typical of Socratic dialogues in which the content often assumes "the monologic character of irrefutable truths that contradicted the form-shaping idea of the genre." Like some of its classical ancestors, the Albertian construct subordinates debate to statement. As is the case with the relational value of the object in the perspectival system, monologic space recognizes another person as "an object of consciousness, and not another consciousness."[43] The dialogic space thus becomes the stage for a kind of puppet show immune to sophistic and Socratic perplexity (Plato, *Meno*, 80). The Albertian dialogue does not unfold within the dialectic context of the market square, but in the private household of inherited privileges, where ready-made truths are consonant with the dictates of authority. What transpires is an unprecedented measure of "pre-emptive" idealism.

For Nietzsche, the Socratic emergence of a *theoretical man* in classical antiquity produced "the unshakable faith that thought, using the thread of logic, can penetrate the deeper abysses of being, and that thought is capable not only of knowing being but even of *correcting* it." Critical of that development, the German philosopher asked whether "the net of art, even if it is called religion or science, that is spread over existence be woven even more tightly and delicately, or is it destined to be torn to shreds in the restless, barbarous, chaotic whirl that now calls itself 'the present'?" For his

part, Alberti wove his virtual net over existence by intertwining reason and imagination. In Nietzsche's words, such a "metaphysical illusion accompanies science as an instinct and leads science again and again to its limits at which it must turn into *art*." Neither a loss nor a failure for Alberti, such leaps revealed forms of plenitude that made it possible for his *theoretical man* to "correct the world by knowledge, guide life by science, and actually confine the individual within a limited sphere of solvable problems."[44] The treatise institutionalized human conduct into an atemporal scheme of unimpeachable standards.

5

As in the insect societies to which they bear resemblance, rational models of order are prone to remain static.[45] In fact, the comparison bears on the endemic disease of analogical thinking, namely, an ironclad reliance on categorical "sameness." And there lies the limit of much Renaissance *aemulatio*, which aimed at maintaining a condition of achieved maturity.

Yet, it took a long time before any hardening of analogical categories settled in, and the Petrarchan claim that there is "no aspect of knowledge one could not improve" was symptomatic of an enviable state of health.[46] The relationship between the old and the new was therefore equated with the mixture of individuality and resemblance typical of parental relationships. Young poets were urged to make "something out of the works of the ancients," who had to be surpassed. Stretching over millennia, humanist commentaries set up interactions which became essential to the very structure of knowledge. For Petrarch, there was no better way of doing things than by "comparing one's mind with those it would most like to resemble." Comparison (as quotation-illustration-example-commentary) provided the key for securing a world of certainties where the writer could be "happier with the dead than with the living."[47]

Linear perspective, treatises, and panegyrics celebrated creativity well beyond what antiquity had ever attempted. Whereas the ancients had "models to imitate and from which they could learn," the moderns discovered "unheard-of and never-before-seen arts and sciences without teachers or without any model whatsoever" (Alberti, *O.P.*, 40).[48] Their pursuit of originality was relentless. While Brunelleschi did not reject the stratification of architectural styles, Alberti, who was a theoretician more than a practitioner, often sacrificed historical developments to an ideal canon. Romanesque and Gothic elements are subordinated to a modern hierarchy in his façade of S. Maria Novella (plate 6), much as the triumphal arch that he designed for the equestrian statue of Niccolò III d'Este in Ferrara updated a Roman custom and disregarded the medieval square-church in front of it (see plate 7).[49] Likewise, the classical exterior (1450) of

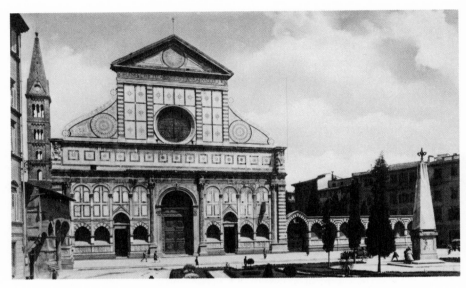

Plate 6. Alberti, S. Maria Novella, 1456–70. Florence (Alinari, 2269)

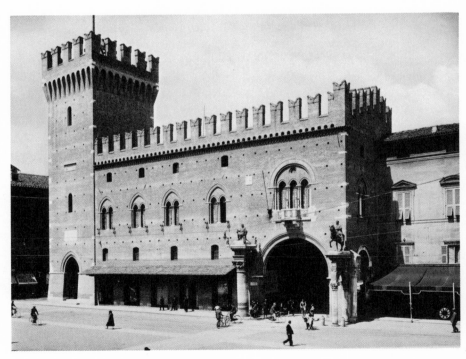

Plate 7. Alberti, Arco del Cavallo and Equestrian Statue of Niccolò
III. Ferrara (D. Anderson; Alinari, 30344)

the Tempio Malatestiano in Rimini seems to have swallowed the preexistent medieval church. In the language of architecture, the classical vocabulary produced the new lexicon of columns being purely decorative (Alberti) or supporting directly the arch (Brunelleschi), Mantegna's *ordine a pilastro*, and the synthesis of *firmitas* (Asian emphasis on mass), *venustas* (Greek grace), and *utilitas* (Roman usefulness) in the Albertian treatise on architecture (book vi, chapter 3).

As convinced as Petrarch that each individual ought to do his "best to become greater and greatest,"[50] artists and writers looked down on the gregarious herd of "monkeys" and "parrots." While tolerance and intransigence kindled polemical exchanges, emulation urged provocative contacts between tradition and individual talent. Although regressive attitudes often have deflected the linearity we usually associate with the idea of artistic progress, the past remained a point of departure.[51]

6

Inevitably, the humanists turned their attention to linguistic challenges. Economic and scientific progress demanded a vocabulary at pace with the times, a fact that heightened the problematic dialogue between Latin and the vernacular. Insofar as it weighed on truth itself, language exceeded matters of style and tradition. For Platina (Bartolomeo Sacchi), what did not follow Latin standards could still be said according to the truth, so much so that discussions on theological issues in Latin began to disturb "contemporary minds."[52] Fortunately, debates about the purity of the *volgare* did not produce serious rejections. Instead, the vernacular begot an exemplary status when Alberti wrote *La prima grammatica della lingua volgare* (1450). He took pride in having "fixed the basic principles" of the Florentine language, which made it possible for people to "write and speak without corruption (*scrivere e favellare senza corruzione*)."[53] On linguistic grounds, perfection rested with the ennobling power of language.[54]

Latin gave measure, strength, and elegance to the *volgare*, which in turn influenced Latin in terms of linear progression, simple syntax, intuitive connections, and inner eloquence. Much as his *ragionamento domestico* (household discussion) sought to reconcile classical learning with modern taste, Alberti's *stile pacato* in fact was a linear and easy-flowing style. To illustrate the relationship between form and function, he resorted to an architectural metaphor. The master builders of aqueducts "take care to determine the most suitable and unimpeded course for drawing off the water before they open its source. So in this naturally vast, grave, and diffused material, I should have to arrange my discussion so that it would be not abrupt, disjointed, or confused, but conducted from topic to topic with pleasing aptness and ease."[55] It was hoped that people would master the

fabric of language before using it, just as the family leader was to master the fabric of knowledge before enforcing it. While architecture bridged the gap between the medieval extremes of colossal cathedrals and minute details, the vernacular combined lengthy Ciceronian constructions (opening paragraphs of Boccaccio's *Decameron* or Alberti's own in *On the Family*) with the colloquial brevity of everyday speech. In both instances, adaptation prevailed, and the emergence of technological Italian rushed in a new way of thinking.[56]

The Renaissance coordination of knowledge, art, and language thus came full circle. Grammar shaped rhetoric, which disciplined the narratives that gave meaning to the images of art. The pictorial *istoria* set up classes of emotional experience drawn from Quintilian's discussion of the subject. Oratorical gestures became the painter's business. In his commentary on Horace (1482), Cristoforo Landino described poetry by using terms taken from Cicero's discussion of periodic style (*Orator*), which in turn influenced the structure of the Albertian treatise on painting. Rhetoric, literature, and art shared a common vocabulary. A number of critical terms that Bruni applied to literature—*figura, status, color, lineamenta, forma*—were visual metaphors applicable to painting. Such a lexical fact reflected classical exchanges between literature and art criticism, much as the Albertian *compositio* presumed an interdisciplinary concept of form.[57]

The Albertian ideal of *ragionamento domestico* gained visual presence when Andrea Mantegna painted (completed 1474) the Camera degli Sposi (Ducal Palace) at Mantua. As an artistic whole, the story of the Gonzaga household mixed historical events with prosaic details, Latin quotations (*stucchi* and ornaments) with a modern narrative (the family's own story) that established the *volgare* as the figurative language of art. The young cardinal holding his brother's hand (*Arrival of Cardinal Francesco Gonzaga*, 1474, plate 8) exudes more than dynastic pride; above all, he enacts the importance of having a family. After Mantegna had painted classical images (1454–57) in the Ovetari chapel (Eremitani Church, Padua), his move to Mantua (right after Alberti had finished the church of S. Andrea there) produced the most authentic portrait of the humanist *famiglia*.[58] The dignified grandeur of those secular frescoes echoed the hopes and memories of Alberti's own domestic model.

7

Understood as the Latin translation of the Greek *hypokeimenon*, *subjectum* names, in Heidegger's comment, "that-which-lies-before, which, as ground, gathers everything onto itself. . . . This metaphysical meaning of the concept of subject has first of all no special relationship to man. . . .

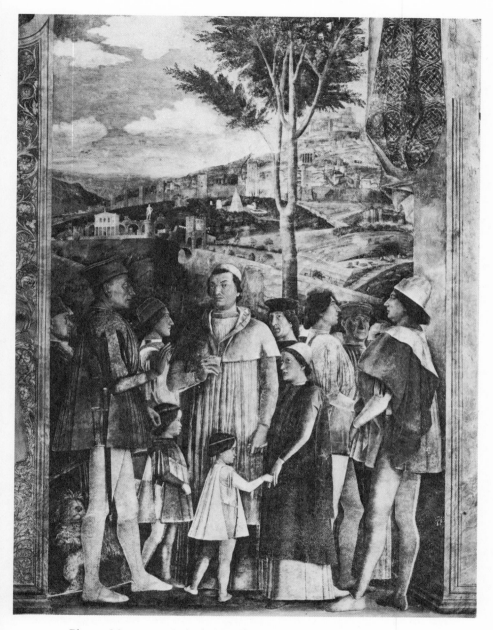

Plate 8. Mantegna, *Arrival of Cardinal Francesco Gonzaga*, completed 1474. Camera degli Sposi, Palazzo Ducale, Mantua (Alinari, 18713)

Greek man *is* as the one who apprehends that which is, and this is why in the age of the Greeks the world cannot become picture. . . . However, when man becomes the primary and only real *subjectum*, that means: Man becomes that being upon which all that is, is grounded as regards the manner of its being and its truth. . . . Man becomes the relational center of that which is as such." Since he did not isolate himself from the spatio-temporal coordinates of the outside world, Protagoras' man could not set reality at a distance under his control. By contrast, linear perspective and the treatise were belated products of the latter view, and they acknowledged reality inasmuch as it could accommodate human creativity. Representation thus bore on a "setting-before" that arrests and objectifies. There "begins that way of being human which mans the realm of human capability as a domain given over to measuring and executing, for the purpose of gaining mastery over that which is as a whole."[59] Perspectival representation does not mean a picture of the world, but the world conceived and grasped as picture. Greek apprehending thus gave way to modern representing. Although Heidegger traced the emergence of the world-picture concept back to the eighteenth century, his words shed light on the Renaissance as well.

Late in the fourteenth century, the new trust in the certainty of intellectual choices was confronted by writers who filled space with brewing interactions (Boccaccio's *Decameron*) and painters who were urged to rely on natural models (Cennini's *Trattato della pittura*, 1390). Yet, rational concerns outranked the potential naturalism inherent in any psychophysiological outlook. The lively humanity of Boccaccio yielded to Alberti's hypothetical protagonist, and the problem of sight, in passing from optics to geometry, shifted from the objective to the subjective sphere. In the 1420s, empirical and mathematical spaces confronted each other in the works of Masaccio (*The Tribute Money*) and Gentile da Fabriano (*Adoration of the Magi*). A few years later, Filarete was calling Gothic art modern, and humanist art ancient. In the end, the challenge of reality provided the mimetic cover for intellectual postures whereby linear and narrative distance expanded the personal sphere.[60]

Predominance of the subjective thrust paved the way for Pico della Mirandola's *Oration on the Dignity of Man* (1486). Unlike all the other creatures to which God has given a specific place in the universe, man stands outside the cosmic hierarchy. Still endowed with spatio-physical attributes (microcosm, the center and measure of things), he is free to mold a realm of his own making. In "the universal chain of Being," man is to be "envied not only by brutes but even by the stars and by minds beyond this world" (*Oration*, 223). For Alberti, man is "not born to stagnate at rest, but to be up and doing . . . whenever man thinks and acts with reason and with virtue, he, in his felicity, is like a mortal god" (*O.F.*, 133–34). In his philosophical

criticism of the age, Ernst Cassirer wrote that man is "what he *makes* of himself—and he derives from himself the pattern he shall follow."[61]

8

In a common effort, Brunelleschi and Alberti set out to bar discontinuity from the representation of life. At last, the vanishing point (painting) and the concept of *virtù* (literature) reconstructed self and world beyond the mimesis of life. The antinomy between theoretical freedom and empirical necessity collapsed, and reality became a projection of the Ego.

At the vanishing point of human ingenuity, the Albertian *virtù* consists of a metaleptic accretion of meanings—*fama, diligenza, prudenza, gloria*—that exceeds any mechanical sum of attributes. Such an elusive quality could be neither fully explained nor taught; like Castiglione's *sprezzatura*, it had to remain as virtual and unique a talent as the prototype it was meant to serve. To a substantial extent, it magnified the fragmentary complexity of Protagoras' virtue, which included wisdom, courage, justice, temperance, and holiness (Plato, *Protagoras*, 323–25). When it came to defining notions of excellence, the sophists could only enumerate a swarm of specific virtues *à la* Gorgias, which however remained inadequate, shallow, and particular. The Romans were not any more precise. Horace understood *virtus* as a standard of conduct, which he associated with frugality, agreeability, simplicity, courage, honesty, modesty, and prudence (Sat., I, 3; Epist., I, 12—II, 3). Whatever its shortcomings, virtue was Zeus' gift, and led to political distinction. Like Platonic grace, Renaissance *virtù* was fundamentally incommunicable. Yet, whereas the former was a God-given dispensation (*Meno*, 99e), the latter was man-made.[62] So conceived, *virtù* stood as an Archimedean point from which Alberti derived his geometry of perfection.

Man is made in the image of God, but is not completely *like* him. Likewise, the family leader was a model for merchants whose talents stood at bay of his exceptional *virtù*. The gap between model and reality signaled a hierarchical privilege. Their link was proportional; one could not be identical with the other. Although it tends to resolve the problematic into the familiar, analogy points to an imperfect likeness.[63] Set against the achievements of the past, the Albertian concept of *virtù* suggests that the idealization of power can beget acts of unbridled self-idealization.[64] Like most of the theories that the Greeks proposed, Renaissance treatises were more remarkable for their abstract clarity than for the close linkage of theory to empirical data.[65]

9

Throughout his works, Alberti underlined the difference between theory and practice, what painting is and what the painter does. Yet, his

standards were accepted as the principles of architecture, and quickly inaug-
urated a cultural style that inspired cityscapes (Piero della Francesca) and
recreations of ancient Rome (Mantegna).[66]

Since they were written for artists and merchants at their professional
best, the Albertian treatises on art and the family were meant to upgrade
excellence into perfection. Such a theoretical outlook made of the individual
"the center of nature, the middle point of all that is, the chain of the world,
the face of all, and the knot and bond of the universe."[67] However illusory,
art and literature mirrored life as the "baseless fabric" of what should have
been. In that spirit, Alberti's quest of certainty set up a utopian paradigm
which could best be evaluated "by what it designed" than "by what it
actually achieved."[68]

PART II

Metahistorical Forms of the Mediterranean Experience

3

In Adam's Likeness:
Creation as a
Constant Sacrament of Praise

True, he possesses this humanity in potentia *before
every determinate condition into which he can conceiv-
ably enter.*

*The Person, which manifests itself in the eternally
persisting "I," and only in this, cannot become, cannot
have a beginning in time.*

Friedrich Schiller

1

In Michelangelo's rendition of the archetypal simile, Adam is born into à
God-like image. The *élan vital* flows from God to man, who will eventually
return his spirit to the Creator. At birth, man stands by the object of his
own—and mankind's—salvation history. Since the moment of creation is
projected toward eternity, the analogy includes separation and reunion;
resemblance charters human destiny out. Adam and God body forth the
juxtaposition of ultimate states of being before any process of growth is to
begin.

The place where Adam awakens to life is as vaguely terrestrial as his
name, which means earth in Hebrew. Pico della Mirandola also acknowl-
edged that the "name 'human' is given to what has been made from
'humus.'" Yet, "earth, that is, potency, is void and empty, void of act and
empty of light" (*Heptaplus*, V, 1). Indeed, an appropriate commentary on
Michelangelo's primeval setting. In both instances, man and reality are
potential representations of actual forms. While Jacopo della Quercia had
placed God on earth at the moment of creation (relief on the main portal of

San Petronio in Bologna 1425–38, plate 9), Michelangelo depicted a heavenly realm closer to the Creator's uranic nature.

Voicing Florentine praises of human dignity, language added to the unitive character of the primeval similitude. While he used "the singular when he created the animals and everything else," God voiced Adam's appearance in the "privileged" plural (*faciamus hominem*). For Giannozzo Manetti, God was referring "not to the body, but to the soul" when he decided to make man in his own image.[1] Adam is the prelapsarian man who would never perish, because he has been conceived above the gravity of a natural setting.

Even Pico della Mirandola (*Oration on the Dignity of Man*) let God speak to Adam in either the future tense or the conditional mode ("mayest," "thou thyself shalt desire," or "shalt ordain for thyself"). The very notion of a time about to unfold projects the idea toward existence, where likeness and analogy relate God to earthbound forms. Right before entering the flux of life, man would take cognizance of himself through an act mirroring creation: "As though the maker and molder of thyself, thou mayest fashion thyself in whatever shape thou shalt prefer" (*Oration*, 225). The reflexive activity of self-making underlines man's all-powerful optimism.[2] Consistent with the Rabbinic contention that the spiritual Adam was created before the physical Adam, the prelapsarian man is generated in the mind and represented through language. As such, he does not bear a proper name. The first man is, in name, still a prototype, a kind of Adam Kadmon, the Primordial Man of the Kabbalah tradition Pico was familiar with.[3] Adam stands at the threshold of existence, where the conditional ("thou mayest") gives precedence to intention over performance. The potential is yet to be tested in reality, which prototypes such as the *pater familias* and the Courtier never intended to enter.

On the Sistine ceiling, Adam is about to awaken to life in the form of a breathless ideal whose divine resemblance bears on a boundless faith in human beginnings that would last forever. Since hope often presumed accomplishment, the process of history yielded to intellectual forms of certainty. The analogical mode operated on virtual grounds where a whole epoch could be new born and perfect. Above all, birth meant conception.

Although hypothetical, Pico's emphasis on free will could transform Adam's status as the beginning of imitation into a model from which imitation itself would unravel. Inevitably, the choice of self-making was bound to antagonize conformity with the archetypal "like," which in fact set up a privileged restriction. Freedom of choice contained the seed of the fall. In Pico's description, "God the Father, the supreme Architect, had already built this cosmic home we behold . . . when everything was done, He finally took thought concerning the creation of man," who was to "ponder the

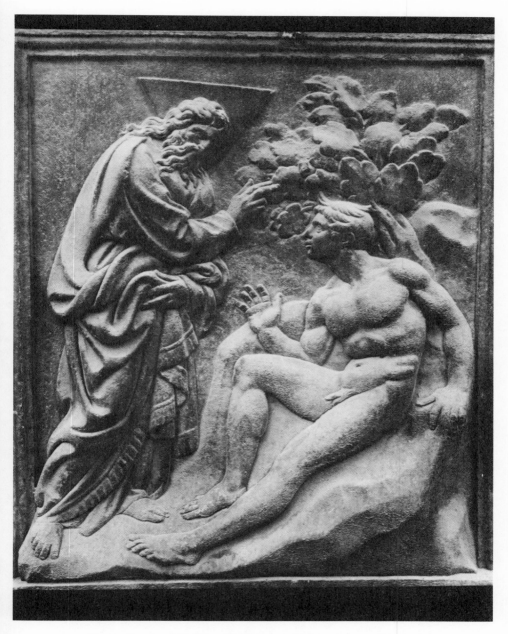

Plate 9. Jacopo della Quercia, *Creation of Adam,* 1425–38. Panel on Main Portal, S. Petronio, Bologna (Alinari, 35458)

plan of so great a work, to love its beauty, and to wonder at its vastness" (*Oration*, 225). Such a contextual priority was updated through the preexistence of the city over the individual in antiquity,[4] as well as those modern networks (linear perspective, treatise) that heightened man's trust in the certainty of knowledge.

Birth to perfection depended on selection, which led the artist to produce figures as proportional as the Vitruvian drawings of Leonardo da Vinci and Francesco di Giorgio.[5] Actually, the very word *analogy* is Anglicized Greek for proportion (of a mathematical kind), and Cajetan later wrote that analogy indicates "proportion or proportionality," meanings which are as remote from life as they are germane to the Albertian standard of congruity.[6]

At this point, Thomas Greene's comments on Pico's *Oration* are provocative: "It is the conception of a very young man, instructed less by human experience than by books and ideas. It could never be the conception of a novelist, whose equipment must include a practical awareness of all those inhibitions to freedom imposed by society and character and the human condition."[7] In terms of novelistic archetypes, the lost paradise myth (Genesis 2:4b–7, 9a, 18–24; 3:1–19, 22, 24) would have provided a better environment for man's trying experience of a fallen world. By contrast, Michelangelo envisioned Adam at home in a place of bliss. Between the Bakhtinian poles of completeness (ancient-epic) and open-endedness (modern-novelistic), the Renaissance shaped forms of ideal maturity which bypassed, as it were, ancient being and modern becoming.[8]

Man-made laws replaced psycho-physiological conditions with a paradigm of ideal models that were human in an intellectual sense. While treatises threaded webs of hope, commentaries and orations proclaimed an unconditional faith in human freedom (Pico della Mirandola's *Oration*), civic commitment (Matteo Palmieri's *Della vita civile*, 1433), and intellectual excellence (Poggio Bracciolini's *De nobilitate*, 1440). The Albertian assumption that "nothing is ever so difficult that study and application cannot conquer" (*O.P.*, 93) could not condone passivity in the face of natural fortunes and spiritual plans measured *ab aeterno*. At its best, artistic creation was inspired by what Wallace Stevens would have called a "constant sacrament of Praise."

2

Since perfection was incompatible with chronology, the Renaissance search of flawless maturity could develop ameliorative views of the human condition only by transforming time into value. Ironically, that preliminary task was undertaken when the rediscovery of the Graeco-Roman past had just unveiled the true face of time as process.

Because of a "law of disjunction" whereby the medieval mind separated form from content, the ancients had been forced to think and act in a Christian manner.[9] While Dante still viewed history as a uniform continuum, Petrarch established an independent point of view at a distance from the temporal plane, which he proceeded to measure against standards of birth, growth, and decline. Until then, history had maintained a qualitative uniformity between the extremes of mythic pasts (pagan) and transcendental futures (Christian). With Petrarch, pagan antiquity regained its identity, for he quickly realized that the classical world had developed a culture as inclusive as Christianity itself.

Petrarch therefore went against the grain of medieval uniformity. The moment he began to compare and evaluate, it became apparent that history could not be reduced to the unbroken continuity of the Christian tradition. At once, he realized that the classical world was historically extinct, and its heritage had been buried under the weight of a different philosophy of human nature. By implication, any drawn-out *imitatio* of antiquity could not ignore forewarnings of a millennial oblivion. Better than most, Gibbon captured the disintegration of the Graeco-Roman past in the conclusive chapter of *The Decline and Fall of the Roman Empire*, whose ruins were "deprived of substance, as well as of place and proportion." The historian then quotes Poggio Bracciolini's humanist encounter with the remains of the Eternal City: "The forum of the Roman people, when they assembled to enact their laws and select their magistrates, is now enclosed for the cultivation of pot-herbs, or thrown open for the reception of swine and buffaloes. The public and private edifices, that were founded for eternity, lie prostrate, naked, and broken, like the limbs of a mighty giant; and the ruin is the more visible, from the stupendous relics that have survived the injuries of time and fortune" (vi, 71). In light of such evidence, any *rinascita* had to occur in spatio-temporal conditions of a radically different kind. Had the humanists surrendered once again to the temporal flux of dark and golden ages, the new era they were bringing to life would not have survived its birthday. Although a source of much needed enlightenment, *imitatio* was to remain instrumental, while *aemulatio* had to find a way of bypassing both the downfall of the Roman world and the near stalemate of its Christian heir.

Aware as he was of the monumental task facing him, Petrarch froze time into a system of transhistorical resemblances that courted abstraction. By the turn of the fifteenth century, in fact, a network of geometric relationships replaced the complexity of the phenomenal world. To borrow from Erwin Panofsky's exemplary analysis, the process of projecting "an object on a plane in such a way that the resulting image is determined by the distance and location of a 'point of view' symbolized, as it were, the *Weltanschauung* of a period which inserted a historical distance—quite

compatible to the perspective one—between itself and the classical past."[10] In other words, history as a stage rather than a flow. Given such a spatial perspective on the past, Renaissance forms were placed in the artificial *now* of a theatrical make-believe which could rearrange human experience as its better, and therefore virtual, Other. At that point, it would indeed be possible to master nature and emulate the past by blending the best of heritage (classical, medieval) and originality.

In the Renaissance vocabulary, the semantic content of *humanus* was retrospective insofar as it linked cultural maturity to an active pursuit of inherited knowledge, that is to say, the written texts (*litterae*) of the unified culture of Graeco-Roman antiquity. Yet, the innate predominance of *aemulatio* over *imitatio* in the modern camp uprooted the etymological meaning of *humanus*, which became present-oriented.[11] Imitation updated the past, and assimilation enriched the present.

Historical juxtapositions became crucial to the analogical syntax of an epoch-making rebirth. On the day he was crowned poet laureate in Rome (April 8, 1341), Petrarch called on Statius (presumably the last to have been so honored by Domitian) to renovate an age "that was happier for poets, an age when they were held in the highest honor, first in Greece and then in Italy."[12] Later, Politian concluded his account of the Pazzi conspiracy against Giuliano and Lorenzo de' Medici by comparing them to Caesar and Augustus. In the world of visual forms, Donatello's bronze *David* (plate 18) combined ancient battle wear with a modern Florentine hat. Filarete criticized the classical attire of the sculptor's *Gattamelata* because a contemporary figure "should not be dressed in the antique fashion but as he was." Although the cuirass imitated the ceremonial armor of imperial statues, arms and legs were sheathed in the latest military gear.[13] Scenes with ancient architecture often accommodated humble stables in adoration scenes (Botticelli), much as old and new were reconciled in Alberti's churches (S. Maria Novella, Florence; S. Francesco, Rimini, plate 10; S. Andrea, Mantua). On the occasion of the *Certame Coronario* (a literary contest), Alberti, Bruni, and other contestants experimented with *metrica barbara*, that is to say, Latin metrics applied to the vernacular (early precedents to the poetry of Giosuè Carducci). Such mixtures invested artistic forms with meanings unknown to their classical prototypes.[14]

If it is a fact that nature forces man to "run, speed, gallop" toward death, a pen (or chisel, or paintbrush) could nonetheless free the artist from the burden of time. "Nothing weighs less than a pen," which can benefit even "men of the future, thousands of years away." Of "all earthly delights," Petrarch insisted, "none is more noble than literature, none longer lasting, sweeter, more constant, none that so readily endows its practitioner with a splendid cloak for every circumstance, without cost or trouble."[15] In the

Plate 10. Alberti, Malatesta Temple: Exterior designed, 1450. S. Francesco, Rimini (Alinari, 17611)

agravitational realm of art, the experience of "here" and "now" could encompass the outer reaches of the mind. At last, legacies of oblivion surrendered to a new heritage of blissful analogues. In that spirit, Pico della Mirandola's comments on the vernacular poetry of Lorenzo de' Medici highlight essential features of the modern form, which

> is neither artificial nor complicated, but linear, pure, and solid; it is neither exaggerated nor insufficient, neither pompous nor distasteful, but gently dignified and seriously attractive. The forms of this poetic expression are chosen, but not extravagant.[16]

Lorenzo Valla found similar traits in Virgil's style:

> I admire the majesty of his language, the appropriateness of his words, the harmony of his verses, the smoothness of his speech, the elegance of his composition and the sweetly flowing structures of his sentences.[17]

Although he set himself free of the microcosm-macrocosm system of medieval correspondences, the Renaissance artist transferred that tightly knit frame of mind to his own universe. To disengage human life from the

whim of circumstance, he fell back on analogical structures that afforded security. Often, he overstated his case and repeated the medieval error; the classics were made to breathe Florentine air. In that inebriated atmosphere, time belonged neither to fate nor fortune, but to man.

3

Mythic remoteness and historical succession stood side by side in Renaissance *studioli*, *accademie*, and *biblioteche*, intellectual islands where books could "talk to you, counsel you, admit you to their living" centuries away. Because of a spatial contiguity more synchronic than diachronic, books "introduce other books; each one creates a desire for another."[18] Accordingly, Petrarch wrote to Socrates, confessed to Augustine, argued with Cicero, and spent leisurely days with them in southern France at Vaucluse, a place of learning immune to the tyranny of time.

Like Petrarch, Alberti sought places of seclusion where he could meet with the "expert and eloquent men" of antiquity as well as with his contemporaries in the Tuscan hills by Camaldoli.[19] After a day of fleshly altercations in the tavern, Machiavelli retired to his *studiolo*, where he would take off "the day's clothing, covered with mud and dust, and put on garments regal and courtly." With almost ritualistic overtones, he thus entered a temple of spiritual treasures: "And reclothed appropriately, I enter the ancient courts of ancient men, where, received by them with affection, I feed on that food which only is mine and which I was born for, where I am not ashamed to speak with them and to ask the reason for their actions; and they in their kindness answer me; and for four hours of time I do not feel boredom, I forget every trouble, I do not dread poverty, I am not frightened by death, entirely I give myself to them."[20] Longings of that kind shattered historical distance and echoed dialogic exchanges in the form of epistles and commentaries.

Intellectual seclusion was equally familiar to political figures, and one need only mention Lorenzo de' Medici's retreats to his villas or Isabella d'Este's elaborate *camerino* in Mantua. When Pedro Berruguete painted Federigo da Montefeltro as a soldier reading a book in his *studiolo* (plate 11), the traditional iconography of the saint-scholar (St. Jerome and St. Augustine as portrayed by Botticelli, Antonello, Dürer, and Carpaccio) gave way to that of the soldier-humanist educated by *sapientia et fortitudo*, *armas y letras*. In the duke's *studioli* at Gubbio and Urbino (plate 12), the perspectival *intarsie* of Baccio Pontelli magnified the artifice of a place folded into its own decorative seclusion. Beauty was sustained by power, and power fulfilled by beauty; an inspired equation that was possible only in the world of art.[21]

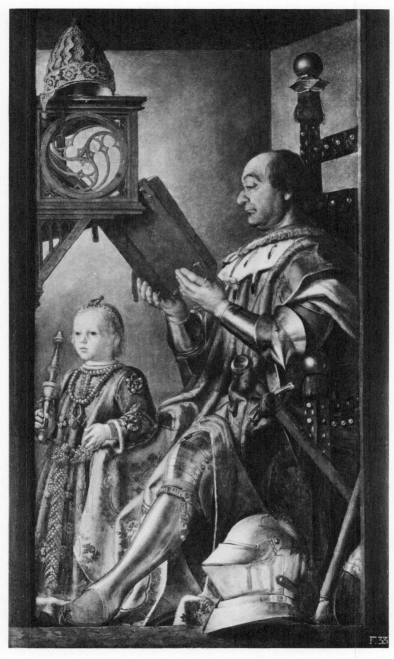

Plate 11. Pedro Berruguete, *Federigo da Montefeltro and His Son
Guidobaldo*. Palazzo Ducale, Urbino (Alinari, 28603)

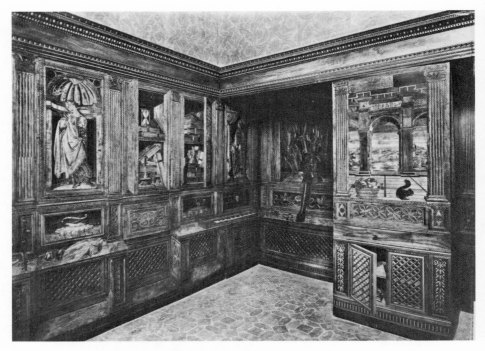

Plate 12. Private Study of Federigo da Montefeltro: Intarsia executed by Baccio Pontelli. Palazzo Ducale, Urbino (Alinari, 37887)

4

In addition to *studioli* and perspectival grids, architectural pictures were a logical extension of the Renaissance commitment to control space and stage history (which became fashionable with theatrical settings in the later sixteenth century). Instead of a background to a human narrative, Luciano Laurana's *Architectural Perspective* (1450–75?, plate 13; also known as *Baltimore Perspective*) presents the monumental environment of "dream buildings."[22] Insofar as spatial transformations of time are concerned, pagan (Colosseum, Triumphal Arch) and Christian (Baptistry) forms share in a man-made synthesis of ideological landmarks anchored to the city. Architecture is the *topos* of a silent rhetoric whose commemorative function bears on the common root of *città* and *civiltà*. In a classical and humanist sense, in fact, knowledge is knowledge of the *polis*.

We have been taught that architecture is memory, compressed time, and encyclopedia. From Cicero and Quintilian to Giordano Bruno, mnemotechnics flourished as a branch of rhetoric meant to impress "places" and "images" on memory. And the more common kind of place was of the

Plate 13. Luciano Laurana, *Architectural Perspective,* c. 1475–1500. The Walters Art Gallery, Baltimore

architectural type.[23] For Augustine, memory is "like a great field or a spacious palace, a storehouse for countless images of all kinds which are conveyed to it by the senses" (*Confessions*, X, 8). Mnemosyne was the mother of the Muses, and mastery of its powers influenced the whole range of human knowledge.

When dream buildings such as Laurana envisioned them did see the light of day in Pienza, contacts between the impeccable geometry of the humanist island (*piazza-chiesa-palazzo*) and the more natural setting of the medieval town created problems. Likewise, Biagio Rossetti's Herculean Addition in Ferrara became a residential area, but failed to turn the socio-economic life of the city away from its medieval center. Often, such landmarks stood out as sore thumbs. Where reality resisted ideal plans and historical synthesis, architectural perspectives and stage designs let the imagination have its way, especially when political power consolidated in the hands of a few families who sponsored urban projects and outright utopias.[24]

It already has been noted that millennial fortunes had corroded the monuments that paganism and Christianity had assembled in Rome. However decayed or pillaged, the co-presence of those symbols still provided an arresting sight for men who had just mastered a better understanding of them. Petrarch's preparation for, and reaction to, his first visit to Rome set the trend for humanist subordinations of time to space. Because his readings had magnified the contrast between the grandeur of antiquity and "the abandoned effigy of old Rome" inherited from the Middle Ages, the poet feared that he would meet with disappointment. Once in Rome, however, the presence of ancient monuments "diminished nothing" but "increased everything. Rome was greater than" one could suspect; no wonder "that the world was ruled by this city," where one could never say that "present reality

is always hostile to greatness."[25] Amidst pagan and Christian buildings, Petrarch found himself surrounded by the spatial simultaneity of over a thousand years of history all staged in one place. In a letter dated October 1764, Gibbon reminded his father that "whatever ideas books may have given us of the greatness of that people, their accounts of the most flourishing state of Rome fall infinitely short of the picture of its ruins."

If anywhere, it was in Rome that humanity could look back on much of its accomplishments. There, Petrarch wrote, was "the world's head, the citadel of all lands, where aforetime was Jove's seat, where now stands the *Ara Coeli*." There, and only there, could he be crowned poet laureate. Only on the Capitoline hill could individualism and tradition join forces in staging the triumph of the artist-hero over time. At the end of the ceremony, the poet went to St. Peter's, where he laid his crown upon the altar.[26] Six years later (August 1, 1347), Cola di Rienzo, who briefly took power in Rome while the Papacy was in exile at Avignon, was consecrated *Candidatus Spiritus Sancti miles, liberator Urbis, Zelator Italiae*, and *amator urbis*. Moreover, he was proclaimed *Augustus* in the Baptistry of San Giovanni in Laterano, where Constantine was said to have been baptized. Ancient and modern, Cicero and Augustine, Baptistry and Colosseum, stood side by side in the landscape of ideas.

As the old saying goes, all roads lead to Rome, because one can meet history there. And Aelius Aristides reminded his contemporaries that "whatever one does not see here neither did nor does exist" (*Roman Oration*, 13). Historical perspectives were adjusted to visual distance. At least in Rome, time could be fixed into the experience of an everlasting now-that-is-here. In the Eternal City, history is what we see.[27]

The Petrarchan experience was classical in nature and readily calls to mind Constantius' (Constantius Augustus II) entrance in Rome (A.D. 357), where "the sanctuary of the whole world was present before him" (Ammianus Marcellinus, *Res Gestae*, xvi, 10). By the Rostra, he "stood amazed: and on every side on which his eyes rested he was dazzled by the array of the marvellous sights." Constantius met the past, and approached his father's arch. As he rode in his chariot, "he kept the gaze of his eyes straight ahead, and turned his face neither to the right nor to the left, but neither did he nod when the wheel jolted." History was unfolding right in front of him; paternal legacies and imperial heritage stood next to each other, with all their compelling presence. If it is true that any object in space is a memory system, then we must surmise that Constantius had in fact entered a dimension of human eternity. A similar spirit inspired leading families (Gonzaga, Montefeltro, Medici) to build churches, chapels, porticos, and *palazzi* meant to perpetuate, in Castiglione's words, one's "honour" and

"memory" (*The Courtier*, 320). The generous patronage of architecture secured fame to individuals, descendants, and cities.[28]

At a time when the printing press had yet to make its impact, people were impressed more by visual (Brunelleschi's cupola, Ghiberti's doors, Donatello's statues) than by literary forms. The building programs for Florence (Brunelleschi), Rome (Alberti), Urbino (Laurana, Francesco di Giorgio), Ferrara (Biagio Rossetti), and Pienza (Bernardo Rossellino) embodied ideology in the artform which had best stood the test of time; architecture truly was the medium of eternity.

The archaeological interests of Flavio Biondo and others were significant, but most modern contacts with the Latin world were competitive. Artists recreated buildings from scattered ruins (Piero della Francesca, Laurana, Raphael) and painted pictures (Botticelli's *Calumnia*) from ancient descriptions. They even wrote treatises (Alberti, Dürer) from scanty literary evidence. At all levels, fragmentariness called for imaginative approaches, and Alberti based his concept of architecture on a few buildings that fitted the image of ancient architecture as he envisaged it. To move from the formless to the formed, artists had to sub-read the ruins. At the very dawn of the fifteenth century, antiquity stimulated invention more than scholarship. In spite of expert readings and rigorous measurements, the predominant tendency was to sub-reading and re-presenting the ancient world. Actually, the myth of antiquity preceded its imitation.[29] As the modern poet was to phrase it,

> There was a myth before the myth began,
> Venerable and articulate and complete.
>
> (Wallace Stevens, *Notes toward a Supreme Fiction*)

When the Renaissance artist resurrected the past, what emerged was his own perfected image of it.

Centuries later, Gibbon checked the original records, both Greek and Latin, from Dion Cassius to Ammianus Marcellinus. In the Forum, the memorable spots where Romulus stood, or Tully spoke, or Caesar fell, were at once present to his eyes. And it was among the ruins of the Capitol, while "the barefooted friars were singing vespers in the Temple of Jupiter," that the idea of writing the history of the decline and fall of the Roman Empire came to his mind.[30] For Petrarch and Michelangelo, the Capitol and St. Peter's shouldered a transhistorical concordance essential to their cultural outlook. Gibbon, instead, realized that the authority of the past had long vanished. Paganism had surrendered to Christianity, and the Renaissance itself had bowed to the process of history. With the singing of the vespers, it was time to eulogize antiquity.

When some half-buried remains were excavated during his visit to the city, Goethe was annoyed because archaeology was "the gainer at the expense of the imagination."[31] At that point, the mind displaced the centrality of physical presence from the experience of history. Modern reconstructions of the Roman past plunged into psychological waters of unknown depth.

Whether real (Roman Forum) or imaginary (painted perspectives), the geometric stability of architectural settings could bring time to a standstill. Laurana's architectural painting, in fact, has reduced people to insignificant silhouettes. At every step, their motion disrupts both perspectival order and linear designs (on the floor). Space is so geometric that man's own freedom of action stirs disorder. The women approaching the fountain to draw water perform a practical task which courts absurdity in such a monumental place. More appropriate, instead, is the human presence in the form of statues resting on top of the columns. Their bloodless condition was typical of forms verging on the columnar (Piero della Francesca), the statuesque (Mantegna), and the mechanical (Uccello). While nature has been replaced, paved over by tassellated marble, architectural perspectives (from Laurana to Piero della Francesca), courtyards, and squares (Florence and Pienza) sacrificed nature to man's potentiality as a creator.[32] It is equally revealing that Ficino illustrated the hierarchy of creation through the image of God operating mechanical puppets on a stage. While the writer was more at home with books than people, the artist gave priority to the order of geometry over the shapes of life.[33] At all levels, forms of perfection tended to denaturalize nature and to dehumanize man.

5

Whichever direction they were actually pointed at, analogical correlations injected a mythologizing attitude into all aspects of life.[34] Petrarch wore a poetic crown like Statius; as patron of the arts, Lorenzo de' Medici rivaled Maecenas; and the splendor of modern Florence emulated that of ancient Athens. Reliance on similarity tended to mute the dynamics of history, to equalize socio-economic variables, and to transform the indeterminate into the known. While promoting reduction and amplification, the analogical mode discouraged process and change.

Going back to the archetypal analogy, Adam is endowed with the fullness of human dignity at conception. Since the simile magnifies the virtual form of man, the ideal cannot become real. In fact, Pico's oration and the Sistine fresco circumvent the "testing" inherent in either the fall or any empirical becoming (birth, growth). Between Adam and God, there lies an intellectual vacuum wherein the human is about to touch, or move away

from, the divine. In any case, time, space, and choice are yet to appear at the horizon.

Consistent with pagan (Golden Age) and Christian (Earthly Paradise) mythmaking, Adam finds perfection at the beginning. To make it possible, the ancient god Kairos sponsored propitious moments. And Ficino made it clear that "the only person never to be affected by misfortune is the one who does not await an end after and beyond the beginning but establishes his own end in the beginning." In the realm of perfection, the beginning is the end. For once, the Renaissance Kairos bypassed Chronos' implacable march, and made of "favorable beginnings" a self-fulfilling epiphany.[35]

Because they are conceived as new born and perfect, Adam, the family leader, and the Courtier are models who would be neither repeated nor superseded, for their creators—like their classical ancestors—were mainly interested in the paradigmatic principle of things (*principium* rather than *initium*). Reality only needed to offer pretexts for justifying promises of perfection; where life would more likely fail, art bestowed glory on the human potential.

At the time he was crowned poet laureate, Morris Bishop informs us, Petrarch was writing some historical works. He also made it known that he had begun an epic poem in Latin. His qualifications in 1340 for the laureate-ship seemed quite slight; his projects, however, raised great expectations.[36] In 1340, his *Africa* was in progress (begun in 1337), and so it remained in 1350 (*Letter to Posterity*). Yet, he steadfastly believed that the Latin epic would gain him fame. His anticipation probably echoed Propertius' prediction that the *Aeneid* would overshadow the *Iliad* even though Virgil "was just beginning his work."[37] Among the honors bestowed on the modern poet, there was the approval of his present and future writings. Moreover, he assumed the privilege of "teaching, disputing, interpreting, and composing in all places whatsoever and on all subjects of literature" (Gibbon, *Decline and Fall of the Roman Empire*, vi,70). Nevertheless, the *Africa* was never finished, and its publication did not take place until 1501.

From literary to historical grounds, Cola di Rienzo's successful revolt against the Roman barons (1347) lasted only six months, but stirred un-suspected hopes. In Machiavelli's account, Cola "made himself head of the Roman republic, with the title of Tribune, and brought her back to her ancient form, with such fame for justice and vigor that not merely the neighboring cities but all Italy sent him ambassadors. Hence the ancient provinces, seeing how Rome was reborn (*rinata*) raised their heads and honored him" (*History of Florence*, I, 31). Although the rebirth of Rome was more a matter of form than substance, Petrarch addressed Cola as the younger Brutus. In the atemporal realm of analogical correlations, the new republic was dated *anno primo*: time was well on its way to becoming value.

In the world of historical facts, however, fortunes quickly changed, and Petrarch later wrote: "Recently came to the Curia (the Papacy was at Avignon), or rather did not come, but was led here a prisoner, Cola di Rienzo, formerly the widely feared Tribune of Rome, today the most wretched of men." His fall taught a fundamental lesson:

> He might have died a glorious death on the Capitol. . . . The deeds which he was performing and which he gave promise of performing at the time when I wrote, were most deserving not only of my praise and admiration, but of that of the whole human race. I hardly think that all those letters should be destroyed for this one false step: that he chose to live in shame rather than die in glory. . . . I allowed myself to love and worship him beyond all other mortals. And, therefore, the more I hoped in the past, the more do I now grieve at the destruction of those hopes. I frankly confess that, whatever the end of it all may be, even now I cannot help admiring his glorious beginning.[38]

If one could live with hopes and beginnings alone, the process of time would not turn promises into failures!

The Petrarchan experience called for alternatives. Often enough, acts of faith overshadowed facts, even on as broad a subject as Bruni's *Panegyric to the City of Florence*, which he modeled after Aristides' *Panathenaicus*. In the ancient text, Athens was recognized as the only *polis* which, "when brought to the test," proved "superior to its fame." That standard of value echoed Pericles, who reserved honor and power not to those "who want them" but to those "who have been tested."[39] Overlooking the emphasis that the ancients placed on achievement, Bruni's comparison edged on wishful thinking in 1403, when Florence could only show a bright promise of her future splendor.[40] As Machiavelli wrote, "life in the city was quiet from 1400 to 1414." Actually, the wars against Giovan Galeazzo, Duke of Milan, and Ladislas, King of Naples, ended only because of their deaths. "So death was always more friendly to the Florentines than any other friend, and stronger to save them than any ability of their own" (*History of Florence*, III, 29). In the Preface to his work, Machiavelli also wrote that Bruni's *History of Florence* described matters of internal strife so briefly that readers could "get no profit or pleasure . . . if anything in history delights or teaches, it is what is presented in full detail." Deviance from that precept was ever more pronounced in Bruni's panegyric, where tests could have discredited claims to greatness as either premature or unfounded. On the other hand, his method contained all the basic elements that were typical of epideictic literature (from religious oratory to panegyrics). "Like Minerva," Erich Cochrane writes, humanist historiography "was born fully grown."[41]

Whatever the actual course of events, promise overrode results. A host of histories (Bruni, Bracciolini), churches (Alberti's Tempio Malatestiano, Brunelleschi's façade of San Lorenzo), and monuments (Michelangelo's

tomb for Julius II) were never finished. Filarete's utopian city of Sforzinda paralleled the ambitious schemes of Nicolas V for the Borgo Leonino in Rome, of Pius II for Pienza, and of Lodovico il Moro for Vigevano. At all times, the will was present, but the means were lacking.[42] Planning bloomed, but construction quickly stalemated.

Rather than a thought-out project, the urban plan for the Borgo Leonino was no more than an Albertian idea. Nevertheless, the dying Nicolas V endorsed its execution in his political testament. And he favored the construction of magnificent buildings over the needs of defense, convinced as he was that beauty alone could keep barbarians and invaders at bay. Discrepancies between Manetti's story and the documented evidence raised Nicolas's contribution toward myth planning, that is to say, a model for later building programs. Once again, mythmaking rested on anticipations.[43]

In antiquity, the city was never formed by the slow increase of the number of men and houses, but it was founded in a day, so to speak. Livy describes the origin of Rome as a kind of miraculous leap into existence of the Eternal City, and Graeco-Roman historiography paid little attention to matters of development. Cristoforo Landino later renewed such hypothetical leaps when he proposed in his *Disputationes camaldulenses* (1480): "Let us imagine that we have built a city with every kind of public, private, religious, and profane buildings, all magnificent and large." Sitting by the gate, the governor-philosopher "will not let anybody in without having first examined with the greatest diligence the service which each candidate might perform for the community."[44] No consideration was to be given to either the atypical or the experimental, and only mature professionals would become part of a community modeled after standards of perfect functionality. Ready-made plans replaced the organic growth of medieval environments. Even urban forms were new born and perfect.

To restore the imperial magnificence of ancient times, Julius II brought Bramante, Raphael, and Michelangelo to Rome. Great projects were drawn, but they soon collapsed. Yet, the few accomplishments that saw the light of day were of the highest quality, a fair match for the pope's own driving ambition.[45] Like some of his predecessors, he probably was moved by Suetonius' remark about Augustus (*Lives of the Twelve Caesars*), who found a city of bricks and left it a city of marble.

6

Commitments to untangle fame from the snares of history became autobiographical in the case of Aeneas Sylvius Piccolomini, the humanist pope Pius II. During a journey from Rome to Siena (1459), he stopped in his native Corsignano, a little village in the Tuscan hills near his destination:

Here Pius was born and here he passed his childhood. Returning to it at this time he hoped to have some pleasure in talking with those with whom he had grown up and to feel delight in seeing again his native soil; but he was disappointed, for most of those of his own generation had died and those who were left kept to their houses, bowed down with old age and illness, or, if they showed themselves, were so changed as to be hardly recognizable, for they were feeble and crippled and like harbingers of death. At every step the Pope met with proofs of his own age and could not fail to realize that he was an old man who would soon drop, since he found that those whom he had left as children had sons who were already well along in years.

With brutal immediacy, the telescoping of memory set Pius' aging self amidst childhood friends who had become crippled harbingers of death. Nothing is new born and perfect in one's birthplace, where the unrelenting march of time began to unravel. The pope's reaction was an authentic act of "re-naissance" faith, for he decided to build

a new church and a palace and he hired architects and workmen at no small expense, that he might leave as lasting as possible a memorial of his birth.[46]

More than a memorial to Aeneas Sylvius Piccolomini, Bernardo Rossellino's project was to consecrate a rebirth into the adulthood of Pius II. The utopian island became symbolic of what the ideal birthplace of a spiritual-literary-political leader should have been; there, time could be conquered at its source.

The little village of Corsignano was reborn as a city-state and named Pienza, not after the family (like Sforzinda) but the pope's humanist name. The topography of ancestry made room for that of learning.[47] The modern Aeneas drew the boundaries of a new place of propitious beginnings. Yet, Pienza never grew beyond the author's best intentions. The architectural nucleus (church-square-palace, plate 14) that was built was of no practical consequence. As a symbol, however, such a utopian promise has stood as the gravitational center of any map of Renaissance culture.

For Ariosto, Biagio Rossetti's Herculean Addition in Ferrara pointed to a perfect synthesis of arms and learning (*Orlando Furioso*, VI). Before sixteenth-century utopias, writers produced *laudationes* of real cities such as Florence, Urbino, and Rome, which did offer glimpses of what the life of art could be. From an almost archetypal standpoint, a transition was taking place from states of warrior-heroes to the utopias of the artist-hero, a transition which usually springs from a dissatisfaction with the way actual states have turned out. The hope of order corrupted, art visualized a new sphere of perfection, where an imaginary rational State made its appearance.[48]

However ambitious, myth-planning at Pienza was part of yet more

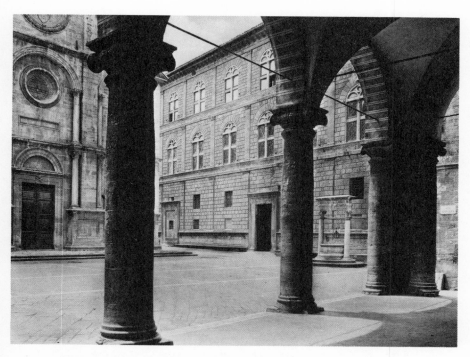

Plate 14. Bernardo Rossellino, Piazzo Pio II. Pienza (Alinari, 32800)

hypothetical pursuits of a religious order. While Venetians and Florentines were too busy trading and banking, Pius II finally called on Christendom for another crusade against the growing Eastern threat. Although old and sick, he "did not discontinue any activity but rather planned greater and heavier ones every day by declaring war on the Turks."[49] After a long and painful trip, he eventually reached Ancona (1464), the port city on the Adriatic coast. There he died while waiting for ships and troops to show up. His crusade of one had been more in cadence with the poetry of Ariosto than with the solemn rhythm of the Song of Roland. Yet, the pope fulfilled his ideal role, for the heir to Peter was expected to be deeply committed to the diplomatic and social life of the time.[50] It was customary for religious orators to call for a crusade (Constantinople had fallen to the Ottomans in 1453) in the *Oratio de eligendo Pontefice*, which was traditionally delivered to the college of cardinals before the Conclave. From Pius II to Julius II, the Papacy tried to meet spiritual and political expectations, even though a crusade was not to be.

Memorials of birth aside, there were instances when artists created forms which rationalized death itself. In Castiglione's Urbino, "the greatest part of those persons who are introduced in the conversations were already

dead" (*The Courtier*, 2). Had those men lived, "they would have attained
such eminence that they would have been able to give to all who knew them
clear proof of how praiseworthy the Court of Urbino was" (*The Courtier*,
286). Wishful thinking in the conditional mode was coated with the veneer
of oncoming certitude. But the "clear proof" never materialized; it thrived
on the promise of the brightest yesterday.

The Courtier thus portrayed an incomparable elite at its cultural peak.
Amid historical circumstances, however, it would have declined, had it been
allowed to endure "a very long life" (*The Courtier*, 2). While the brave die
young, "the passing years take with them many of the good things of life"
(*The Courtier*, 89). Premature death did not allow the test of time to betray
hopes. Expectations of that sort were nurtured in the illusion of inevitable
success, and flourished precisely because growth had been denied. Death
did not let the future vilify the present in the pages of Castiglione's book,
which celebrated the Montefeltro court in the first day of spring. In his
citadel of hypothetical perfection, the artist could stand above antiquity and
posterity.

Propitious beginnings were exploited to the point where hope and
accomplishment coincided. In terms of the archetypal simile, Boccaccio
wrote that Adam, persuaded by the devil, "tested the instability of Fortune"
(*The Fates of Illustrious Men—De casibus virorum illustrium*—1, "About
Adam and Eve"). The Michelangeloesque Adam had to avoid any testing
because he knew the virtual character of his own perfection. He was, and
could only be, prelapsarian.

7

At the very beginning, Adam is secure in his enclave of unlimited
potential. He is the *Urmensch*-Savior equidistant from time and eternity.
Since the future age is seen in terms of the original, the two figures come to
have similar functions. Past and future coincide in the transhistorical pres-
ent of mythic prototypes. P.O. Kristeller insists that, in Pico's oration,
human dignity is given to Adam as a goal, not as a birthright.[51] Yet, God's
words are such that the goal is well within reach at the moment of creation.
Likewise, when Michelangelo presented his sculptural David before engag-
ing Goliath into combat, the suggestion was made that the potential had to
be celebrated rather than validated.

At least in works of art, progress was conquered in the name of conclu-
sive standards whereby Bruni could write that Florence, because of its
achievements, was "without doubt far ahead of all the cities that exist now
and all that ever will." There was nothing to ask for: "What more can a city
desire? Nothing at all. What, therefore, should we say now? What remains
to be done? Nothing other than to venerate God on account of his great

beneficence."[52] Similarly, the blessings of the court of Urbino would "not decline" (*The Courtier*, 287) but shine even brighter in a *città* that was raised to heights where antiquity had placed the Eternal City.

Remembrance and hope shaped time in the guise of the would-be, to which memory added the aura of the must-have-been.[53] The transformation of time into value turned hopes (*opinioni*) into certainties (*certezze*). At a personal level, Ficino had "no wish to depend on the future, the uncertain, and thus be deceived. No! I stand in the present, the certain. . . . I act because it satisfies me now and in eternity, and not with a view to its satisfying me at some future time, and then but for a while."[54] The Renaissance world view folded onto itself; man could move forward by looking backward, and what he found validated foregone conclusions.

It ought to be noted, perhaps by a lucky coincidence, that Italian literature somehow came to life "new born and perfect." In poetry (Dante, Petrarch) and prose (Boccaccio), its initial accomplishments were the highest; the first work in the vernacular was its masterpiece.

However virtual, the attainment of perfection forced artists to exhaust the possibilities of *aemulatio* into a state of *completed* maturity. Once again, antiquity offered models that belittled growth. On mythic grounds, Zeus' upbringing rapidly came to a standstill, while Ovid considered the combination of youth and maturity a heavenly gift granted to emperors and demigods. Hercules, Pindar, and Christ displayed precocious signs of their mature talents, and the mythic tendency has always been to endow the hero with extraordinary powers at birth, since herohood is predestined rather than simply achieved. In the *Aeneid*, Virgil placed two helpless babies next to the world empire of Augustus, as if to emphasize the peculiarly Roman experience of unstoppable and swift growth.[55] Interest in the educational trials of adolescence remained peripheral to the classical mind, which instructed adults toward higher stages of maturity.

While the Romans linked youth to adulthood through an educational process unusually brief (Pliny, Ovid, Virgil), the medieval mind leaned toward more drastic juxtapositions of *boy* and *old man*. The Virgilian *puer maturior annis* was replaced by a more paradoxical combination: the *puer senex*. As a hagiographic cliché, such a topos influenced the writing of saints' lives (Gregory the Great). Closer to the modern posture was the representation of God "as a hoary old man with snow-white hair and a youthful countenance," an apt introduction to the figure in Michelangelo's fresco. Even more akin to the Renaissance bent of mind was Alan of Lille's *Anticlaudianus*, in which nature, assisted by the arts, created *Iuvenis*, a perfect and beautiful human being symbolic of a regenerated humanity. Within that tradition, Ficino found in the young Lorenzo de' Medici "all the qualities of the old man."[56] Later, Castiglione wrote that "Don Carlos,

Prince of Spain, is also showing very great promise. Although he has not yet reached the tenth year of his age, he already reveals so great a capacity and such sure signs of goodness, prudence, modesty, magnanimity, and every virtue, that if the rule of Christendom is to be in his hands (as men think), we can believe that he will eclipse the name of many ancient emperors and equal the fame of the most famous men who have ever been on earth" (*The Courtier*, 322). At that point, the rhetoric of wishful thinking took on a dynamics of its own.

<div align="center">8</div>

What was new born had to be perfect. However, while classical births of perfect beauty (Venus) and knowledge (Athena) were godly affairs, their Renaissance counterparts were the prerogative of the *author-artifex*, whose creations replaced development with what Nietzsche has called a "sudden appearance of the perfect."[57]

The Nietzschean phrase seems to capture echoes of Ficino's comments on the poetic frenzy: "Neither prudent men nor those learned from their youth have proved to be the best poets. Indeed, some were out of their minds, as Homer and Lucretius were known to have been. . . . Passing beyond the limitations of skill, these men suddenly produced astonishing poetry." Moreover, "Plato adds that some very unskilled men are thus possessed by the Muses, because divine providence wants to show mankind that the great poems are not the invention of men but gifts from Heaven."[58] In terms of contemporary *aemulatio*, gifts of that sort were dispensed by artists unabashedly proud of having endowed their adult prototypes with flawless rules of conduct. Man stood at the world's center, where he could make the universe in his own image.

Antiquity had not ignored celebrations of human dignity, and the Renaissance found abundant materials on the subject in the pseudo-Platonic *Axiochus* (which bore a preface by Ficino), whose Roman heritage included Seneca's axiom: "The mind grows from within, giving to itself nourishment and exercise" (*Epistles*, 80). At a higher pitch of idealism, "the human soul is a great and noble thing; it permits of no limits except those which can be shared even by the gods . . . no epoch is closed to great minds" which "plan for immortality" by preparing themselves to meet the gods (*Epistles*, 102). For Cicero, "men are sprung from the earth not as its inhabitants and denizens, but to be as it were the spectators of things supernal and heavenly. . . . The world itself was created for the sake of gods and men, and the things that it contains were provided and contrived for the enjoyment of men . . . for they alone have the use of reason and live by justice and by law" (*De natura deorum*, II, 56–62). And Seneca echoed that, within the given order of things, Nature has "set us in the center of creation,

and has granted us a view that sweeps the universe. . . . Our thought bursts through the ramparts of the sky, and is not content to know that which is revealed. . . . Fortune wrecks no part of that which Nature has appointed for him, yet man is too mortal to comprehend things immortal. Consequently I live according to Nature if I surrender myself entirely to her, if I become her admirer and worshipper" (*De otio*, 31). Privilege had limits, and man still was at the mercy of capricious forces (nature-time-fate) that were simultaneously punitive and providential.[59]

Alberti interpreted stoic and sophistic views of man's role in nature as "observer and manager of things," since he had been appointed to preserve "an order established, created, and given to us by God himself" (*O.F.*, 133). That self-contained view almost broke open when Alberti and Pico gave full exposure to the relentless "doing" of man's ever-fulfilling activism. At any rate, their emphasis on art as a carrier of culture harked back to the sophistic heritage echoed in Cicero (*De inventione*) and popularized through Ficino's translation of Plato's *Protagoras* (1466–68). In Pico's words, "not only the Mosaic and Christian mysteries but also the theology of the ancients show us the benefits and value of the liberal arts" (*Oration*, 233). The *Oration* in fact contains nothing less than a theodicy of art, which is the expression of the "creative" nature of man.[60]

At last, the Renaissance mind reversed classical stands when it proclaimed that the freedom and autonomy of "acting" determined "being." As Landino wrote, "man's life, insofar as he is a man, consists in acting and speculating," and his knowledge stems "from his own mind."[61] Man finally came to believe that he could indeed create his own "artifice of eternity."

4

Aemulatio's Last Beginning:
David and the Epiphany of Culture

*But does such a State of Aesthetic Semblance really
exist? As a need, it exists in every finely attuned soul; as
a realized fact . . . only in some few chosen circles, where
conduct is governed, not by some soulless imitation of
the manners and morals of others, but by the aesthetic
nature we have made our own.*

Friedrich Schiller

1

Adam enjoys the unique privilege of being allowed to set the limits of his
own nature in Pico della Mirandola's oration on the dignity of man. And, as
the embodiment of original perfection in the Sistine fresco, he is about to
transfer such a birthright to his oncoming humanization.

On sculptural grounds, Michelangelo's *David* upheld the Renaissance
concept of human dignity in a form as compellingly representative as its
pictorial counterpart at the moment of creation. David is victorious before
engaging Goliath, whose presence is suggested by the youth's open side and
purposeful glance. The viewer cannot but think of Alberti's words: "Noth-
ing is so hard to keep hidden as human excellence" (*O.F.*, 138). Machiavelli
would add that a superior ambition, which "no man has the power to drive
out of himself" and whose companions are "Method and Vigor" (*On
Ambition*, 163–65), inspires David; in fact, his physical relaxation and intel-
lectual commitment exude the aura of the absolute.[1]

One can detect an equally alert state of mind in Michelangelo's early
sculptures, and the *St. Proculus* (1495, plate 15) immediately comes to mind.
In the relief of the *Battle of the Lapiths and Centaurs* (1492, plate 16), the
standing figure toward the left stares at the centaur to his right in a battle of
wills free of injuries.[2] The nude is a David-like figure about to throw a rock

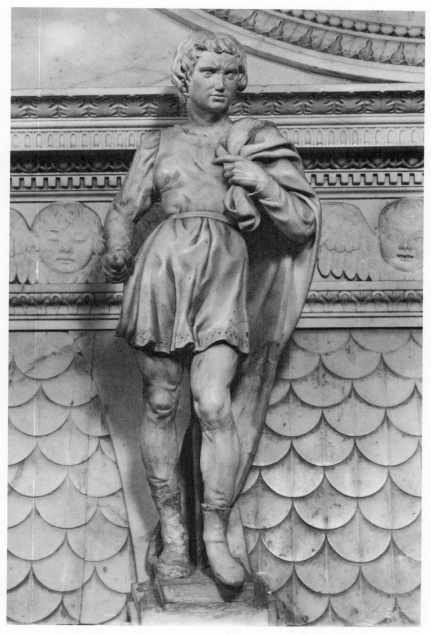

Plate 15. Michelangelo, *St. Proculus,* 1494–95. San Domenico, Bologna (Brogi; Alinari, 26792)

against the beastly Goliath-centaur. At that early stage, St. Proculus is immaturely intense, while the nude's prowess leads to a specific act. The sculptural youth, however, hides the rock, and his challenge is contained in an image of unassailable confidence. Later, his slaying of the colossal enemy on the Sistine spandrel (plate 17) again exploited the dynamics of the act.

Earlier and later versions of the biblical hero emphasized details (cuirass, hat, sling, shepherd's clothes) and either the final moment of victory (Donatello, plate 18, and Verrocchio) or the "during" of the action itself (Bernini). The latter's *David* (1623–24, plate 19) is a shepherd about to throw a rock with a sling, a familiar act that unfolds "here" and "now." The biblical reference is symbolically important, but not essential to the meaning of the figure. While replacing the monumental with the lifesize, the sculptor seems to suggest that the absolute past of gods and heroes was to be reincarnated into common events. David in fact exists at the descriptive level of baroque experience, where heroism was reduced to attempts as indeterminate or even foredoomed as Don Quixote's. Above all, value was a matter of effort rather than achievement.

Neither a warrior (Donatello, Verrocchio) nor a shepherd (Bernini), Michelangelo's giant has resolved the action into a state of mind. He stands forever ready to prove his *virtù*. In Alberti's words, "to gain glory a man must have excellence. To gain excellence he need only will to be . . . only a firm, whole, and unfeigned will, will do" (*O.F.*, 139–40). David's monumentality (*il gigante*) transcends reality, and access to a symbolic frame of reference is crucial for understanding a sculpture which rests on a pedestal of meanings. He is, and can only be, bigger than life.

The biblical adolescent was an instrument of providence, and so he appeared in the statues of Donatello and Verrocchio. Michelangelo's youth, instead, is a transcendental individual out to enforce a perfective view of human destiny.[3] His majestic aloofness has so mastered the Greek ideal of power guided by reason that his will to action presumes success.[4] Actually, David looks out toward a revealed destiny, and his confidence rests with the certainty of foreknowledge. History, therefore, can only stage events according to a preconceived *istoria*-script.

David's embodiment of *virtù* and *dignità* also upgraded the Roman notion of *dignitas* in the sense of propriety and fame (*decus* and *decorum*) stemming from distinguished political, social, and moral rank. Cicero associated *dignitas* with the harmonious beauty of the male body and with "honourable conduct," which consists of "self-control, reasonableness, the calming of the passions, and observation of the happy mean." While such values cannot "be separated from moral goodness," physical pleasure is quite unworthy "of human dignity" (*De officiis*, I, 36, 27, 30). From Petrarch (*viri illustres*) and Donatello (*St. George, Gattamelata*) to *condottieri*, tri-

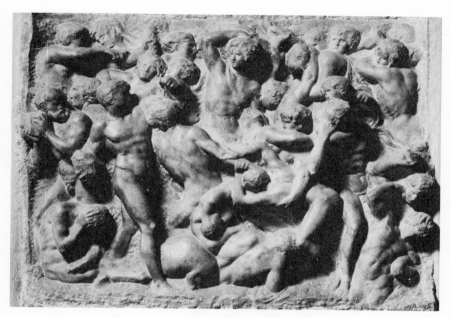

Plate 16. Michelangelo, *Battle of the Lapiths and Centaurs*, c. 1492. (Alinaria, 3534)

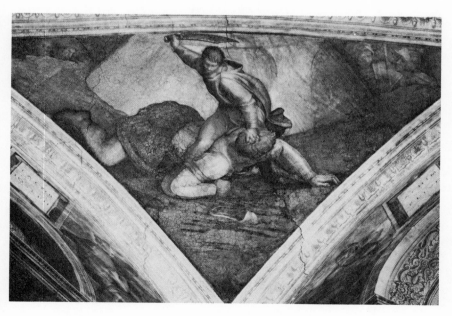

Plate 17. Michelangelo, *David and Goliath*, 1509. Spandrel of the Sistine Ceiling, Vatican, Rome (Alinari, 7550)

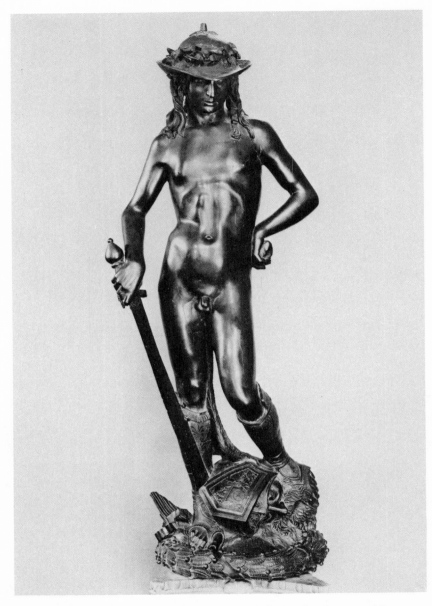

Plate 18. Donatello, *David*, c. 1430. Museo Nazionale, Florence (Alinari, 64035)

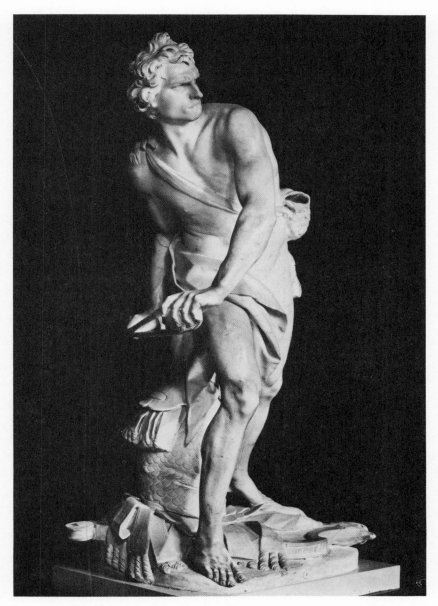

Plate 19. Bernini, *David,* 1623–24. Galleria Borghese, Rome (Alinari, 6808)

umphs, galleries of heroes (Castagno's *Pippo Spano*, 1448, *Nicolò da Tolentino*, 1456, or Piero della Francesca's *Triumph of Federigo da Montefeltro*, 1465), and Michelangelo's sculpture, Renaissance art created its own proud images of *dignitas*.

It ought to be noted that the Greek word for virtue (*arete* from Ares, the god of war) and its corresponding Latin term (*virtus*) originally denoted activity; the hero was such because he performed heroic deeds. Gradually, however, less stress was placed upon action per se. A hero would be a man with heroic potential. Eventually, virtue became a state of mind, and the Florentine giant upheld the predominance of *status* over *actus* (to which Bernini would return).[5]

David symbolized the *ideal truth* of republican freedom and political responsibility. At a time when Italy was constantly revaged by war, his defiance put to shame states that challenged the sound of invading trumpets of war with no more than mercenary troops or the ringing of church bells. Unlike the Machiavellian Prince, matters of expediency would have been beneath the range of the giant's invulnerable glance. There is a point where the comparison between these figures—brought to light by two Florentines nurtured in a common historical climate—gains relevance. Reconciliation of theory with practice remains largely virtual in the pages of *The Prince*. As idealized as the mythic Theseus to whom he is compared, the Prince is to enact the *sublime machiavelliano* within a literary exercise based on psychology and probability. By contrast, the static parallels that are drawn between ancient and modern events fail to account for the socio-economic changes that had taken place. In a significant progression, the analytical character of the initial chapters of *The Prince* (1513–16) gives way to the prophetic vision of a free and regenerated Italy. At the end of the book, imagination subdues the extreme hostility of *praxis*, and experience becomes no more than a front for the invention of hypotheses.[6] Somehow, the historian was betrayed by his own intentions, and ran into normative problems that his trust in *verità effettuale* could only mitigate. Likewise, Michelangelo invented the hypothesis of a monumental symbol at bay of, and immune to, political fortunes. Prevalent was the tendency to transform events into symbolic images which eventually emulated one another.

2

Beyond the grip of either fate or fortune, the Renaissance pursuit of fame inspired Coluccio Salutati to identify history with glory: "The first of the muses is obviously Clio, because the first impulse to learning stems from 'cleos,' which is glory."[7] Since the analysis of documentary materials did not warrant distinction, facts were subordinated to the reading of classical texts through which the past was known and upon which the present could be

modeled.[8] As a matter of method, a blend of Livy's Roman history, legendary patterns, and archetypal prototypes provided a variety of models for battle scenes, speeches, and political strategies. Rhetorical mixtures of exemplary tassels made up a mosaic of history at its best.

Once ancient myths regained their integrity, the symbols of art turned to concerns of a transhistorical nature. Carlo Marsuppini's epitaph for Bernardo Rossellino's funerary monument of Leonardo Bruni—who wears a laurel wreath and holds his book of the *History of Florence* (plate 20)—tells spectators that History and the Muses are in mourning since Leonardo has departed from life. Beyond death, the spirit of the sepulcher still voiced the Periclean conviction that love of honor and glory "is the only feeling that never grows old."[9] Within the Triumph-over-Death motif, the Albertian Tempio Malatestiano at Rimini housed an impressive Pantheon of heroes instead of a burial-ground with its traditional associations.[10] Like many of his fellow artists, Ghiberti was driven by a "most human ambition" aimed at "prolonging the memory of men" who had conquered oblivion.[11]

On this side of death, fame saves man from the tomb by giving him new life. The sun itself shed light on a fundamental doubt in Petrarch's *Triumph of Fame*:

> For if a man who had been famed in life
> Continues in his fame in spite of death,
> What will become of the law that heaven made?
> If mortal fame, that soon should fade away,
> Increases after death, then I foresee
> Our excellence at an end, wherefore I grieve.
> What more is to befall? What could be worse?
> What more have I in the heavens than man on earth?
> Must I then plead for equality with him?

Does man outlast the setting sun? Does history continue beyond the farthest horizon?

> For I am envious, I confess, of men.
> For some I see who after a thousand years,
> And other thousands, grow more famous still,
> While I continue my perpetual task.

In spite of Augustine's warnings, the poet made innumerable attempts at breaking the mold of perennial endeavors. Eventually, time would claim its right:

> Your grandeur passes, and your pageantry,
> Your lordships pass, your kingdoms pass; and Time
> Disposes wilfully of mortal things.

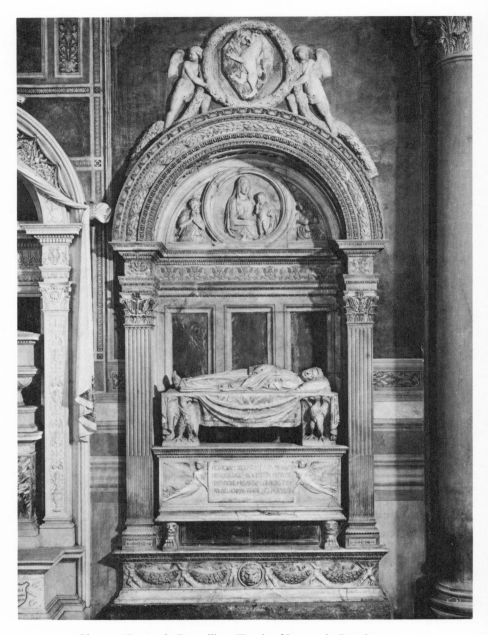

Plate 20. Bernardo Rossellino, Tomb of Leonardo Bruni, c. 1445.
Santa Croce, Florence (Alinari, 2101)

Yet, much energy was dedicated to the pursuit of human glory, and Petrarch left to posterity a pattern of transcendence suitable for other conceptual systems as well.

A divided allegiance to mundane and spiritual goals marked Petrarch's whole career. The very content of the poet's cherished word-ideal, *lauro*, blends poetic (laurel), emotional (Laura), and spiritual (golden) meanings into an atemporal accretion whereby he could see "past, present, future" combined

> In a single term, and that unchangeable.

Posterity would finally reveal

> A world made new and changeless and eternal.

History was to provide an architectural setting in which the forms of eternity could be housed. So located, the future was to endure as long as fame would last.

By the turn of the fifteenth century, it was assumed that historiography would pursue a literary *concinnitas* as rational as perspectival ratios and physical proportions. Rather than a collector of facts, Bruni organized events into the attractive form of rhetorical history.[12] Once deeds, narrations, and the portraiture of leaders were presumed to fit formal patterns, historians found it legitimate to alter facts. Pierantonio Paltroni conceded in his biography of Federigo da Montefeltro (finished and revised between 1474 and 1478) that many historians, "to make their work more appealing to people, present historical characters not only as they have been, but also as they should have wanted to be in order to appear perfectly virtuous, so that they could teach others virtue itself."[13]

At a higher pitch of abstraction, Platina considered the reading of history "so instructive that even those who had not taken place in the events appear to know and understand more than others when they narrate them with style and elegance."[14] A tendency emerged among historians to intimate, like poets, the would-be. Since it was meant to teach, history demanded choice and interpretation. To offer models of moral guidance, it was legitimate to alter factual accuracy.[15] Petrarch verged on the hypothetical when he ended his narration of Horatio's successful stand against the Etruscan army on the Sublicius bridge by stating that the past was to be "admired more than believed."[16] Although Bruni warned that "*aliud est historia, aliud laudatio* (history is one thing, the panegyric another)," it often was difficult to separate the two.[17] In the name of mythopoeic constructs, *decorum* and *gravitas* so influenced the language of history that rhetoric bore

heavily on truth. Hayden White has called such a methodological posture metahistorical.[18]

The humanists were painfully aware of the elusiveness of political might, and familiarity with the recurrence of war weighed on their criticism of the tyranny of the Roman Empire. While Petrarch still feared that "from every side people are marching against us looking for revenge," it was generally understood that many nations flourished throughout Italy until they fell under Rome (whose expansion and impending decline had already troubled Livy).[19] Like Goliath, the bigger the matter of sheer force, the harder its fall. Since the Italian peninsula was divided into a plethora of states, the concept of nation rarely exceeded the fanatical spirit of local *campanilismi*, and that political configuration favored a concept of *patria* drawn after republican Rome.

Beyond democracy and tyranny, the more lasting heritage of the Eternal City—what Flavio Biondo called *Roma Triumphans* (1450s)—rested on her standard of a civilized way of life. Lorenzo Valla insisted that, whereas those who extend national boundaries are honored by being called emperors, those "who have improved the human condition are honored with a praise which is not worthy of men but of gods. . . . If therefore our Roman fathers have surpassed all other nations on account of their military excellence, they also have surpassed themselves when they taught their language to others. Although they lost their freedom to the Romans, many nations conceded that Latin had ennobled their own language." As a matter of fact, linguistic unity under the aegis of Latin spearheaded education in the liberal arts, which in turn led entire nations to break free of barbarian shackles. "We lost Rome, we lost the Empire, we lost political strength. . . . Nevertheless, we still continue to reign over much of the world because of the Latin language." Above the rise and fall of empires, Latin secured stability to a world where transhistorical constants counted more than variables.[20] History was a stage on which the Muse filtered facts through patterns of words.

Latin thickened the connective tissue binding Romans and Florentines, whose study of eloquence could overshadow political power and fulfill social ideals. In a kind of pre-Vichian turn of mind, Politian concluded that the beauty and effectiveness of eloquence originally attracted people feuding in the fields to the city, where a new civic spirit cemented society through customs, laws, and education. The modern praise of Latin calls to mind the climax of Aristides' panegyric on Athens, whose language became a standard of excellence for the Hellenes.[21] Later, Latin salvaged antiquity from Christianity, which, as Machiavelli wrote, "tried to get rid of all ancient records, burning the works of poets and historians, throwing down images, and destroying everything else. . . . Hence if to this persecution they had added a new language, in a very short time everything would have

been forgotten" (*Discourses on the First Decade of Titus Livius*, II, 5; written 1513—17).

Since the etymological meaning of *storia-histoire-historia* in the Romance languages carries both story and history, mixtures of fact and fiction updated an ingrained tendency to juxtapose literary and historical truth. Believing as he did that there was nothing which the pen of a learned man could not achieve, Petrarch was the first to entrust—from *On the Solitary Life* (*De vita solitaria*) to *Letter to Posterity*—the writer-rhetorician-philosopher-academician-historian with the new task of enlightening society in the seats of power (court) and knowledge (academies and universities). His lead was so contagious that kings (Robert of Naples) considered letters "sweeter and more precious than the kingdom itself," while popes (Aeneas Sylvius Piccolomini) found in literature a "guide to the true meaning of the past, to a correct estimate of the present, and to a sound forecast of the future."[22]

At his best, Petrarch believed that the man of letters would counsel rulers on matters of principle (what Cristoforo Landino called the "study of great problems")[23] and taste compatible with the emerging view of the State as a work of art. To follow Aristotle, man was indeed a *poli*-tical animal whose natural habitat was the *polis*, the only place where harmony and happiness could flourish. In a Roman (Sallust) and Christian (Augustine) sense, *civitas* also defined a concordant multitude of men. In this and other instances, Petrarch's heirs adapted Greek, Roman, and medieval precedents to their discriminating needs. Even anonymous treatises such as the one on the *arte della seta* (circa 1480) located the center of civilization ("*centro della comune civiltà*") in Florence.[24]

3

Historiography was so closely intertwined with literature and the arts that actual events had to fit ideal roles. In Rome, Petrarch was crowned as "a great poet and historian—*magnus poeta et historicus*." That kinship was broad based, and he was buried in the purple gown of a master of poetics and history. Traditionally, pastoral poetry was considered to be the child of fancy, the daughter of memory, and, by extension, the sister of history.[25] In the form of poetic coronations (Petrarch), private dialogues with the ancients (Machiavelli), political excellence measured in terms of oratory and *studia humanitatis* (Florentine chancellors), or the conversations at Urbino and Mantua (Castiglione, Mantegna), cultural events and artistic representations by far upstaged historical data. Even antiquarian interests did not consider the evidence of history in a modern sense (as Ranke in general and Mommsen in particular have made it familiar to us). Instead, Petrarch's coronation was symbolic also because it drew on ceremonies that "reno-

vated" (*renovatio*) the ancient concept of "remembered history." In the realm of memory, it was easy to shift toward "invented history," which makes of literature a viable source for understanding the progress of humanity. Recently, scholarship has proposed that "history nears perfection in so far as knowledge and art work in harmony." And we can indeed suggest that the Renaissance invested its best talents in outlining the poetry of history.[26]

To better describe the intellectual climate which gave historiographers a unique proclivity toward the hypothetical, one ought to turn to Eugenio D'Ors' concept of *metahistoria*, which takes into account "the ancients' eclectic acception of history as a Muse among the Muses." More recently, Northrop Frye has insisted that "metahistory has two poles, one in history proper and the other in poetry." Like the poet, the metahistorian "works deductively," a method particularly akin to the theoretical bent of the humanists.[27] Analogically speaking, history related to metahistory as active to contemplative life, and Landino stated the difference: "Those who are engaged in action certainly help, but only in the present or for a brief period of time. Conversely, those who pursue and explain the mysterious nature of things will help for ages to come. Actions end with men; thoughts conquer the centuries, and lift themselves into eternity." Education, beauty, thought, and power merged into a concept of transcendental politics.[28]

On metahistorical grounds, Alberti found in beauty a guarantee for the preservation of great architecture: "Beauty will have such an effect even upon an enraged enemy, that it will disarm his anger . . . there can be no greater security to any work against violence and injury than beauty and dignity" (*De architectura*, II, 2–3). The commanding splendor of Roman monuments seems to have mitigated even the unmatched ferocity of Attila, who eventually halted his descent toward the City. Perhaps, that could explain why Raphael placed a Roman setting with the Colosseum in *The Meeting of Attila and Leo the Great* (Stanza d'Eliodoro, 1511–12, plate 21), an encounter which actually took place in 452 by the river Mincio in northern Italy. Unfortunately, we shall never know whether the mythic grandeur of the Eternal City restrained Huns and Carthaginians from taking it, but we do know that by 1527 its sack tested the metahistorical validity of Renaissance culture, and probably paved the way for Bernini's baroque design of a triumphant Rome.

Whatever its fortunes in the political arena, the Italian peninsula—like Athens—was the European "theater of eloquence."[29] Of the Greek model, the Florentines cherished the geographical boundaries of *politeia*. Vitruvius' architectural parameters were imperial, whereas Alberti and Brunelleschi adhered to a more urban scale. Heir to Rome, Politian did not spare criticism of its imperial tyranny, which probably steered Bruni to model his panegyric after the Athenian example. At the turn of the sixteenth century,

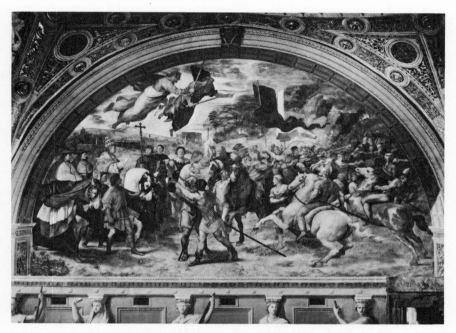

Plate 21. Raphael, *The Meeting of Attila and Leo the Great*, 1511–12. Stanza d'Eliodoro, Vatican, Rome (Alinari, 7930)

however, even the Florentine mind widened its horizon, and Machiavelli tackled the limits of city-states in his discussion of "what the Roman people did pertaining to the expansion of their empire" (*Discourses on the First Decade of Titus Livius*, II, Preface). The recurrent problem of political size led to a dilemma: "Without a large number of men, and well armed, a republic never can grow larger, or if it does grow larger, never can maintain itself" (I, 6). Having noted that "it is not possible or natural for a slender stem to bear up a large limb," the historian turned to Sparta, whose expansion was short lived because its citizens "did everything to keep foreigners from having dealings there." By contrast, the Romans immediately understood that "a little state cannot take possession of cities or kingdoms that are stronger and greater than itself" (II, 3). In antiquity, even Aristides praised the size of imperial Rome over Greek cities: "What another city is to its own boundaries and territory, this city is to the boundaries and territory of the entire civilized world. . . . Though the citizens of Athens began the civilized life of today, this life in its turn has been firmly established by you, who came later but who, men say, are better" (*Roman Oration*, 61, 101). In the path of Pompey and Julius Caesar (*dominus mundi*), the doctrine of Rome as a universal Empire clearly took shape under

Augustus' leadership. His claim to be a *cosmocrator* took on the symbols of globe and sceptre on the coinage, not to mention the breastplate of his Primaporta statue.[30]

It was in Rome that the scope of Renaissance metahistory began to link back to the Eternal City, an "empire without end" (Virgil, *Aeneid*, I, 278–79) fulfilling the metaphysical longings of all nations. That ecumenical project became a priority under the pontificate of Julius II, whose plan for the new St. Peter's was to mark the coming of *Plenitudo Temporum*. In Rome, the idea of rebirth combined the restoration (*instauratio*) of the Church with the renewal (*renovatio*) of the Empire. And Erasmus saw a new Julius Caesar when the pope (whose very name made the onomastic reference explicit) entered Bologna. Like Constantine, the *papa terribile* updated the tradition of *Caesaropapism*. Rome was to assume again a leading role on the Italian and international scene.[31] By so doing, the pope revived the concept of Roman unity first within the boundaries of the Empire (*Romania*) and finally wherever Christians could be found (*Romanitas* and *humanitas*). Slowly but inevitably, the civic ideal of *politeia* gave way to that of a universal *basileia*; rather than one's birthplace, the City became a matter of spiritual belonging. On such grounds, the artist assumed the role of a metahistorical bard. At first, he was crowned on the Capitoline hill, and finally took on the features of Michelangelo in Raphael's *School of Athens*, where homage was paid to the superiority of ideology over time.

Like the epic past, which is absolute and complete precisely because it has been severed from the flux of time, the Renaissance was folded into a system of self-fulfilling standards. To be absolute, the historical present had to be reborn into the atemporal condition of either mythic or aesthetic realms. In both instances, the issue was not one of distance "in" history but "above" it. The absolute past of antiquity had to find a counterpart in the metahistorical present. The succession of epochs gave way to *epifanias*, and *natura naturans* was converted into *natura aulica*, that is to say, nature "as value . . . what before was Nature has become Culture."[32]

The classical work, Goethe noted, "raises man above himself; it rounds out the sphere of his life and activity and deifies him for that present moment which includes the past and the future. Such were the feelings of those who gazed upon the Zeus of Olympia."[33] A similar state of mind probably stirred Renaissance artists when they looked at their own artifacts. The ancient projection of human life into ideal "doubles" found modern descendants in the family leader, David, and the Courtier.

Reality often met the highest expectations in such a mythmaking climate. Ficino spoke for most humanists when he described Medician Florence in more than laudatory terms: "If we are to speak of a Golden Age, it

certainly would be that which could produce golden minds (*aurea ingenia*) everywhere. And nobody can doubt that our century is such, if one only considered its achievements. This golden century has returned to the light the liberal arts (almost dead), grammar, poetry, eloquence, painting, sculpture, architecture, music, and the ancient sound of the Orphic lyre. And that took place in Florence."[34] Cosimo de' Medici was presented as *pater patriae*, a Platonic philosopher-ruler, and a new Maecenas. Nostalgia and propaganda alike nurtured a magic efflorescence of the human spirit throughout the new Athens; its place enhanced by cupolas that rivaled ancient pyramids; its sacred texts written by Manetti; its artists verging on the superhuman; its history glorified by Bruni; its heroes celebrated by Vespasiano da Bisticci, who found in Florence a new "golden age, full of learned men."[35] In antiquity, the founders of cities were regarded as heroes, and so did the Florentines look on their immediate ancestors. Cristoforo Landino went so far as to see in Dante the first of "those who by their immortal virtue have changed from mortals to immortals" in a city where "various rewards are always placed in front of learned men."[36] Caught in a state of sloth, Boccaccio was visited by "the most famous man" of his time, who thus spoke "to an ordinary mortal." Petrarch's divine-like intervention spurred him to take up his "dutiful pen." Because it would be written "among the immortals," his name was to gain "eternal fame" (*The Fates of Illustrious Men*, "The Renowned Francis Petrarch and His Reproof of the Author").

In Rome, Pietro Bembo glorified Julius II, and allusions to a new Golden Age took on bombastic overtones during the pontificate of Leo X. Contacts between Florentine and Roman Humanism had become particularly active during the 1430s, when Eugenius IV attended the Council of Florence (1439) and brought Alberti with him. In St. Peter's basilica, Giles of Viterbo proclaimed in 1507 that the Christian golden age had been fulfilled under the pontificate of Julius II.[37] The myth of the *renovatio Romae* at the end of the *Quattrocento* also thrived on the decline of Florentine influence in the balance of power across the peninsula. Whether a Medici or a Montefeltro (and a Malatesta, Ezra Pound would recommend), the great man of the Renaissance "asserted his personality centripetally, so to speak: he swallowed up the world that surrounded him until his whole environment had been absorbed by his own self."[38] At first, Julius II made of the Church's temporal power a necessary factor for its spiritual expansion; later, he chartered his *renovatio imperii* on a universal scale. After Columbus' discovery, in fact, Christianity had outgrown even the imperial range of ancient Rome. A lifetime would not have sufficed to carry out such a program, let alone the few years Julius had left to live (he became pope in 1503, at the age of sixty, and died ten years later).

4

Because of an historical inversion whereby a most harmonious vision of mankind had been located in the past, the Greeks placed their better world back into a time when the beginning was great: the bright day before yesterday. After Homer, a long time had to pass before the present could become the object of poetic invention; with a few exceptions, it was never accepted wholeheartedly.

By contrast, the Renaissance mind carved a great beginning from its remembered past-present, its bright yesterday. Castiglione clearly focused on that temporal perspective: "I am not praising things so ancient that I am free to invent, and I can prove my claims by the testimony of many men worthy of credence who are still living and who personally saw and knew the life and the customs that once flourished in that court: and I consider myself obliged, as far as I can, to make every effort to preserve this bright memory from mortal oblivion, and make it live in the mind of posterity through my writing" (*The Courtier*, 202). The immediacy of personal testimonies is set against the conceptual magnitude of "memory," "mortal oblivion," and "writing" for "posterity." In a way, artists and writers created their own antiquity by magnifying the few years that lapsed between historical facts and artistic representation. *On Painting* is grounded on the artistic accomplishments of the 1420s, and *On the Family* on the retrospective experience of the author's father and friends. Aesthetic distance compensated for chronological proximity.

Interestingly, Alberti's own knowledge of his forebears did not extend beyond two generations, much as contemporary Florentine *ricordi* dealt with the immediate past. The concept of family was centered on genealogy as a tradition of prestige rooted in one's memory of his own (or his father's) achievements. In Florence, the medieval heritage of an extended family, or *consorteria*, changed when continuity gave way to ramification during the fifteenth century. The theoretical isolation of the Albertian family leader marked a break away from the medieval continuity of socio-political bonds. Whereas the entire clan occupied a number of indistinguishable buildings in medieval architecture, the new *palazzi* symbolized pride, power, and the isolation of a man's household. Lineage yielded to individual concepts of power and nobility.[39] The new merchant was quite autonomous, and a network of alliances was to protect his new vulnerability. In Alberti's own words, "to decide which is the most suitable career for himself, a man must take two things into account: the first is his own intelligence . . . the second, the question requiring close consideration, is that of outside support, the help and resources which are necessary or useful and to which he must have early access, welcome, and free right of use if he is to enter the field for which he seems more suited for than any other" (*O.F.*, 137). Indeed, the outline of a

family myth which Alberti presented in his literary treatise, Mantegna painted on the walls of the Camera degli Sposi (Gonzaga), and Castiglione celebrated in *The Courtier* (Montefeltro).

The moderns therefore were not dwarfs who could see farther than anybody else only because they stood on the shoulders of ancient giants. Bernard of Chartres' famous simile is ambiguous, since it implies that we are at an advantage only because of our predecessors' greatness.[40] It could hardly be denied that the idea of progress was tested by the decline of the Roman empire and the barbaric invasions, not to mention Christian falls, approaching days of apocalyptic doom, and millennial deadlines. The new Apollonian lineage of creators could not settle with that heritage, for its emulation of the past could have easily dwarfed antiquity itself. The issue was not to see farther, but better.

Machiavelli measured the stature of his hero against Theseus, Moses, and Cyrus in the last chapter of *The Prince*, while Michelangelo's David shouldered the conviction that the piling up of historical experience would yield to a model free of the frustrations inherent in the very concept of progress. Richard Collingwood would suggest that, for Michelangelo as for Tacitus, the idea of development in a character, an idea so familiar to ourselves, was an impossibility. A "character" is "an agent, not an action; actions come and go, but the 'characters,' the agents from whom they proceed, are substances, and therefore eternal and unchanging."[41] David's *contrapposto* best illustrates the sculptural stability of substantiality.

Between the extremes of the Cynics' denial of progress and Seneca's belief in the continuous unfolding of knowledge, antiquity offered a number of intermediate approaches. Among them, the Pre-Socratics and the Sophists were progressivists and antiprogressivists at the same time. They knew how important progress was for the survival of mankind. But their commanding sense of security did not encourage growth beyond satisfactory achievements. Actually, they credited man with as much as they denied him.

For Seneca (*Epistles*, 102), "all time is open for the progress of thought." As a mental dimension, however, fulfillment exceeds time. At empirical levels, "all the works of mortal man have been doomed to mortality, and in the midst of things which have been destined to die, we live. . . . let the mind be disciplined to understand and to endure its own lot, and let it have the knowledge that there is nothing which fortune does not dare" (*Epistles*, 91). It would seem that fate could destroy the objects of culture, but not the creativity of the human spirit. In fact, "virtue ought to test her progress by open deed, and should not only consider what ought to be done, but also at times apply her hand and bring into reality what she has conceived" (*De otio* 32).[42] Once again, antiquity was reluctant to steer action away from reality.

Accounts of *res gestae* and classical models of prudent *mediocritas* were superseded by Renaissance quests of virtual accomplishments. Against the ineluctable course of time, metahistory secured utopian oases where knowledge, criticism, and invention amalgamated pagan, Hebrew, Christian, and Arabic legacies. History became a matter of meaning, for it tested the value and validity of ideological choices.

However summarily, one might try to outline the sources of the Renaissance concept of meaning in history. In a Greek sense, man could do no more than meeting every situation with magnanimity. Since everything was fated to undergo cyclical annihilation, no substantial difference set the past apart from the future. By and large, a philosophy of history would have been a contradiction in terms. On Latin shores, however, one cannot disregard the Virgilian vision of an ecumenical *Romanitas*, which he probably passed on to Augustus. Yet, even the apocalyptic tradition of Rome was denounced (Catullus, Lucretius, Sallust), and the *Aeneid* wavered between Rome's realistic power and an aureate future under Augustus. Likewise, Horace's criticism of contemporary Rome in the *Odes* was set against a cycle at the end of which Augustus would learn from the poets. Completion and origination coincided at a mythic point where the artist envisioned a moral recreation of Augustan Rome. As a more explicit quest for meaning independent of Roman myths, the future of history belonged to Christian eschatology and the Hebrew prophets. As a Christian intermediary, Augustine probably paved the way for later notions of meaning and development in history. Having been educated as an ancient, he made it easier for Petrarch to reconcile classical with Christian humanism, the Eternal with the Heavenly City.[43] While responding to the ancient emphasis on the memory-myth coordinates, Renaissance minds subordinated the record of events to the configuration of intentions; history (as past-oriented) was reconciled with prophecy (as future-oriented).

Still on the subject of postclassical heritage, even the Florentine preference for geometric design and proportional relations can be traced back to the Romanesque walls of the Baptistry and the façade of S. Miniato, early examples of a uniquely Tuscan style stemming from a geometric culture.[44] If the inlaid pavements of Egyptian temples triggered Pythagoras' discovery of geometry, the marble inlays of twelfth-century buildings probably made a similar impact on Brunelleschi, whose ignorance of Greek temples made it easier for him to favor the wall architecture of Christianity. From the statues at Reims to the Carolingian proto-Renaissance, the classical reliance on measure, geometry, and volume exercised a sustained (though problematic) influence through a number of medieval "renascences." With such precedents in mind, Renaissance architects outlined a hypothetical vision through buildings that fulfilled progress there and then.

5

Whether it be through the powerful architecture of a monumental nude, a mercantile prototype, or a courtly model, Renaissance culture came to a standstill, for it could neither improve nor decline. The Petrarchan legacy came to fruition; history could see its beginning as well as its end:

> "Has been," "shall be," and "was" exist no more,
> But "is" and "now," "the present" and "today,"
> "Eternity" alone, one and complete.
> (*Triumph of Eternity*)

At last, now and forever were dissolved into images pregnant with a potential for eternity.

So conceived, metahistory could as well define the distinction between history and culture, between what people do and the idea of what they ought to do. Culture sets up perfective and ground-breaking values that transcend experience. Oswald Spengler contends that what culture leaves behind is civilization, which settles in when the creative drive slows down. According to a pattern of "necessary *organic succession*," civilizations are "the most external and artificial states of which a species of developed humanity is capable. They are conclusions, the thing-become succeeding the thing-becoming." What expands and becomes is culture, of which "civilization is the inevitable *destiny*." Civilization transforms quality into quantity, and symbolic values into real life. Living as they were in an age of violent instability, Renaissance artists knew that culture could not exceed the boundaries of art. In a significant way, their works could support Nicolas Berdyaev's contention that culture "realizes truth only in philosophical and scientific treatises; goodness in ethics and social commandments; beauty in poems, pictures, statues, plays, music, or architectural monuments." Culture seeks "symbolic achievements, civilization 'realistic' ones."[45] There was no room for organic successions in the Renaissance cosmos, where culture would not leave ruins, and civilization could never settle in.

Yet, Renaissance *aemulatio* had to master its own dynamics if perfection could ever be maintained. At best, the future would perpetuate the present; what was conceived in the mind could not touch life without making its achievements both transitional and inadequate. The actual had to yield to the virtual. At an early stage in the metahistorical synopsis of the would-be, Livy described Rome as the Eternal City, because he thought of her in substantial rather than historical terms. Within that perspective, critics have proposed that in Julian Rome "culture was a kind of epiphany, a 'showing forth' in particular forms of the precepts, ultimately of the divine principles, which particular things were taken to exemplify."[46] In a cultural spirit, we still associate a cluster of aesthetic and philosophical attitudes with the

"Renaissance Man," an image-idea equally substantial, nonhistorical, and topical.

6

By the turn of the sixteenth century, a constellation of new deities had emerged. Artists (Andrea del Castagno, Bernardo Rossellino, Giannozzo Manetti) crowned Dante, Petrarch, Boccaccio, Bruni, Federigo da Montefeltro, and Lorenzo de' Medici. Later, Bembo, Castiglione, and Vasari deified Raphael and Michelangelo; the Renaissance generated its own mythology. After so many centuries, Apelles and Phidias, the makers of gods, found worthy descendants in Michelangelo and Raphael; the *Apollo Belvedere*'s turn of the head (plate 22) shared with the commanding pose of the Florentine David a sense of epiphany and the glance toward a more radiant world. To borrow from Johann Winckelmann's inspired words on the classical form, their "lofty look, filled with a consciousness of power, seems to rise far above" their "victory, and to gaze into infinity."[47]

Aemulatio had conquered its last beginning; after the works on the Sistine ceiling and in the Stanza della Segnatura, it could not go any further. To the extent that it could be visualized, perfection had mastered past and future. How could anyone think of emulating such masterpieces on his way out of the Vatican?

On matters relating the Renaissance to mythic survivals, Jean Seznec has found it significant that no Italian history of the gods appeared between Boccaccio (1350–70) and Giraldi Cinthio (1548). It "is as if nothing more was now needed in order to know and understand the gods."[48] Beyond medieval travesties of the ancient story (Tertullian, Lactantius, Augustine), Prometheus recreated the ignorant man of nature into an educated human being in Boccaccio's *De genealogia Deorum* (44), where the *doctus homo* becomes a teacher and educator (*quasi de novo creet, docet et instruit, et demonstrationibus suis ex naturalibus hominibus civiles facit, moribus scientia et virtutibus insignes*). Castiglione returned to Prometheus in a passage that placed much of the dialectic of *imitatio-aemulatio* in perspective:

> Wherefore Prometheus stole from Minerva and from Vulcan that artful knowledge whereby men gain their livelihood; but they did not yet know how to congregate in cities and live by a moral law, for this knowledge was guarded in Jove's stronghold by most watchful warders who so frightened Prometheus that he dared not approach them; wherefore Jove took pity on the misery of men who were torn by wild beasts because, lacking civic virtues, they could not stand together; and sent Mercury to earth to bring them justice and shame, so that these two things might adorn their cities and unite the citizens" (*The Courtier*, 295–96).

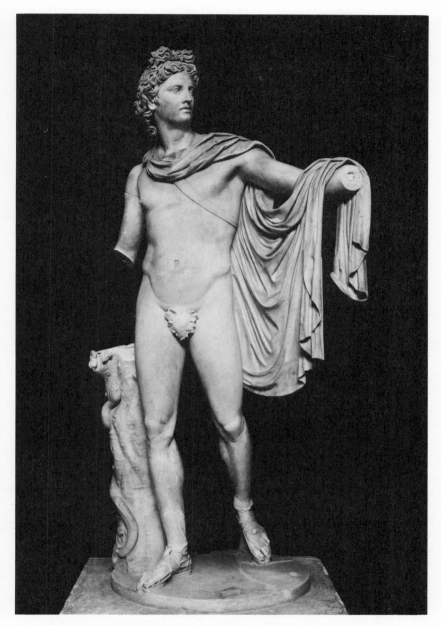

Plate 22. *The Apollo Belvedere,* c. 350–320 B.C. Roman copy, Vatican, Rome (Alinari, 6501)

"Stealing" and "pity" could no longer do, for civic virtues had grown to a point where man could be independent of the gods. Revealing are Charles Trinkaus' words on this matter: "Classical mythology with its portrayal in art and literature of the terrible consequences of man's attempts to play god little comported with this Renaissance effort at human apotheosis."[49] It could thus be suggested that stories of the Olympians lost much of their luster because the culture of the Renaissance had replaced the gods of myth with its own likenesses of the new *homo triumphans*.

Actually, the ancient deities legitimized their modern descendants in Ferrara (Este), Mantua (Gonzaga), Florence (Medici) and Urbino (Montefeltro), where the ruling families sponsored dynastic glorifications. Mantegna painted the triumph of Caesar; the triumphal arch of Castel Nuovo honored Alfonso the Great's entrance in Naples (1443); the Sistine Chapel housed a triumphal arch (Botticelli's *The Punishment of Corah and the Sons of Aaron*) before Michelangelo began to paint its ceiling, and the last book of Flavio Biondo's popular *Roma Triumphans* explored the subject at length. Reborn and renamed on Italian shores, the artist did not steal fire, but kindled his own when it came to illuminating a new Parnassus of his own making. The fact is that every aspiration of the fifteenth century took on a visual form when the artist conquered the instruments of immortality: tomb sculptures, memorable buildings, and cycles of painting in the style of the new age.

In the culture of the epic, the mind found no insurmountable difference between inside and outside, essence and existence. Life and art joined forces within a finite circle where novelty was suspect. Beyond epic completeness, man has invented the creative productivity of the spirit. Any resurrection of the epic world therefore would demand that art produce out of itself all that was once simply accepted as given. In other words, art must create by its own power alone the preconditions for such effectiveness.[50] Renaissance treatises met the classical challenge on potential grounds that made room for the individual's a priori effectiveness. Since they were obviously aware that their ideal figures could not survive empirical testings, Alberti and Castiglione recreated life in the realm of art, where contextual insulation was at once propitious and necessary.

When he wrote the *Africa*, Petrarch was a Virgil without Rome. Whereas one celebrated the progress of history toward its Augustan climax, the other stood in a vacuum.[51] Who could be Petrarch's Augustus? King Robert of Naples died two years after the poet's coronation, Cola di Rienzo failed miserably, and the Church was in exile. In spite of all that, the modern poet filled the void with his literary heritage. On the page, the context of his *Africa* became polysemous. It was the history of Rome as the Eternal City echoing Augustine's City of God, and of Scipio as a military leader and an

agent of divine providence. If the historical present was barren, Petrarch filled it with forms of cultural plenitude. Mikhail Bakhtin explains that the absolute past of the epic is a world of "beginnings," and "peak times," a world of "fathers and of founders of families, a world of 'firsts' and 'bests.'"[52] In an emulative spirit, Medician Florence and Julian Rome glorified their own absolute present. While Athena's owl did not take flight until dusk had fallen on the Greek world, the Renaissance eagle began soaring toward the mountaintop in the first days of spring, and it has been gliding over the culture of the West ever since.

The classical and Renaissance insistence on triumphs, coronations, panegyrics, and monumentality mirrored a utopian perspective that was intrinsically cultural. The utopian mode, in fact, measures the distance between things as they are and things as they should be. At the metahistorical level of culture, forms of perfection cannot change.[53]

Alberti's conviction that man stands at the center of the historical landscape made of past and present a human-made and human-inhabited world that we can imitate, and hopefully improve. By implication, we are, and we know such a world. A direct link can therefore be drawn between that challenge and Giambattista Vico's axiom: "The world of civil society has certainly been made by men, and that its principles are therefore to be found in the modifications of our own mind" (*New Science*, par. 331). Such a precept was central to Renaissance culture, which also thrived on the Vichian triad of art, myth, and language.

Within the Graeco-Roman tradition, the Renaissance made and remade the civic society. In the words of Paul Valéry, for whom Socrates' "all-powerful thought" changed "poison into an elixir of immortality" (*Eupalinos or the Architect*),

> The formation of the human personality, an ideal of the most complete and perfect development of man, was sketched out and realized on our shores. Man as the measure of all things; man as the political element and member of the city; man as a juridical entity defined by law; man as equal to any other man before God, and considered *sub specie aeternitatis*—these are almost entirely Mediterranean creations.[54]

From Athens and Rome to Florence and Urbino, such have been the supporting structures of culture along Mediterranean shores.

7

Whether they are about to awaken to life (Adam) or ready for action (David), Michelangelo's heroes do not direct their divine-like potential toward specific acts. David's impending motion contains ever new possibilities, for no single goal can satisfy him. At a distance from Goliath as well as

from action itself, the hero is about to become what he makes of himself. Much of the superhuman character of the sculptural giant is nestled in a repose that has mastered all antagonisms. His relaxed confidence seems to equate history with an ameliorative vision which no foe could ever threaten, much as his stand is forever bearing the full weight of an unswerving faith in the intellectual nobility of man.

In mythology, omnipotence does not speak; neither does David, since his very act of being commands an authoritative language of speechless demonstration. In a Godlike fashion, Michelangelo bestowed on posterity an image of man at his potential best. For Walter Pater, the sculptural giant is a form of "moral expressiveness," and his is "the repose of perfect intellectual culture." Symbols of that sort generate "a genuine enlargement of humanity and a decisive step towards culture."[55] We can indeed read in these words our own heritage of hope.

PART III

The Promise of Eternity

5

Rebirth as Synthesis in *The Courtier* and *The School of Athens*

There we shall see actual life governed by the ideal, honour triumphant over possessions, thought over enjoyment, dreams of immortality over existence. . . . Aesthetic semblance can never be a threat to the truth of morals.

Friedrich Schiller

Part One

1

If only for brief moments, art conquered life in Florence, Urbino, Mantua, and Rome. Such "monuments of unaging intellect" might have made of Italy that "country with Unity of Culture" Yeats longed for throughout his life. His fascination with mathematics did not fail to capture the driving force of the age when he saw in the pictorial perspectives of "mid-Renaissance" the sign of a quest for "certainty." Man "knows what he has made. Man has made mathematics, but God reality." Art illuminated "all beautiful things" at the Montefeltro court, where an aloof elite was magically delivered from "the fear of life."[1] On his way to Byzantium, Yeats probably found in Urbino (and Ravenna) much of his aesthetic "artifice of eternity."

In a similar spirit, *The Courtier* presented Urbino as the ideal *locus* of Renaissance culture. Since the book was written after "the greater part of those persons who are introduced in the conversations" had already been dead, memory recreated exceptional moments when "poets, musicians, and . . . the most excellent of every kind of talent that could be found in Italy" (*The Courtier*, 2) gathered in a homeland where citizenship was a

matter of distinction rather than birthright. Truly, there did not come forth "from the Trojan horse so many lords and captains as from this court have come men singular in worth and most highly regarded by all" (*The Courtier*, 286). Readers were therefore confronted with, and lured by, a paradigm whose historical details are there to gain credibility for a literary representation that would endure as a cultural legacy.[2] The moment had come when the artist could formulate ideas as realities, and no wedge was drawn between hope and remembrance.

<div align="center">2</div>

Since he was born out of a dead past and set against an impossible future, the Courtier could exist only as a hypothetical figure sheltered by art and nurtured by a world of words. Very much like Auden's aesthetic hero, the Courtier was endowed with exceptional gifts, and had to "command others' admiration" as long as he could.[3] Having been conceived "without defect of any kind" (*The Courtier*, 11), he was to master perfection.

Even if Urbino did not actually exist for any extended period of time as Castiglione envisioned it, posterity could still attempt to live in the utopian "manner of that city" (Plato, *Republic*, ix, 592b). In the Graeco-Roman world, the *polis* entrusted its best achievements to the cultural and educational ideal of *paideia*, which the Renaissance bestowed on its own present-posterity.[4] Indeed, "the" education and "the" culture of "the" Courtier.

Castiglione's overriding idealism challenged even the limits of language. In fact, his new word, *sprezzatura*, did not satisfy utilitarian needs; on the contrary, it voiced a talent no less hypothetical than a model "without defect of any kind." Thriving on indeterminacy, *sprezzatura* was to conceal "all art and make whatever is done or said appear to be without effort and almost without any thought about it" (*The Courtier*, 43). Statements such as "we may call that art true art which does not seem to be art—*si po dir quella esser vera arte, che non appare esser arte*" (*The Courtier*, 43)—fostered even greater elusiveness. Semantic ambiguity was crucial to a mode of behavior whose *mots-clés* (or word-histories) mixed the unique with the representative.[5]

In the tradition of ancient (Cicero, Quintilian) and modern (Gelli, Dolce, Francisco de Hollanda) recommendations that art should conceal art (*art artem celare est*), R.J. Clements has wisely steered toward a contextual—or associative and lexical—field of meaning for *sprezzatura*: "Within lightness of touch, easiness of manner, effortless deftness, the semantic value of *sprezzatura* is somewhere in this area."[6] Of the parent verb *sprezzare-disprezzare* (to disdain), *sprezzatura* maintains the presumption of a righteous superiority capable of foreshadowing a yet greater ingenuity, since "it impresses upon the minds of the onlookers the opinion that he who performs well with so much facility must possess even greater skill" (*The*

Courtier, 46). Language bordered on that no man's land where vision and experience shaped images of life that the artist presented, but would not— or could not—fully reveal.

Sprezzatura was rooted in memory as hope, and voiced a mythic potential that was at once outreaching and exclusive, discrete and discreet. Castiglione's book did not utter the words spoken in the conversations at Urbino, for its silent vocabulary appeared on the page long after the sounds of life had been spent. In other words, the way life could have phrased perfection.

Consistent with the contemporary bent of mind, Castiglione used *sprezzatura* in conjunction with *disinvoltura*, "*sprezzata disinvoltura*," which is inadequately translated as "cool *disinvoltura* (ease)" (*The Courtier*, 44). The term thus became relational. Likewise, Michelangelo's sculptural talent stemmed from tensions between *facilità* and *difficultà*. In turn, *difficultà* and *terribilità* merged into a single understanding of art; one arose in the Middle Ages, and the other was taken over from Graeco-Roman rhetoric. *Terribilità* thus updated the Greek *deinotes*, which included a cluster of classical terms (*megethos, semnos, augustus, pondus, gravis*) bearing on loftiness, power of expression, and technical skill. Translations and adaptations of Latin terms into the vernacular also weighed on linguistic polysemy. Words without exact synonyms often were defined by quoting them in context, and by noting shades of difference between contiguous terms. Among the layers of contemporary meanings that have been lost, *terribilità* described behavior as style-performance, which became legendary in the case of Michelangelo's work on the Sistine ceiling (as his own verses bear witness). Because of his assertive personality, Julius II also was called *terribile*, a trait that Machiavelli took to include "ardent spirit," "natural wrath," and "raging madness" (*Second Decennale*, 85–88). To endow them with the clarity of a geometric analogue, Castiglione placed "all the virtues" at a "midpoint" where they "are equally distant from the two extremes, which are the vices . . . for just as with a circle it is difficult to find the point of the center, which is the mean, so it is difficult to find the point of virtue set midway between the two extremes" (*The Courtier*, 323). As the unitive measure of harmonious proportions, the artistic "mean" encompassed language as well.

To a significant extent, the relational character of Renaissance word-histories echoed classical precedents. In fact, Cicero's concept of *virtus* "is not appropriate to all virtues," even though "all have got the name from the single virtue which was found to outshine the rest, for it is from the word 'man' (*vir*) that the word virtue is derived" (*Tusculan Disputations*, II, xviii, 42–43). Like *virtù* and *sprezzatura*, *virtus* is the perfect sum of parts arranged in a manner similar to an anatomical whole. Aristotle and the Scholastics

called the mechanism of such analogical transfers *metabasis*, which defined ambiguous transitions from one genus or species to another. That method came to include language, and Vico later noted that "in all languages, the greater part of the expressions relating to inanimate things are formed by metaphors from the human body and its parts" (*New Science*, par. 405). Inevitably, each transfer widened the metaphorical range of words, whose semantic texture was enriched at the expense of precision.[7]

When Castiglione demanded that the prince be endowed with a "sweet and amiable humanity—*umanità dolce ed amabile*" (*The Courtier*, 319)—a reference was made to the Roman concept of *humanitas* as a community-oriented ideal equivalent to the Greek *paideia*. On that subject, Alberti had written that "virtue is the bond and the best source of friendship, and that friendship flourishes and brings forth good fruit where there is good will, agreement on goals, and frequent association" (*O.F.*, 268). The humanist vocabulary betrayed an overriding emphasis on "connectedness," and *virtù* was understood as an accretion of active (court) and contemplative (cloister) values. Semantic boundaries overlapped, and words complemented their meaning through other words. At court, magnanimity would make temperance and justice greater; yet, it could not "stand by itself because whoever has no other virtue cannot be magnanimous. Then the guide of these virtues is prudence, which consists of a certain judgment in choosing well. And linked into this happy chain are also liberality, magnificence, desire for honor, gentleness, pleasantness, affability, and many other virtues" (*The Courtier*, 302–3). We might agree that deviation and *écart* bear auspicious inclinations for the modern self. Within the classical-Renaissance trajectory, instead, it is resonance and imitation that enhanced artistic identity.[8]

Along the relational path, the Courtier's best talents were to be placed at the service of "his prince's virtue; and it is enough that both of them have this intrinsic aim in potency—*basta aver questo fine intrinseco in potenza*—even when the failure to realize it extrinsically in act arises with the subject to whom this aim is directed" (*The Courtier*, 331). *Sprezzatura* and *virtù* finally met; their encounter should have inspired the Prince, the Court, and, at the very end of the book, the whole community. Aristotle and Plato would not "have scorned the name of perfect Courtier, for we clearly see that they performed the works of Courtiership to this same end. The one with Alexander the Great, the other with the kings of Sicily. . . . The office of a good Courtier is to know the prince's nature and inclinations . . . and then to lead him to virtue." Wishful thinking took on religious overtones when the officiating preacher stated in his papal eulogy: "Although antiquity dared not ascribe all the virtues to one of the gods, such an ascription is demanded in the case of Nicholas V."[9] However improbable his role as

counselor and "preceptor of the Prince" (*The Courtier*, 332–33) might have been, the Courtier did not fail to crystallize the pursuit of an educational ideal.

Virtù (Alberti, Machiavelli), *sprezzatura, grazia* (Castiglione, Raphael), and *terribilità* (Michelangelo) formed a charismatic cluster of words that blended individual talent with public expectations. As evasive as the secret of excellence itself, those terms could not be explained without vilifying their rarity. On matters of definition, Petrarch had already understood that "there is a mysterious something" the quality of which "is to be felt rather than defined."[10] Alberti reiterated "that perhaps the first thing necessary is not so much either virtue or riches, but a certain something for which I cannot find a name, which attracts men and makes them love one person more than another" (*O.F.*, 250). The excess of meaning over definition was innate to classical and Renaissance word-histories, which also uttered the excess of aspirations over results. In the economy of classical language, words were not so much signs as carriers of relationships. However linked to what took place in Florence, Urbino, and Rome, *virtù* and *sprezzatura* were the verbal symbols of a society wherein knowledge had woven feeling, thought, rhetoric, and tone into a moral style.[11]

On ancient and modern shores, many doubted that talents such as *virtus* and *virtù* could be taught. Plato believed that the "search for truth is nothing but an opening-up of the soul, with the contents that are naturally within" (*Meno*). Socrates rejected the word "teach" because it implied "filling the soul with knowledge poured in from the outside." Knowledge, therefore, is recovery through acts of reminiscence. Conversely, Protagoras called himself a "Sophist or teacher of virtue and education" (349a, Jowett's translation), or "a teacher of culture and virtue" (Versenyi's translation) in the Platonic dialogue bearing his name. Against Socrates' better judgment, Protagoras presumed that virtue was the sum total of an educational process. Whereas the Greek concept of education was geared to the development of the boy (*paideia* from *pais*), the Roman mind replaced beginning with maturity, the boy with the man (*humanitas* from *homo*). As an educational ideal, *paideia* quickly became part of a Christian tradition that made of Jesus himself the teacher, and of education the unfolding goal of divine providence. Within that trajectory, the fullest expansion of man's potential became a Renaissance ideal.

Many pages are given to the education of the young in the Albertian treatise on the family. Yet, "teaching" remains as elusive as on Socrates' lips. Although "all mortals are by nature sufficiently able to love and preserve some highly honorable excellence . . . the father should be on the watch and quick to recognize the temperament and the will of his sons. He should aid them toward their praiseworthy goals, and draw them away from any loose

ways and ugly indulgences" (*O.F.*, 75–76). Parents are responsible for creating favorable conditions for the youth's choice of virtue over vice. At best, they can control the context, not the matter, of education. Excellence therefore seems to open up from within man's own self. Since beauty (environment) and order (society) heightened inborn tendencies, the concept of the state as a work of art fulfilled educational ideals as well.

In Castiglione's adult world, the Courtier is required to accompany "his actions, his gestures, his habits, in short, his every movement with grace," which is "that seasoning without which all the other properties and good qualities would be of little worth" (*The Courtier*, 41). Like Plato's "divine dispensation" (*Meno*, 99e), *grazia* is "a gift of nature or the heavens." Empyrean favors aside, the question is raised as to whether one could acquire *grazia* by putting forth "labor, industry and care" (*The Courtier*, 41). The answer is unequivocal: "I am not bound," said the Count, "to teach you how to acquire grace or anything else, but only to show you what a perfect Courtier ought to be" (*The Courtier*, 41). Castiglione could not have been more specific without transforming a unique construct into a manual of practical behavior. Because they are God-given rather than learned (as an art-craft; *The Courtier*, 296), *grazia* and *virtù* could exist only in the realm of aspirations. At a potential level, Castiglione foresaw a Prince who, trusting the Courtier's counsel, would become "the most glorious and dear to men and to God by Whose grace he will attain the heroic virtue that will bring him to surpass the limits of humanity and be called a demigod rather than a mortal man" (*The Courtier*, 306). Pico and Castiglione joined forces in placing their hypothetical forms beyond the limits of the human.[12]

To refer for a moment to Paul de Man's comments on the ideology of the aesthetic, formalization inevitably "produces a special kind of grace, but can this elegance be taught?" The negative implication is that one moves into unknown territories where the concept of the text shifts from an "imitative" (merchants and courtiers) to a "hermeneutic" model (*pater familias*, Courtier) standing at bay of mimesis and education. An analogous shift occurs from "stated" to "intended" meaning, which was "the author's interest to keep hidden" (as Alberti and Castiglione in fact did). In the archetypal mode, criticism has confirmed that the biblical account does not intend to teach how man was created, but that he was created.[13]

Undoubtedly, the Renaissance succeeded in molding an unprecedented typology of images that were to exercise a lasting influence. Still within that tradition, Schiller based his concept of aesthetic education on the essential interaction between permanence (Person) and mutability (Condition). Since "in man, a finite being, Person and Condition are distinct, the Condition can neither be grounded upon the Person, nor the Person upon the Condition . . . outside of ourselves something other than ourselves

exists too." Condition implies time, which involves becoming. In reality, man is a "Person situated in a particular Condition." Without time, "without becoming, he would never be a determinate being; his Personality would indeed exist potentially, but not in fact." The tension between *Person* and *Zustand* is crucial to the human character. To preserve the Courtier as "absolute formality," Castiglione resisted incarnation and glorified the potential. He would have agreed with his German heir that it is within man's own self

> that you must rear victorious truth, and project it out of yourself in the form of beauty, so that not only thought can pay it homage, but sense, too, lay loving hold on its appearance. And lest you should find yourself receiving from the world as it is the model you yourself should be providing, do not venture into its equivocal company without first being sure that you bear within your own heart an escort from the world of the ideal. Live with your century; but do not be its creature. Work for your contemporaries; but create what they need.[14]

While Condition strained the romantic embodiment of art into life, Renaissance aloofness could affect its century only by making it "its creature," that is to say, new born and perfect.

Paul de Man would have found Castiglione and Schiller in agreement insofar as "reason governs with unconditioned necessity" in the "realm of aesthetic semblance." Unlike Schiller, Castiglione might have located the "State of Aesthetic Semblance" at Urbino, or at least at Urbino as he represented it. It would seem that culture had grown to a point where art was essential to any appreciable definition of *umano*. Epistemological implications are always in play "when the aesthetic appears over the horizon of discourse," and so it happened with the Renaissance vocabulary of perfection.[15]

Part Two

1

Born and raised in Urbino, Raphael translated its legacy into a yet more encompassing synthesis. His fresco cycle (*School of Athens*, *Disputa*, *Parnassus* 1510–11, plates 23, 24) in the Stanza della Segnatura marks the triumph of philosophy, theology, and the arts. *Paideia* and *humanitas*, the educational ideals of antiquity, thus came of age; the school of Hellas found a worthy counterpart by the banks of the Tiber, where Plato and Aristotle joined company with Raphael and Michelangelo.

At the turn of the sixteenth century, the Florence-Athens connection pointed south toward Rome. Battista Casali struck an unconventional note in the final apostrophe of a papal sermon preached before Julius II in 1508.

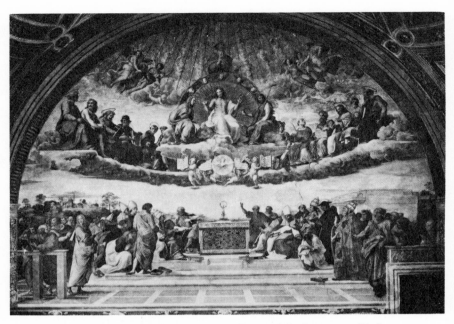

Plate 23. Raphael, *Disputa*, 1509–11. Stanza della Segnatura, Vatican, Rome (Alinari, 7854)

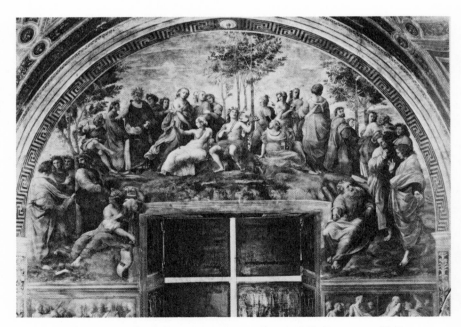

Plate 24. Raphael, *Parnassus*, 1509–11. Stanza della Segnatura, Vatican, Rome (Alinari, 7905)

At first, he praised the cultural accomplishments of Athens, and then developed the idea that through the Greek books in the papal library Athenian learning had been transferred to Rome. It was Julius' intention to make of the Stanza della Segnatura his *studiolo*.[16] Before him, Nicolas V had dreamed of creating in Rome a collection comparable to Augustus' Palatine Library. In that climate, the Vatican Library quickly came to be ranked among the best in Europe. *Studioli* and *biblioteche* treasured legacies stretching across the Mediterranean experience.

Authority lies with books (*Timaeus, Ethics*) written by men for men in the *School of Athens*. Seminal to the context of human knowledge is Pythagoras' inscription of mathematical and musical symbols on a slate (plate 25). The upper part of the diagram illustrates the harmonic ratios governing musical tones, and the lower part presents the Pythagorean theory of numbers ($1+2+3+4=10$) emphasizing multiplicity out of unity. It is the harmonic law of universal proportions that inaugurated the mathematical approach to nature, and, by extension, number symbolism and number aesthetics. The celestial *harmonia* of the spheres set the planets apart from each other according to the same relative distance as the notes of a musical scale containing the perfect consonance of the octave in its fusion of parts

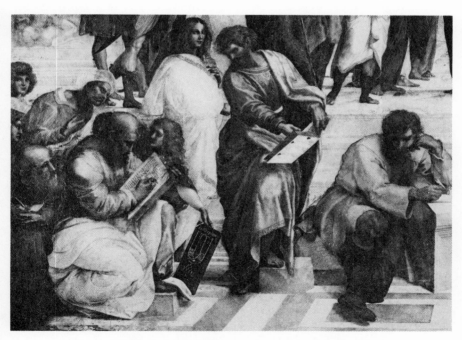

Plate 25. Raphael, *School of Athens*, 1509–11: Detail of Pythagoras. Stanza della Segnatura, Vatican, Rome (Alinari, 7899)

(3:4 and 2:3) into a whole (2:1). It ought to be remembered that the ratios of
the consonant intervals composing the octave were purely mathematical in
the Platonic "Timaeus scale." Number could therefore explain the unknown
and measure the infinite. As Leo Spitzer eloquently put it, it is to the
harmonizing thought of the Greeks, and "its power of making the world
poetic that we owe the first picture of the world seen in a harmony patterned
on music, a world resembling Apollo's lute."[17]

The very word *cosmos* originally meant order (*Gorgias*, 507e), and of a
mathematical kind. Plato warned that "if number were banished from
mankind, we could never become wise at all." Number is the "foundation"
of social order, and "the art of number" (*Epinomis*, 977d) is essential to the
existence of the arts. Furthermore, the discussion of musical harmony
makes it clear that the soul which understands music also understands the
beauty of order. The whole cosmos, in fact, is based upon numbers (*Timaeus*, 47b). For Aristotle, "music has the power of producing a certain effect
on the moral character of the soul, and if it has the power to do this, it is clear
that the young must be directed to music and must be educated by it."
Eventually, music contributes "to intellectual entertainment and culture"
(*Politics*, 8,5,9; 8,4,3–4). A link was therefore established between the
Pythagorean slate and the book on ethics Aristotle holds in his hand in the
background of the fresco. And we are reminded that the etymological
meaning of Apollo, who stands on a pedestal as a protective deity in the
School of Athens, is a combination of "together," and "turn" or "rotation" of
the spheres (*Cratylus*, 405); in other words, the symbol of universal concord.

Centuries later, Castiglione confirmed that "the world is made up of
music. . . . The heavens in their motion make harmony . . . even the human
soul was formed on the same principle" (*The Courtier*, 75). Hence, the world
order was secured to a pictorial as well as a musical frame. Such a consonance already had inspired Alberti (*De re aedificatoria*, ix, 6) and Brunelleschi to look into the musical proportions of the ancients.[18] Since
proporzioni musicali belonged to the mathematical arts (geometry, astronomy, arithmetic, music), the artist could finally claim an intellectual status
for painting, sculpture, and architecture. Alberti refers to the maxim of the
ancient painter Pamphilos, who "thought that no painter could paint well
who did not know much geometry. Our instruction in which all the perfect
absolute art of painting is explained will be easily understood by a geometrician" (*O.P.*, 90). The formula of the harmonic proportions set the standard
for human anatomy, architectural ratios, musical scales, and linear perspective.[19] The common aim was the configuration of a mathematical consonance encompassing the whole universe. One cannot but think of the poet's
verse:

Measurement began our might
(Yeats, *Under Ben Bulben*)

The Pythagorean slate in the Vatican fresco thus symbolizes the governing idea, or first principle, of ancient and modern visions of perfection. The Pythagorean proportion was exquisitely theoretical, and stood behind the Platonic idea of "just tuning"—idealized but impracticable on account of its endless complexity[20]—and what in the fifteenth century was called *musica speculativa*, which severed ideas about music from music actually performed. The analogy between sound and number offered aural access to mathematics; an epiphanic coincidence whereby the abstract could be "imitated" in the perceptual. As such, a note is not a number, nor can musical principles be identified with the laws of physics. Although it could be useful as a taxonomic instrument of analysis, mathematics is marginally relevant to musical value.[21] Yet, it remains significant that such a coincidence was detected when the cultural climate needed it. Likewise, Roman ruins had been there for centuries before Donatello and Brunelleschi found their measurements so revealing.

Plato confronted the number-sound issue when he criticized "students of harmony" who "waste their time in measuring audible concords and sounds one against another." They "prefer their ears to their intelligence." Even worse, there were some Pythagoreans who, "intent upon the numerical properties embodied in these audible consonances," do not "rise to the level of formulating problems and inquiring which numbers are inherently consonant and which are not, and for what reasons" (*Republic*, 531). The matter in question was one of expression, and what Plato wanted was not an analysis of audible music but pure number theory, above and beyond experience. Since antiquity, therefore, the Pythagorean analogy was part of a "cosmical hypothesis" whose unity of principle—in Walter Pater's words—rested with "the dominion of number everywhere, the proportion, the harmony, the music, into which number as such expands."[22] The analogical expansion of number into music was not important for its truth, but for its instrumentality. It was the discovery of a rhetorical device whereby mathematical certainty could organize, explain, and govern the whole cosmos. Intuition overshadowed observation, and if the world of sense did not fit mathematics, so much the worse for the world of sense. On Platonic grounds, mathematics would lead the prisoner out of the dark cave, and we need only mention that the concepts of theology as geometry and the Deity as a mathematician are ingrained in the tradition of the West. The rhetoric of mathematical certainty was indeed Godlike.

Wherever they saw geometric figures drawn in the sand, the Greeks were reassured that civilized men had been there, for commensurability was

essential to the very concept of humanity. In Rome, the Greek analogy became proportion (Cicero, Quintilian), which replaced the empirical with the artistic. Including sensible and spiritual objects alike, space measured relations instead of distances. By the time Renaissance culture took center stage, mathematical and geometric proportion foregrounded blueprints of eternity.

Since its inception, the Renaissance will to create patterns of order often bent truth and experience. Petrarch chartered the new path when he wrote that "it is better to will the good than to know the truth."[23] The idea of man's dignity thus reconciled Greek, Roman, and Christian views on the subject through rhetorical juxtapositions that made the best of all worlds. The rhetorical mode was predominant in philosophy and theology. For Charles Trinkaus, the so-called individualism of the Renaissance stemmed (as cause or consequence) from a "rhetorical outlook" that extended from Lorenzo Valla's essential link between philosophy and oratory to Cusanus' *sermocinalis theologia*. Both *studia humanitatis* (classical) and *conditio hominis* (Christian) pointed toward a new *theologia rhetorica* and a *philosophia moralis Christiana modo rhetorico*.[24] The Ciceronian ideal of rhetoric (*Orator*, I, 146) as the tectonic "mean" that would unify all the arts was upgraded into their modern sharing in the style of perfection. Once choice, synthesis, and evaluation came to bear on artistic consciousness, epistemology largely rested on hermeneutics, which provided method and certainty. To voice modern concerns, hermeneutic "distancing," or point of view, became itself epistemological.[25]

Synthesis in the *School of Athens* also centers on the seated figure (perhaps Boethius) who translates numbers into words, thereby transferring the diagrammatic symbol to philosophy and the arts. In the middle ground, the parallel groups headed by Pythagoras (Music, Arithmetic) and Euclid (Geometry, Astronomy) represent the *quadrivium*.[26] Such a man-measured cosmos of equivalent words and numbers is ultimately anchored to Ptolemy, who wears a crown and holds a globe. The philosophical texts (*Timaeus, Ethics*) contribute principles of moral conduct to the total harmony, which could be described through Ficino's commentary on Plato:

> At the entrance to the Academy was inscribed: "No one lacking geometry may enter here"; which, indeed, he wished to be understood as not only the due measurement of lines but the due measure of the state of mind as well.[27]

Measure therefore means measured behavior, that is to say, moderation. Likewise, *symmetria* generates beauty and goodness (*Philebus*, 64e). For Aristotle, measure was a tool; for Plato, it was a goal. Long before the humanists, he did not condone ignorance of geometry. As John Onians has

phrased it, "no one ungeometrical" could enter the Academy; neither would he have been admitted to the *School of Athens*.[28]

The contiguity of the real with the ideal (Aristotle and Plato) at the dead center of Raphael's fresco humanizes the architectural geometry. Symmetry here stands as the impeccable concord of the intellect at rest in a cosmos under its control. As a gift of the mind, knowledge engenders dialogic exchanges. In a truly Greek spirit, *paideia* has created a sharing fellowship amid philosophers and scientists who explain what they know, that is to say, the collective truth (*aletheia*) of what they have unconcealed from darkness (*lethe*). In the eloquent words of a modern whose literary "persona" sought unflawed images of antiquity, Raphael in fact shaped for us "the discovery of a vision, the 'seeing' of a perfect humanity, in a perfect world—through all his alternations of mind, by some dominant instinct, determined by the original necessities of his own nature and character, he had always set that above the 'having,' or even the 'doing,' of anything" (Walter Pater, *Marius the Epicurian*, 4, 28).

2

At the modern apex of the historical structure of the *School of Athens*, Michelangelo (in Heraclitus' guise) sits as the pensive genius whose meditations demand a withdrawl from human contacts. Right in the foreground, he leans on the marble block to write. At a threshold, the geometric space of antiquity borders on the depths of a Christian soul dressed in the rugged clothes of a sculptor.

The immediate question is: Why was Michelangelo identified with Heraclitus? Certainly, one would expect neither arbitrary nor superficial associations from Raphael. In fact, I would like to submit that attention to scanty statements of the Greek philosopher is crucial to the symbolic range of the fresco. Fragment B 50 reads: "Listening not to me but to the Logos, it is wise to say, in accordance with the Logos: all is one." Here we confront the ideal standard of unity in the harmony of that which is perfect within the complete boundaries of its own wholeness; a world view the Greeks projected into the self-contained circularity of the Globe, which Ptolemy holds up in the Vatican painting. Fragment B 16 raises the question: "How can one hide himself before that which never sets?" The spatial becomes conceptual. The One is the total knowledge of *aletheia* as it is brought out of darkness into the unconcealed and the unforgotten splendor of its oneness, which indeed captures what unfolds behind the seated figure in the *School of Athens*. Unhidden unity therefore measures the center and circumference of perfection as the classical hypostasis of Being. The modern likeness of Heraclitus, however, is given in the act of probing into the unconcealedness

of truth and creation. By so doing, Raphael has shifted perfection to Christian grounds where the unmovable Oneness of the Being of Beings has given way to the living infinity of God, whose perfection is ever unfolding.

For the Greeks, Being was perfection, which rested on completeness. Within a circular movement of self-aim, thought finally turned into self-thought, which "demonstrated" its plenitude in the *School of Athens*. By contrast, God is never called "perfect" in the Old Testament. And Martin Foss reminds us that the innermost nature of Jehovah is expressed through the Hebrew word *kabod*, meaning force, will, heart, or soul. The word "force" is a "very indistinct and imperfect expression of something which we cannot grasp with our intellect, but which as our will lives in us." An apt comment for capturing the *imitatio-aemulatio* embedded into the figure of Heraclitus-Michelangelo. The One no longer could be contained within its own sphere, for search had pierced the limit, and wholeness was on its way to becoming more a matter of perfectibility than perfection. While paying tribute to the "tested" unconcealedness of ancient knowledge, Raphael brought forward the boundlessness of Christian faith. In Martin Foss's happy phrase, religious confidence "is deeper than testing," for it points to a way where belief is more credible than reason.[29] Collective explanations (pagan) thus stood as a background to individual search (Christian). Without disturbing that vision of ultimate reconciliation, Raphael's addition of Heraclitus-Michelangelo added an image of inner depth that echoed the contemplative and yet tensive pose of the prophet Jeremiah on the Sistine ceiling. The parallel is significant, since it betrayed an unclassical restlessness that was to affect both artists shortly thereafter.

The figure of Michelangelo is pivotal also to the extent that it links the *Creation of Adam* to the *School of Athens*. One presents man's original potential for perfection, whereas the other stages the golden moment of the scientific and philosophical achievements of antiquity.

The *Disputa*, instead, begins with contemporary Christian history at the ground level. Right on the altar, the name of Julius II is inscribed on the golden cloth and on the blue frontal. The surrounding popes (Innocent III, Sixtus IV) and Church Doctors trace the growth of Christianity back in time. Above, the heavenly seats are occupied by figures of the Old and New Testament. On the left, time is pushed back to Adam himself, whose creation stands at the center of the Sistine ceiling. Michelangelo and Raphael therefore joined hands in representing the story of man from myth to history, and from drunkenness to glory. Finally, the ultimate symmetry was rounded out, and the two masters inspired posterity for ages to come. Artists, poets, and musicians mingled with philosophers, scientists, and theologians in the new Olympus of a humanity inhabiting its own utopian map.

As such, the Stanza della Segnatura marks the triumph of art well beyond the *Parnassus* fresco. Mankind in the *School of Athens* takes on the features of modern artists (Bramante, Michelangelo, Perugino, Sodoma, and Leonardo have been identified) that taught and inspired Raphael (looking toward the viewer in the lower right-hand section), who reappears to exalt Catholic faith and literary glory in the other two frescoes. The painter therefore brought together the schools of poetry, philosophy, and religion. Such a synthesis of the human experience could only occur on aesthetic grounds, and one could not find a better illustration for Eugenio Garin's contention that "the humanist moment fulfills its most important contribution in the educational activity and in the institutions that make it possible."[30]

3

As we have been told, the Genesis cycle is a majestic theme, which Michelangelo treated in a grand manner. Perhaps by a fortunate coincidence, the Renaissance drew strength from the rebirth of antiquity, and reached a new summit when it reinterpreted the Genesis myth. While Adam was new born and perfect on the Sistine ceiling, the best of classical culture was reborn in the *School of Athens*, where *concinnitas* rests on the distribution (Plato-Aristotle) and coordination (various groups) of knowledge. For the Greeks, "the noblest and greatest of harmonies may be truly said to be the greatest wisdom; and of this he is a partaker who lives according to wisdom" (Plato, *Laws*, III, 689–90). On Latin shores, the educated Roman mind

> gave to *humanitas* about the force of the Greek *paideia*; that is, what we call *eruditionem institutionemque in bonas artes*, or "education and training in the liberal arts." Those who earnestly desire and seek after these are most highly humanized. For the pursuit of that kind of knowledge, and the training given by it, have been granted to man alone of all the animals, and for that reason it is termed *humanitas*, or humanity.
> (Aulus Gellius, *The Attic Nights*, xiii, 17)

Pursuit and training came to rest in Raphael's fresco, where the architecture of ancient culture sheltered the plenitude of demonstration.

As a supreme harmonizer, Raphael linked the *School of Athens* to the *Disputa*, in which the circle of classical completeness (architectural arch) became the focus (eucharist) and perimeter (circular arrangement) of a transcendental system wherein the globe no longer was held by the philosopher, but by God himself. The circle which Euclid draws by bending down (plate 26) in the *School of Athens* underlines the earthbound thrust of a man-measured reality. By pointing toward heaven, Plato provides a counterthrust that becomes all the more symbolic if one remembers his words on the analogical construct:

Plate 26. Raphael, *School of Athens,* 1509–11: Detail of Euclid. Stanza della Segnatura, Vatican, Rome (Alinari, 7902)

What life is agreeable to God, and becoming in His followers? One only, expressed once for all in the old saying that "like agrees with like, measure with measure," but things which have no measure agree neither with themselves nor with the things which have. Now God ought to be to us the measure of all things, and not man, as men commonly say (*Protagoras*): the words are far more true of Him (*Laws*, IV, 715–18).

Marsilio Ficino commented on this passage as follows: "By these words Plato seems to confuse Protagoras, saying man is the measure of things, whose error is subtly refuted" in *Theateteus*.[31] The Platonic statement thus bridged the gap between the *School of Athens* and the *Disputa*, whose vertical composition and eucharistic theme call to mind Cusanus' words on the subject: "God is the measure of all things" (*De sapientia,* 1450). Yet, "the mind is that which limits and measures all things. Indeed, I conjecture that the mind (*mens*) is named from measuring (*mensurando*)" (*De mente*).[32] The very concept of "measure" is therefore analogical and proportional. The mind's ennobling activity reflects God in man, just as the etymological meaning of Athena is "she who has the mind of God" (Plato, *Cratylus,* 407). The School became a Church, and harmony conquered the spiritual future of the heavens.[33] Raphael's frescoes demanded that demonstration be

combined with the power to search, for the human will had to lead faith and knowledge to conquer heaven and earth.

Unquestionably, the Renaissance genius for assimilation carried a Roman stamp, which Augustus coined and the non-Roman Polybius polished. If St. Paul declared the bankruptcy of Greek wisdom, Raphael and his cohorts reintegrated it into the Mediterranean experience.[34] Before the frescoes in the Stanza della Segnatura were painted, Pico had sought a similar concordance with regard to Averroës and Avicenna, Eastern and Western thought. From the *Oration on the Dignity of Man* to *Of Being and Unity* (*De ente et uno*, 1492), central theses of his philosophy found visual illustration in the Vatican frescoes. Attention could be called to the ideal of a universal harmony among philosophers, and to attempts at reconciling classical philosophy with Christian theology.[35] In Raphael's paintings, Pico would have seen images of "that friendship which the Pythagoreans say is the end of philosophy" and "that peace which God creates in his heaven" (*Oration*, 232).

Synthesis denied any developmental open-endedness, and Pico shared with Raphael a rather atemporal approach to the past. The arts, Machiavelli sanctioned, "are so glorious that time can take from them or give them little more fame than in themselves they deserve" (*Discourses on the First Decade of Titus Livius*, Preface to Book II). After Ammianus Marcellinus set up synchretistic comparisons between earlier and later Roman history, the Christian Middle Ages saw Plato as a Christian *avant la lettre*. Abreast of that posture, Renaissance artists juxtaposed prophets and sybils (Michelangelo), the Pantheon and Constantine's basilica (Bramante's Tempietto in San Pietro in Montorio), Hebrew, Arab, and modern knowledge (Giorgione's *The Three Philosophers*, 1504–9?), *pax romana* and *pax Christi* (Julius II). Upon entering Bologna on November 11, 1507, Julius II was carried through thirteen hastily constructed triumphal arches, while his treasurer threw gold and silver coins to the people. That practice emulated ancient Roman triumphs as well as the ceremonial procession of the newly crowned pope. When he later entered Rome, a replica of the Arch of Constantine was built in front of St. Peter's. Since the first Christian emperor marked the transition from the religion of culture to the culture of religion, reproductions of his arch symbolized both traditions in Julian Rome.[36]

4

For Yeats, pagan fall and Christian ascent met in the middle of the first millennium at Byzantium:

Each age unwinds the thread another age has wound, and it amuses one to remember that before Phidias, and his westward-moving art, Persia fell, and

that when full moon came round again, amid eastward-moving thought, and brought Byzantine glory, Rome fell; and that at the outset of our westward-moving Renaissance Byzantium fell; all things dying each other's life, living each other's death.

(*A Vision*, book V: Dove or Swan)

Raphael, instead, did not fix another golden moment in the ineluctable cycle of rise and fall. His oneness of heart and mind shaped a metahistorical synthesis that transcended the recurrence of epochs "living each other's death."

Classical and Christian Humanism met at the peak of their maturity in the Stanza della Segnatura, where Raphael's "synoptic intellectual power worked in perfect identity with the pictorial imagination and a magic hand. By him large theoretic conceptions are addressed, so to speak, to the intelligence of the eye." For Walter Pater, the result fulfilled an overarching tradition: "Plato, as you know, supposed a kind of visible loveliness about ideas. Well! in Raphael, painted ideas, painted and visible philosophy, are for once as beautiful as Plato thought they must be, if one truly apprehended them."[37]

6

Homo Artifex:
The Analogue of Creativity

Every individual human being carries with him, po-
tentially and prescriptively, an ideal man, the arche-
type of a human being, and it is his life's task to be,
through all his changing manifestations, in harmony
with the unchanging unity of the ideal.

Friedrich Schiller

1

The Renaissance *naming* of utopian places (Pienza, Sforzinda) and individual talents (*sprezzatura*, *terribilità*) updated biblical links between language and the creative act through the formulaic alternation (Genesis 1:3; 1:11) of "Let there be," and "He named." Adam names things because he knows their essential nature. The pictorial analogy finds here its linguistic counterpart.

At this point, attention ought to be paid to the Christian rhetoric of religion. God creates through the word, which ties theology to logology in the archetypal act. Time and eternity, matter and spirit, diversity and unity generate theological as well as verbal implications. Kenneth Burke points out that the linguistic analogue to a unitary concept of God (the One as Unity) is "to be found in the nature of any name or title, which sums up a manifold of particulars under a single head. . . . Any such summarizing word is functionally a 'god-term.'"[1] Accordingly, *virtù* is a summarizing word which by far exceeds its numerous components. Pico deconstructed, mixed, and recombined the letters of the Hebrew *bereshit* ("in the beginning"), coming up with several words forming the expression: "The Father, in the Son, and through the Son, the beginning and end, or rest, created the head, the fire, and the foundation of the great man with a good agreement"

(*Heptaplus*, VII, Final Exposition). The organic concept thus found a rhetorical equivalent.

At a linguistic level, "god-terms" could be abstracted from physical associations, and Petrarch so phrased his disappointment with Cola di Rienzo's political failure: "The clay of any mortal creature, even of the most sacred and pure, can indeed be destroyed; but virtue fears neither death nor reproach. Virtue is invulnerable, and survives uninjured all calumny and attack."[2] *Virtù* maintained a life of its own in the realm of ideas, where "god-terms" were prone to be hypostatized as "the names." In the verses of Psalm 8, the magnificence of creation ("O Lord, our Lord, how glorious is your name over all the earth") mirrors the Lord's Name, that is to say, his Perfection. For the Renaissance *artifex*, that model was easily applicable to *virtù* and *sprezzatura*, which he enthroned at the top of the logological pyramid. At the end of his book, Castiglione refers to "that virtue which perhaps among all human things is the greatest and rarest, that is, the manner and method of right rule: which of itself alone would suffice to make men happy and to bring back once again to earth" the Golden Age (*The Courtier*, 302). The word incorporates the meaning, structure, and method of creativity at its best. Neither translation nor commentary should be attempted in the case of names whose metaphorical attributes could reconcile unity with latitude.

Even Machiavelli exploited the logological potential of language when he defined *virtù* as a composite of wisdom, self-control, justice, popularity, eloquence, and more. So endowed, the Ideal Leader would be "ordained by God" as a "redeemer" (*redentore*) for the "redemption" (*redenzione*) of Italy. Whether a Sforza, a Medici, or a Borgia, the leader was under divine protection (*The Prince*, chapter 26). Heaven itself "was striving to show its virtue when it gave us a man so surpassing, to make us partake its beauties." By implication, such a "celestial youth" of "godlike qualities" was to be "fittingly praised by a godlike man" (*A Pastoral: the Ideal Ruler*, 13,31). A common virtue brought the Adam-Artist-God triad to partake of the divine-like identity. In the epideictic mode, logology set the tone for a rhetoric thriving on secular and religious juxtapositions that Boccaccio had brought to the fore in mid-*Trecento*: "Only by the aid of poetry is it possible, within the limits of human weakness, to follow in the footsteps of the Holy Writ. For as scripture reveals the secrets of the Divine Spirit and the prophecies of things to come under the guise of figures of speech, so poetry tries to relate its lofty concepts under the veils of fictions" (*The Fates of Illustrious Men*, 3, "The Author Acquitted and Poetry Commended"). At the turn of the *Cinquecento*, Castiglione wrote that Henry (Prince of Wales) and Don Carlos (Prince of Spain) were "divine princes—*divini principi*—sent by God on earth" (*The Courtier*, 322) to unify Christendom once again.

Even the much-vexed word *renaissance* (*rinascita*) incorporates the rebirth of antiquity as well as the rebirth in Christ and the Holy Spirit; the rebirth of ancient Rome and its institutions (Petrarch, Cola di Rienzo, Nicholas V, Julius II) as well as the rebirth-reformation of the Church to its intended mission (Gioacchino da Fiore, Dante, Savonarola).[3] Through birth and rebirth, the *renovatio* of man bore on both the Augustinian renewal in the prelapsarian Adam and Machiavelli's reformation of the Italian spirit. In the visual language of Michelangelo's *Creation of Adam*, the figure of Eve (or the Virgin) prefigures the incarnation-redemption of Adam-Christ.

Pierre Guiraud would suggest that *sprezzatura* is a rhetorical figure whose etymology lies in mythic creation. Whereas *étymologie* presumes that things normally precede names (Adam names things which already exist), *ethymologia* generates a mode of literary invention by means of words which create meaning instead of representing it.[4] That distinction is analogous to the difference between learned and natural virtues. The former are a conse-quence of human actions, and, in Castiglione's words, "have regard to the future, to the end that he who has erred may err no more. . . . The contrary is noted in things that are given us by nature (and God), which we first have the power to practice and then do practice" (*The Courtier*, 297). Creation is indeed a matter of "beginning." Because they bear on a field of possible objects, *virtù* and *sprezzatura* are inspirational rather than functional: "It does not seem to me that this goodness of mind and this continence and the other virtues which you would have our Courtier teach his Prince can be learned" (*The Courtier*, 295). As cultural signposts, "god-terms" were im-mune to the usage that social intercourse forces on language. A *fantôme étymologique*, *sprezzatura* was as hypothetical as the Courtier himself. Em-phasis was placed on the subjective moment of words which took on a semantic density unknown to life. *Ethymologia* established the origin and range of its own genealogy, for its roots delved into utopian grounds where the artist presented posterity with "a new word" (*The Courtier*, 43): the ideal "Other" of language itself.

Walter Benjamin contends that "we know of no naming language other than that of man . . . in man God set language, which had served Him as medium of creation, free. God rested when he had left his creative power to itself in man." Creation begins with the "omnipotence of language," which eventually "assimilates the created, names it. Language is therefore both creative and the finished creation, it is word and name." The Adamic "naming" established the *principium* of man's contact with reality, which the word made man-bound. In terms of archetypal reciprocity, the Renaissance *artifex-author* named his world, wrote its vernacular grammar (Alberti), and generated words which were prelapsarian insofar as they contained the

immanent magic of knowledge as noun (and of action as a possibility). As a form of creativity become knowledge, *sprezzatura* would make of man a "knower in the same language in which God is creator."[5] From prototypes of ideal Others to orations on human dignity, the vocabulary of virtual perfection drew much of its power from language itself.[6] Eloquence was the Renaissance clay for molding perfection into a verbal theory of knowledge.

In antiquity, Platonic rhetoric foregrounded "the best of human things," since there is nothing "greater than the word" which persuades senators, judges, and citizens (*Gorgias*, 451–53). Furthermore, "not every man is able to give a name but only the maker of names; and this is the legislator" (*Cratylus*, 389). The classical mind believed that the combination of reason and language generates art, laws, nations, and culture itself. Because he trusted his *mots-clés* as much as geometric forms, the Renaissance writer inscribed his self-contained and hypothetical cosmos in the autonomy of the word. As a legislator, he created a norm, its object, and the pattern of order harmonizing them; as a maker of names, he brought forth an epiphanic "enselfment" that was substantially rhetorical. It was less than coincidental that the arts came to rely so heavily on geometry and mathematics, the most autonomous language that man has ever devised.

We have seen that the Greek word for truth is *aletheia*, which refers to that which is not forgotten. Truth is unconcealedness, and the word is constructed as a negative of *lethe* (forgetfulness, untruth). Hence, the positive of truth is drawn from its opposite, just as cosmos stands at the other side of chaos. Between extremes, intermediate shadings have made it possible to illuminate the concealed through symbols and allegories. On logological grounds, art can only foreshadow God's invisibility. Likewise, his original Word could not be spoken in the clarity of language, but through elusive utterances that bordered on prophetic stammering. In the nomenclature of Renaissance culture, the charismatic ambiguity of *virtù* and *sprezzatura* echoed the logological *aletheia* of the Being of Beings, whose mystery could only be intimated.[7]

The Neoplatonic vocabulary of Ficino presented logology as at once artistic and religious:

> Plato signifies the highest good itself, the one principle of things, by three terms: *the measure, the moderator, the suitable.* . . . In so far as he is called the measure, He bestows truth on all things, which is the pure and determined nature appropriate to each thing. In so far as He is the moderator, He bestows proportion, which is the concinnity and mutual harmony of all things. In so far as He is the suitable, He bestows beauty, which is the grace which is both innate in single things individually and accompanies that comeliness which comes from the mutual congruity of all things.[8]

Such a triad set the centerpiece of Renaissance art in place; the spiritual trinity was aesthetic as well. Theology, logology, and art were reciprocally analogous, and Ficino addressed Matteo Palmieri as "the theological poet."[9]

The autonomy of language reflected the independence of the human spirit, whose *humanitas* rested on freedom. And Marsilio Ficino located the perfect measure of freedom in the attainment of "the full nature of Man." Of all the virtues, "wise men named only one after man himself: that is humanity, which loves and cares for all men. . . . Therefore, most humane man, persevere in the service of humanity." Artists and writers joined forces in answering the philosopher's question: "Who cannot see . . . that the science of caring for Man must be judged the most perfect?"[10]

2

Pico calls on man to ponder, wonder, and love the beauty of creation in his panegyric. Phrases such as "supreme architect," "the Craftsman," "fashion," "the best artisan," or "maker and moulder" are intrinsically aesthetic, and bring home the idea that "naming" is analogous to "authoring." Even the *Heptaplus* ("Moses' Words to be Expounded") insists on creation through the word, which is predominant in Genesis 1. As a painter, Michelangelo needed a more visual point of reference, which was readily at hand in the tradition of the Jewish legends on the genesis of man.[11] All the creatures sprang from the word of God, who however made Adam with his hand. The plastic act forms (*yatsar*) man from the earth (Genesis 2), and *selem* also refers to a plastic material image (Genesis 1:26). Similarly, the Latin *plastes* ("maker") and *fictor* ("molder") refer to sculptural forms. Added to such ancient precedents, Boccaccio's words on the creation of Adam are an apt comment-analogue to the Sistine fresco: "Adam was of the soil of the earth, formed by the finger of God, given life by the breath of God; and made a man whole and mature" (*The Fates of Illustrious Men*, 1, "About Adam and Eve"). Like Adam, the *artifex* "named"; like God, or Godlike, he created and formed.

Homo artifex: the Renaissance artist was *divino*, and so people called Raphael and Michelangelo. As a creator of forms, man enjoyed "the gifts of immortality though still a mortal being," and he could become drunk with "the nectar of eternity" (233) in Pico's *Oration*. Ficino added that, "if anyone is endowed with philosophy, then out of his likeness to God he will be the same on earth as He who is God in heaven . . . to God he is a man, to men God."[12] The perfection of language in particular, and the "cult of letters" in general, were pursuits which entitled men to be "rightly called divine (*vero divinos iustissime dixeris*)."[13] The term "divinity," Vico would remind us,

derives "from *divinari*, to divine, which is to understand what is hidden *from* men—the future—or what is hidden *in* them—their consciousness" (*New Science*, par.342). Beyond the classical recovery of what has not been forgotten (*aletheia*), the future could be divined with certainty in the Renaissance haven of perfection.

Although the words *creare, creator, creatio* and their vernacular equivalents were not applied to Italian artists before the middle of the sixteenth century, the Renaissance *artifex* was an *alter deus*.[14] Since antiquity, creation out of nothing has been God's prerogative, whereas man could make something out of something else (Philo, Augustine, Athanasius), namely, mimesis and the craft's own materials. Spearheaded by Plotinus, Philostratus, and Longinus, the older concept of art as imitation-imagination gave way to that of expression-imagination. At the threshold of Humanism, Petrarch (*Invectiva contra medicum*), Boccaccio (*De genealogia deorum*), and Coluccio Salutati (*De fato et fortuna*) capitalized on the Ciceronian (*Pro Archia*) contention that poetry stems from a purely mental activity. Later, Cristoforo Landino wrote in his *Commentary on Dante* (1481):

> And the Greeks say "poet" from the verb "poiein," which is half-way between "creating," which is peculiar to God when out of nothing he brings forth anything into being, and "making," which applies to men when they compose with matter and form in any art. It is for this reason that, although the feigning of the poet is not entirely out of nothing, it nevertheless departs from making and comes very near to creating. And God is the supreme poet, and the world is His poem.[15]

Beyond making, the artist was a semi-Creator.

3

Edward Said has explained that, on matters of beginnings, the term *authority* implies a cluster of meanings: a power to enforce obedience, a power to influence action, a power to inspire belief, a person whose opinion is accepted. Moreover, *authority* is connected to *author*, a person who originates or gives existence to something, a begetter, beginner, father, or ancestor, a person also who sets forth written statements. Taken together, these meanings are grounded in the following notions: (1) that of the power of an individual to initiate, institute, establish—in short, to begin; (2) that this power and its product are an increase over what had been there previously; (3) that the individual wielding this power controls its issue and what is derived therefrom.[16] Such connotations are indeed akin to the Renaissance attributes of the artist-*artifex*.

Latin words often took on new meanings in the Renaissance vocabulary. For example, the word *ars* retained classical and medieval references to

skill, craft, profession, theory, treatise, and competence learned by rule and imitation. Yet, it also defined a new relationship with *ingenium*, as the innate talent that could not be learned. The two terms thus weighed on style and invention, generating powerful associations with the genius and imagination of the artist; the words were the system.[17] Alberti focused on the issue when he clarified that, "although almost all other artists were called craftsmen, the painter alone was not considered in that category. For this reason, I say among my friends that Narcissus who was changed into a flower, according to the poets, was the inventor of painting. Since painting is already the flower of every art, the story of Narcissus is most to the point. What else can you call painting but a similar embracing with art of what is presented on the surface of the water in the fountain?" (*O.P.*, 64) The metaphorical image might suggest that the object of art is the *artifex*'s own concept of it. His auto-mimesis made of reality an extension of the Ego.

If only rhetorically, Renaissance artists underlined creation *ex-nihilo* vis-à-vis the classical idea of painting as a craft imitating the figurative world. Alberti proudly declared: "We are, however, building anew an art of painting about which nothing, as I see it, has been written in this age." The Godlike implication emerged in no uncertain terms: "Painting contains within itself this virtue that any master painter who sees his works adored will feel himself considered another god" (*O.P.*, 64–65) in the solar kinship of creativity. To legitimize the new Muse of the modern Parnassus, Michelangelo linked excellence in sculpture to *difficultà*, which combined technical with conceptual talents. Philosophy, art, and language stood at a turning point, where the Platonic-classical concept of "making" met with the Hebraic-Christian notion of "creating." The artist therefore ceased a freedom commensurate with, and analogous to, that attributed to the Deity.[18]

Although in the epistolary form, a tone of panegyrical enthusiasm informs Ficino's description of the creative simile:

> The philosophic spirit imitates, and expresses exactly, the secret works of the Almighty God, making them manifest in thought, words and letters, through different instruments and materials. But I think one thing, especially, should be appreciated; not everyone can understand the principle or method by which the marvellously fashioned work of the all-skilled creator has been constructed, but only he who has the same genius for the art . . . who can deny that his mind is virtually one with the author of the heavens himself? And that in a sense he would be able to create the heavens and what is in them himself, if he could obtain the tools and the heavenly material. For he does now create them, albeit of another material, nevertheless on the same design.[19]

By Renaissance and by most standards, this is creation in an analogical mode blessed with, rather than diminished by, God's presence.

4

At the very outset of *On Painting*, Alberti regrets that "so many excellent and superior arts and sciences from our most vigorous antique past could now seem lacking and almost wholly lost" (*O.P.*, 39). The initial wording bears on superlatives ("*ottime*," "*nobilissimi e maravigliosi intelletti*") which, however, are outshined by a transcendental "*divine*" already pointing toward Raphael and Michelangelo. At the end, a "rhetorical Other" shall institutionalize theory as a paradigm of plenitude. It is not by accident that the last two words of the treatise are adjectives which qualify a vision of the art of painting as "*assoluta e perfetta*." The superlative mode of such a forthcoming epiphany upgraded the demonstrative rhetoric of praise (*Rhetorica ad Herennium*, iii,6,10) into a rhetoric of perfection whereby panegyrical enthusiasm (treatise, oration) was lodged into forms of the highest exemplarity. Later, Castiglione set out to outline a Courtier whose "supreme grace" would be free of any flaws. The ideology of excellence betrayed its rhetorical bias when the writer faced "the task of forming in words a perfect Courtier" (*The Courtier*, 7, 29, 25), much as Alberti's emphasis on the narrative *istoria* had bonded rhetoric to matters of ideological harmony.

Still on Greek grounds, it might be added, the heuristic polysemy of words was intrinsically logological. *Telos*, for example, denoted and connoted "aim," "pre-conceived end," "to make complete and perfect," and "to attain maturity," that is to say, perfection. Such attributes qualified much of the meanings of *virtù* and *sprezzatura*.[20] Modern God-terms, however, took on an emulative bent through Hebrew and Neoplatonic philosophers (Philo, Maimonides, Plotinus) who could not settle with the idea of perfection as rounded off, completed. As a result, perfection was equated with excellence as something "more than" to be compared with something else.[21] However indirectly channeled into Renaissance thought, the emulative-relational-comparative dimension of perfection was crucial to the meaning and context of *virtù* and *sprezzatura*. If only in art, Raphael and Castiglione somehow were able to reconcile perfection with order as well as with force. Later, the imperfect and relative acception of the term yielded the tautologies of mannerist dexterity (Vasari's *somma perfezione*) or the baroque perfectibility of a never-ending progress toward the infinity of the Godhead (Giordano Bruno).

Throughout this study, therefore, the standard of perfection has inspired the Renaissance birth of Adam in painting (Michelangelo) and literature (Pico della Mirandola), works of art that brought to fruition seeds embedded in the writings of Ghiberti, Bruni, and Alberti. The rhetoric of praise became an ideological imperative which took on the sacramental flavoring of cultural fulfillment in the Stanza della Segnatura, where the

Muses legitimize a world of education and refinement (Cicero, *Tusculan Disputations*, v,23,66: "*cum Musis, id est cum humanitate et cum doctrina*"); where origin is not located in caves but in the *polis*; where knowledge is not kindled in nature but in the *scuola*; where history points neither toward primitivism nor dark ages but toward the House of Fame. One cannot but agree with Ernesto Grassi that, like Heraclitus-Michelangelo in Raphael's fresco, "the man who is surrounded by fame steps into the presence of the eternally valid."[22]

As such, the standard of perfection must be eternally valid. Pivoting on the interplay between *imitatio* and *aemulatio*. Renaissance art promised eternity to the human experience, whose trust in man's perfectibility became self-fulfilling. Secured to art, that creative impulse affected the very core of the age. Petrarch unwittingly inaugurated a new mythology of excellence through a poetic wreath that honored an era wherein Adam could be "new born and perfect." The equation of birth with perfection caused the creative act to remove its models from the instability of process and the flaws of historical endeavors. Mimesis had to forge likenesses out of the nomenclature of the imperishable. Human-centered and human-oriented, the mimesis of perfection spelled the vocabulary of geometry, uttered sacraments of praise, and bestowed the epiphany of culture. Art therefore legitimized the ideology of the hypothetical, and language phrased a rhetorical *paideia* of hope.[23] From Raphael and Michelangelo to Castiglione, Renaissance *aemulatio* transformed the *alethetic* persistence of classical memory into a metahistorical synthesis whereby the Western mind came to envision forms of plenitude.[24]

If there ever existed one, the golden moment of the Renaissance measured an unprecedented revelation in the Vatican. The style of the divine-like "presenced" the rebirth of culture at the other side of the last *aemulatio*, where art fixed likenesses of the utopian stasis of perfection.

Pointing toward a resemblance of eternity, Alberti wrote that the painter, ennobled by the "divine force" of art, sets "himself up almost as a god (*quasi un iddio* in the Italian version—*quasi alterum sese inter mortales deum praestaret* in the Latin text)" and feels "himself considered another god (*quasi giudicato un altro iddio* in the Italian version—*tum deo se paene simillimos esse intelligant* in the Latin text"; *O.P.*, 63–64). At once linguistic and logological, the Albertian "almost" (*quasi*) bordered on the analogical hiatus of the God-like, where fulfillment came ever so close to bridging the gap between likeness and identity. Like Adam on the Sistine ceiling, the artist was just about to touch God's finger.

PART IV

A Modern Epilogue

7

The Legend of Geometry Fulfilled: Piero della Francesca and Piet Mondrian

I would not hesitate to state that Mondrian still is a man of the Renaissance, the herald of a new Humanism. Like Brunelleschi, he was determined to reduce the matter of color to a proportional value; his obsessive search of a new perspectival system makes us think of Paolo Uccello; and his longing for an ideal polis *brings us back to the utopian plans of* Quattrocento *architects.*

Giulio Carlo Argan

1

Inevitably, the Renaissance quest for certainty had to replace the world of experience with a man-made cosmos of rational forms. We could agree with Northrop Frye that, in such instances, "both literature and mathematics proceed from postulates, not facts; both can be applied to external reality and yet exist also in a 'pure' or self-contained form."[1] Since the earliest times, geometry has heightened stability through symbols of perfection that have become equally typical of mimetic and non-mimetic forms. As a matter of fact, the emergence of abstract art in the twentieth century has lodged the geometry of perfection in what Mondrian would call the nomenclature of absolute purity.

It would indeed be helpful at this point to be mindful of T.S. Eliot's warning: "The historical sense involves a perception not only of the pastness of the past, but of its presence."[2] Because we are interested in the historical aftermath of Renaissance promises, I would suggest that Mondrian fulfilled the most daring hopes of a past pregnant with modernity. As an artist and a critic, the Dutch master exposed the price that figuration has exacted from

the Western tradition. Without reading his statements on the subject, the relevance of the Renaissance architecture of perfection would somehow be diminished for a public whose familiarity with nonrepresentational forms has changed the way we look at all art.

Much as Europe discovered African art when Picasso began to pay attention to it, the Cubists harked back to Piero della Francesca as they turned to geometric forms. Neither Alberti nor Piero would have objected to Paul Klee's warning: "Because all the interrelations between their individual design elements are obviously calculable, works of architecture provide faster training for the stupid novice than pictures or 'nature.'"[3] Mute but present, works of art do not triumph over death by reiterating their original language, but by upgrading their pastness through the dialectic of rejection and retention.[4]

2

Unquestionably, the development of nonrepresentational painting has been crucial to modern art. In 1908, when interest in abstract art was topical among artists and critics, Wilhelm Worringer pointed out that "natural beauty is on no account to be regarded as a condition of the work of art, despite the fact that in the course of evolution it seems to have become a valuable element in the work of art . . . the specific laws of art have, in principle, nothing to do with the aesthetics of natural beauty."[5] From Platonism and Neoplatonism to nineteenth-century idealism, art has involved degrees of abstraction long before the modern departure from mimetic representation.

Whether the product of a fear of nature or of idealistic and technological views of reality, geometric denaturalization of matter neither delights in nature nor strives after vitality; instead, it bears out the atemporal stability of intellectual constructs.

Since Plato, straight lines and circles have been associated with the eternally beautiful (*Philebus*, 51/1). In a universe "created" and "harmonized" by proportion (*Timaeus*, 31–32), ideas are patterns determined by relations which have "nothing to do with the resemblances" (*Parmenides*, 132). From the Romanesque to the Renaissance, linear designs have been predominant in Italian art. Actually, Mondrian and the circle of *De Stijl*—with their trinity of Calculus, Measure, and Number—would have found less than casual affinities in fifteenth-century perspective designs of *mazzocchi* (Uccello) and squares (Laurana), the abstract marble polycromy of church façades (from the Battistero to San Miniato in Florence), and geometric patterns in courtyards. Amidst that culture, Piero della Francesca saw in "natural and accidental things . . . bodies of different forms, such as the

cube and the triangle," long before Cézanne recommended in 1904 that we depict nature by the cylinder, the sphere, and the cone.[6] Mondrian finally noted that, "as nature becomes more abstract, a relation is more clearly felt. The new painting has clearly shown this. . . . And this is why it has come to the point of expressing nothing but relations . . . natural plastic form, natural roundness, in a word, corporeality, gives us a purely materialist vision of objects, while the flat aspect of things makes them appear much more inward. The new painters have come to believe that modeling of any kind makes the picture too material."[7]

Within that trajectory, criticism has made passing references (L. Venturi, M. Praz, E. Battisti) to analogies between twentieth-century painting and Piero della Francesca, whose works epitomized the *geometrizing* style of fifteenth-century art at its purest. More than others, Bernard Berenson admired Piero's "supreme indifference toward physical beauty"; he was "not interested in human characters as living, willful, and active creatures," for whom he would have substituted "arches, pilasters, frames, and walls." His paintings illustrate "a kind of art" which, classical in nature, is "inexpressive, and not eloquent."[8] Out of profound concerns with historical continuity, Mondrian wrote that the "figurative art of today is the outcome of the figurative art of the past, and non-figurative art is the outcome of the figurative art of today. Thus the unity of art is maintained." In the process, abstraction "has become more and more accentuated until in pure plastic art . . . a neutral expression is attained . . . the fact that people generally prefer figurative art can be explained by the dominating force of the individual inclination in human nature. *From this inclination derives all the opposition to art which is purely abstract*. However purified or deformed it may be, figuration veils pure plastics."

In short, plastic art is particular, subjective, and representational, whereas pure plastic art is universal, objective, and nonrepresentational. After centuries of efforts at producing different kinds of naturalistic mimesis through illusory means, figuration has given way to nonfigurative expression.

3

At this introductory stage, a comparison between *The Discovery of the True Cross* (plate 27, part of the fresco cycle—1453–54—on the *Legend of the True Cross* in the church of San Francesco, Arezzo) and *Composition in Black and White and Red*, (1936, plate 28) ought to establish basic affinities of style. If we were to approach the fresco in nonrepresentational terms, we would notice that a geometric system of horizontals (horizon line, the waist band across the middle), verticals (trees, columns, standing figures), and diago-

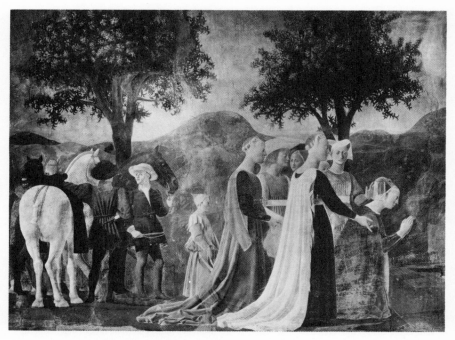

Plate 27. Piero della Francesca, *Discovery of the True Cross,* from *Legend of the True Cross,* probably 1453–54. S. Francesco, Arezzo (Alinari, 38385)

nals (outstretched arms in a progression of parallel angles) set up linear relationships comparable to the pattern of intersecting lines in the modern canvas.

Obviously short of Mondrian's mark, denaturalization of matter is operative in Piero's frescoes at Arezzo, where the linear approach controls, and minimizes, volumetric effects. In *The Discovery of the True Cross,* human bodies edge on lifelessness; the women's plucked foreheads become porcelain spheroids and the long necks conoids. Piero's studies of heads in *De prospectiva pingendi* also center on geometric measurements. In terms of qualitative correlations, the garland of leaves and roses that adorns the angel's head in the *Baptism of Christ* (1450, plate 29) is as perfectly drawn as a circle.[9] Abreast of such equivalences, tunic and bark, dove and clouds, translucent linen and water, tree and Christ's engaged leg weigh on a textural uniformity which best visualizes Ficino's statement: "The beauty of the body lies not in the shadow of matter, but in the light and grace of form; not in dark mass, but in clear proportion; not in sluggish and senseless weight, but in harmonious number and measure."[10]

To confirm abstract priorities, the pyramidal scaffolding in the *Torture of*

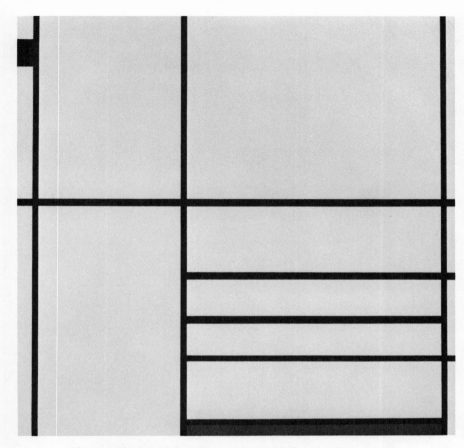

Plate 28. Piet Mondrian, *Composition in Black and White and Red*, 1936. The Museum of Modern Art, New York

Judas (plate 30) carries angularity right to the human figures. Against Alberti's predictable objections, the face of one pulling the rope is covered by another's arm; interest in the balance of triangular forms takes precedence over narrative expression. However impersonal in their geometric aloofness, Piero's figures draw the greatest dignity from their participation in the crystalline lucidity of the architectonic whole. Echoing Hellenic ideals of art, Piero—to borrow from Walter Pater—kept "passion always below that degree of intensity at which it must necessarily be transitory." He allowed "passion to play lightly over the surface of the individual form, losing thereby nothing of its central impassivity, its depth and repose."[11]

In depth, distance and light can alter the pictorial stability of the plane. In fact, "as soon as the observer changes his position," the planes "appear larger, of a different outline, or of a different colour." Whereas it "takes

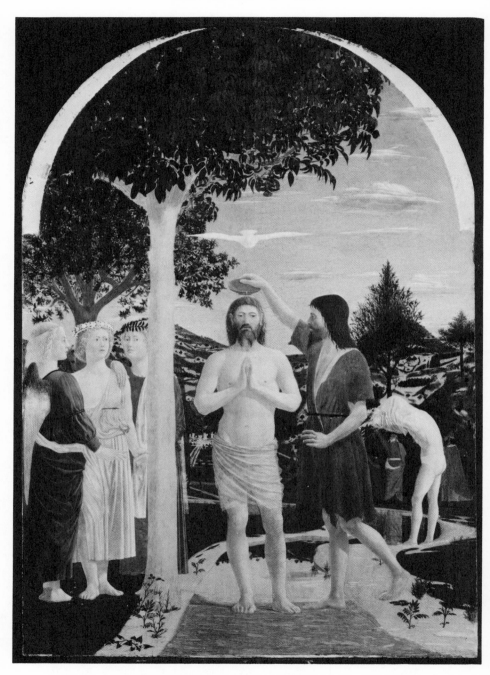

Plate 29. Piero della Francesca, *Baptism of Christ*, c. 1450. National
Gallery of Art, London

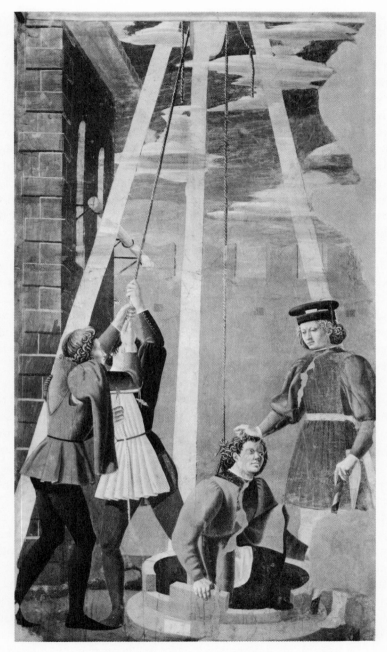

Plate 30. Piero della Francesca, *The Torture of Judas,* from *Legend of the True Cross,* probably 1453–54. S. Francesco, Arezzo (Alinari, 59328)

variations" in the "concave and spherical planes," color "remains uniform in every place" on the flat plane (Alberti, *O.P.*, 45). Light and color had to become as stable as latitude and longitude. To that end, Piero created a flawless brightness immune to atmospheric instability (already present in Masaccio's *The Tribute Money*).

In a similar attempt, Mondrian had to reject the atmospheric perspective of the Impressionists before he could dispense with external sources of light through the reduction of "natural color to primary color," and the "reduction of color to the plane." Furthermore, equidistance from the horizontal and vertical axes transformed color into a relational value. In *Composition in Black and White and Red*, the wide band of red at the bottom of the canvas is balanced by the smaller, but more intense, dot of black in the upper left. Once "color is dominated by relationships," the artwork overcomes the "tragedy" of the particular, and can express "the serene emotion of the universal."

In the Mondrianesque cosmos, diversity is absorbed into the single modality of space, where everything is constituted by relation and reciprocity. Color exists "through another color, dimension is defined through another dimension, there is no position except by opposition to *another* position . . . relation is the principal thing." Comparison (Alberti), measurement (Piero), and relation (Mondrian) were all meant to transform the object into a proportional element of the artistic whole.

Whether pictorial or architectural, perspectival constructs translate objects into relational forms. Because it stands opposite perceptual vision, the system of linear perspective undermines the plastic substance of depth, since the rhythm and symmetry of measurable quality has rid space of phenomenal ambiguities. Aware of the effects of vision in depth, Alberti was concerned with the *orlo*, the edge of things, where flatness turns into depth, and the absolute value of the plane into the impending unreliability of foreshortening. Although linear perspective produced three-dimensional effects, that very achievement exposed two-dimensional certainty (plane) to the illusion of depth effects. A number of compromises ensued. Alberti repeatedly differentiated between stable and variable elements in the pictorial composition: "The plane is that certain external part of the body which is known not by its depth but only by its length and breadth and by its quality (outline)." Since the plane incorporates a stability as absolute as "the surface of the water," the best artist can only be one "who has learned to understand the outline of the plane and its qualities" (*O.P.*, 44–45, 59). It is the surface of the object that is all important in the pictorial geometry, and Piero della Francesca applied the Albertian lesson to the frontal stratification of planes from the early *Sigismondo Malatesta Kneeling to St. Sigismund* (1451) to the mature battle scenes (*The Battle of Constantine and Maxentius* and *The*

Victory of Heraclius over Chosroes) at Arezzo, where relations of depth gave way to planimetric alternations of figurative (helmets, banners) and abstract (sky) forms.[12] Such paintings probably attracted modern artists to Piero, whose *flat* and *abstract* style was distinctive among fifteenth-century painters.

As a theorist, Piero della Francesca circumvented the threat of depth by minimizing *orli* and *volumi* in his treatise. With an eye to the three components of painting (drawing-*disegno*, measurement-*commesuratio*, coloring-*colorare*), emphasis is placed on *commesuratio*, which is limited to geometric composition. The strictly mathematical nature of *De prospectiva pingendi* confirmed a departure from the more comprehensive scope of Alberti's *On Painting*, which deals with *ricezione di lumi*, *istorie*, gestures, foreshortening, and other figurative matters.

Later, Mondrian reduced volumetric effects to planes that "create space without determining a perspectival construction of visual space . . . length and height oppose each other without foreshortening." Since reality is a combination of "form *and* space," "art has to *determine space as well as form and to create the equivalence of these two factors*." In *Composition in Black and White and Red*, unification of objects and planes has been extended "to the planes themselves." In the early *Farmhouse at Duivendrecht* (1908), space pre-existed form. Ever more convinced that the plane could suppress the predominance of matter, the series on *Windmills* (1900), *Dunes* (1910), and *Pier and Ocean* (1914–15) point to an irreversible thrust toward pure plastic art, in which the crossing of lines defines form and space simultaneously.

While perspective interlocked nature and geometry, denaturalization of matter and planimetric uniformity foregrounded the humanist cult of certainty. These similarities notwithstanding, Piero della Francesca still *dressed* lines and volumes with representational shapes. He still needed ceremonial occasions to give visual form to the world's geometry, which, as such, was no more than the compositional skeleton of the painting at a preparatory stage. Mondrian, instead, could see in that linear network the pure plastic content of the artwork in its final form, convinced as he was that "in traditional art, because of the oppression of natural forms, relations are veiled and confused." Pure plastic art neither tells a story nor presents objects, since it exists beyond the spatio-temporal coordinates of figurative events.

4

Reconciliations between three-dimensional effects and planimetric values were but an extension of analogous compromises between imitation and representation, naturalism and idealism.

In fact, the invention of the system of linear perspective was a concession

to man's new consciousness of his individual presence in reality. Better yet, it was a compromise, for it gave the illusion, but only the illusion, of depth. As such, depth was a threat, and artists quickly realized that any indiscriminate trust in the new spatial construct would lead to unsought-for naturalism. Even a quick glance at the paintings of Piero della Francesca and Paolo Uccello cannot fail to show that linear perspective is symbolic precisely because their pursuit of clarity (and certainty) kept the potential disruptiveness of foreshortening under control.

At the surface of the plane, one can know what he sees. Although "no one would deny that the painter has nothing to do with things that are not visible" (Alberti, O.P., 43), linear perspective thrived on abstractions that met with criticism as early as 1425 in a sonnet against Brunelleschi:

> You miserable beast and imbecile,
> Who thinks uncertain things can be made visible,
> There is no substance to your alchemy.
>
>
>
> But never will you, worthless nobody,
> Make that come true which is impossible.[13]

Committed as he was to naturalism, Donatello accused Uccello of trading the real for the unreal—*lasciar il certo per l'incerto*. Writing a treatise on architecture after Alberti's, Filarete denounced perspective, "for it shows you a thing that is not."[14] Yet, the new system of pictorial representation was to prevail for a long time. In our century, Gino Severini credited Alberti and Piero della Francesca with having developed the theory of perspective to its highest degree. By its own making, "art was overcome by the deceit of optical appearance," and "lost any real sense of volume." Nevertheless, he later turned to Piero and Luca Pacioli with a renewed faith in mathematical knowledge as the "synthesis of art, science, and philosophy, which alone can lead to a universal representation dependent on a unified concept of reality."[15]

For Mondrian, natural relations are dominated by a primordial tension between extremes, which he resolved into the most stable of relational combinations: the right angle. In that sense, art reproduces the essential stability of terrestrial surfaces (horizontality), the verticality of the moon in relation to them (gravity), and the star-studded pattern of a cosmic order formed by neutral points. Any alteration of that *normal distance* disrupts our deeper apperception of reality, bringing us back to the "tragedy" of foreshortening. The normal distance of pictorial composition, therefore, is that of intellectual abstractions that are intrinsically aperspectival.

At the beginning of the twentieth century, Cubism resorted to perspectival means in order to articulate a relational vision. Yet, it retained a

figurative space where objects were fragmented, but not abolished. Mondrian noted that Cubism, at its experimental apex, could only return to nature, or continue toward abstraction, where "reality can be completely determined by planes." And it was during those years that Kandinsky paid greater attention to the art of icons, for he realized that the progressive undermining of the object was pushing the composition toward the foreground.

5

As such, depth accommodates foreground and background, near and far, before and after; the conditions, that is, of human events. To that effect, Alberti correlated form and meaning: "The greatest work of a painter is not a colossus, but an *istoria*" (*O.P.*, 42). Pictorial values had to depend on story telling. Spatial foreshortening thus implied narrative foreshortening, and the common aim was to control the potential disruptiveness of temporal dynamics. Accordingly, Piero della Francesca broke the flow of events into a sequence of rational stages in the frescoes at Arezzo. In the *Baptism of Christ*, the unfolding of the action has been blocked; the stillness of water, dove, trees, and angels defies time. However, the figure undressing behind Christ suggests an act which "veils"—if ever so slightly—the transcendental stability of the scene. It was indeed difficult to bring time to a standstill without undermining the immanent vitality of events.[16]

More than anybody else, Paolo Uccello made the *istoria* subservient to geometric designs which took on a life of their own when the circular form of the *mazzocchio* became recurrent. Similarly, the narrative of his San Romano battle scenes (plate 31) broke down into clashes of linear contrasts. While geometric forms foregrounded a decorative autonomy, perspective turned into a game, and man into a manikin.[17] Narration fell outside time, where emotions were restricted to contemplative states of mind. Action was thus fixed into a code, time transformed into a value, and the development of events reconstructed into scenes which would never-happen-here-and-now. In other words, the world of history was transmuted into that of myth and fairy tales whose representational forms fell back on the "un-reality" of geometric guises.

At first, Mondrian attacked the predominant role that narration has played through the centuries. Fascinated by windmills (repeatedly painted from 1900 to 1910) early in his career, he could not help associating their geometric form with the literary concept of the cross. Falling on Brancusi's deaf ears, even the sculptor Henry Moore later recommended that we should perceive an egg as a simple solid shape, quite apart from the literary foreknowledge of what it would become (or could symbolize). To date, we consider the loss of the head of *Niké* (*The Victory of Samothrace*) regrettable.

Plate 31. Paolo Uccello, *Battle of San Romano,* c. 1445. Uffizi, Florence (Alinari, 1033)

The loss of her wings, however, would have been irreparable, pointing as they do to the sphinx, the harpies, and the angels. To be pure, art must be free of figurative as well as literary symbolisms. Unified into the single modality of geometric form and space, *Composition in Black and White and Red* did away with temporal frames and literary content.

At this point, significant differences ought to be sorted out in the hope of reaching a better understanding of modern art. The Albertian concept of painting as a window open on to the world gave way to a view of art as the reproduction of the deeper unity of artistic and natural laws. For Mondrian, pure plastic art is thus opposed to a natural representation of things, but *"it is not opposed* to nature as is generally thought. . . . It is opposed to the conventional laws created during the culture of the particular form but it is one with the laws of the culture of pure relationships." Actually, the act of *seeing through nature* set up nonrepresentational parallels between art and reality. It is indeed the business of the "moderns" to see beyond and beneath the visible world.

Renaissance compromises between geometry and figuration were contained within the pictorial frame. In *Natural Reality and Abstract Reality* (1919–20), Mondrian wrote that, "because of their form, which is usually rectangular, the canvases of naturalistic painters are indeed suitable to the rectangular form of a typical room, provided that we do not look at what is painted inside the frame! It would be preferable to turn the faces of these pictures to the wall, so as to use them merely as elements in the articulation of the wall." Abolition of the frame implied a planimetric continuity be-

tween the canvas and the geometries of walls, rooms, buildings, and urban plans. In that sense, autonomy in pure plastic art does not signal aesthetic alienation, but a rigorous uniformity of relationships extending from the pictorial to the environmental. Through the window-frame, the system of linear perspective leads the viewer into an illusory space that breaks the wall open. Conversely, the absolute planimetry of pure plastic art keeps the spectator in front of the picture-wall, as Byzantine art did in earlier times.

<div align="center">6</div>

Denaturalization of matter in the works of Piero della Francesca and Mondrian fell back on Platonic concepts of beauty. When Plotinus later concluded that "the beautiful thing is essentially symmetrical, patterned," the search of an abstract principle of beauty became heuristic inasmuch as it motivated the artist to see through and beyond. Hence, Plotinus' unanswered question: "Is there some One Principle from which all take their grace, or is there a beauty peculiar to the embodied and another to the bodiless? Finally, one or many, what would such a Principle be?" (*Enneads*, I, 6, 2).

Since antiquity, the reduction of beauty to abstract patterns made it possible for geometry to translate the abstract into the visual. During the Middle Ages, Aristotle's substantial form was transferred to aesthetics by Albert the Great, who equated beauty with the splendor of substantial form revealing itself in matter, but only when the latter has the right proportions.[18]

By the fifteenth century, Platonic traditions surfaced again in Neoplatonic commentaries, Botticelli's iconographies, and the geometric forms of Piero della Francesca. While ideas were "the Patterns of things in God" for Pico della Mirandola, Filarete insisted that "nothing can be done without number, and nothing can be done without order." In pursuit of an inclusive pattern, Luca Pacioli (whose *Divina proportione* quotes Piero's theoretical works) put forth a concept of proportionality applicable to religion, philosophy, perspective, painting, sculpture, architecture, music, and mathematics. As an illustration, the whole composition of Piero's *Baptism of Christ* is filled with geometric and religious symbols (circle, symmetries, triangular divisions and groupings) reinforcing the liturgical narrative. Ficino agreed that geometry makes possible the transformation of the visible into the invisible, and, by extension, of matter into spirit. Beauty enters matter only when arrangement, proportion, and adornment have given it an appropriate shape. At that point, the mind can be given knowledge of mathematics, which concerns number, plane figures, and whole forms.[19] The study of the *Timaeus* became central to the mathematical aesthetics, and Ficino considered Alberti's treatise on architecture an il-

lustration of the Platonic and Pythagorean method. The belief that visual clarity could be equated with moral certainty was embedded in the culture of the time.[20]

7

If successful, contextual artworks such as *Composition in Black and White and Red* would eventually build up a relational frame of mind capable of apprehending reality in a spirit of universal compatibility at once artistic and social: *"Every expression of art has its own laws which accord with the principal law of art and life*: that of equilibrium." As a principle of order, equilibrium is fundamentally ethical.

Within Mondrian's own Dutch tradition, the geometric method in the *Ethics* of Spinoza was not simply a rational way of explaining nature: "I shall consider human actions and appetites just as if I were considering lines, planes, or bodies" (*Ethics*, III, Introduction). He could not consider things *in themselves*, since any individual determination breaks contextual wholeness, and is thus unacceptable. Contextuality bears on neither origin nor derivation, but on placement; it is positional and geometric. Determined as he was to explain the principles that should govern life, ethics, and mankind, Mondrian went back to the geometric method of demonstration, which opened the way toward ultimate objectivity.

First a Calvinist, Mondrian then adhered to theosophy and Dutch idealism, an intellectual tradition of sobriety, clarity, and logic. Theosophy preserved the Platonic reliance on the symbolism of the cross and other geometric forms through the writings of Madame Blavatsky and Rudolph Steiner. Before 1920, the mathematician-philosopher M.H.J. Schoenmaekers (*The New Image of the World*, 1915; *Principles of Plastic Mathematics*, 1916) saw in Mondrian's works the visual translation of his own ideas. For a while, the painter believed that such philosophical doctrines could strengthen his Platonizing leanings.

Those formative influences aside, Mondrian quickly realized that art could determine its own laws in conditions of absolute freedom. At that point, even Plotinus' unanswered question—"Is there some One Principle from which all take their grace?"—was positively voiced in the poetics of the modern painter, who found it in the *"fixed laws which govern and point to the use of the inherent interrelationships between them.* These laws may be regarded as subsidiary laws to the *fundamental* law of equivalence which creates dynamic equilibrium and reveals the true content of reality." Hopefully, his constructive poetics would make it possible to create "a greater equilibrium between nature and spirit" as well as a "better unity with regard to the state, society, and all aspects of life." Since it was rooted in the harmonious coordination of the societal whole, Mondrian's "greater equi-

librium" updated the demonstrative proportionality of Raphael's *School of Athens* as well as the ancient *paideia* of cultural plenitude. To follow Walter Pater, the painter's better "unity" echoed the aesthetic scheme of Plato's "City of the Perfect."[21]

8

In a common effort, Piero della Francesca and Mondrian set out to humanize reality beyond impermanence. In the process, however, nature and man himself became elements of disruption; in the end, much of life was dehumanized. Whether it be pure plastic geometries or those deserted squares in which Giorgio de Chirico blended classical and surrealist realms, art thrived on the absence of man, whose vitality had been drained either by columnar-statuesque (Piero, Mantegna, Uccello) stylizations or outright mechanical assemblages (de Chirico). If the architectural spaces of the *gran metafisico* are inhabited by shadows and manikins, human presence in the cold and inhospitable spaces of fifteenth-century *architectural perspectives* (Piero's circle, Luciano Laurana) amount to no more than insignificant—and often puppet-like—silhouettes. Attracted to, and yet suspicious of, mathematical order, Yeats exposed the disquieting aim of minds lured by rational equations whereby men—as in the dots making up a line—ought to be "all exactly alike, all pushable, arrangeable . . . all intermeasurable by one another" (*On the Boiler*).

For Kandinsky, "the contact between the acute angle of a triangle and a circle has no less effect than that of God's finger touching Adam's in Michelangelo."[22] Be that as it may, such a statement ran against the Renaissance belief that art could not be severed from representation. The link between beauty and the mimesis of reality finally unraveled. By the same token, ideals of maturity shifted toward a cosmos of geometric forms man could trust more than anthropomorphic images. For Mondrian and Kandinsky, figurative compromises could only fall short of artistic purity.

9

José Ortega y Gasset has praised Velázquez' baroque understanding of the material reality of the object, in relation to which "the precision of a thing is its legend. The most legendary thing man has invented is geometry."[23] Yet, the legend of geometry has inspired art from the earliest times to the utopian visions of Plato, Alberti, and Piero della Francesca.

Invested with the humanist heritage, Gino Severini rejected the modern indifference toward subject matter, by which he meant human figures. Drawing from his statement, Jacques Maritain wrote that "quitting the realm of the human" is too much to ask. Nonrepresentational painting "breaks away from Nature as an existential whole, turns away from Things

and the grasping of Things."[24] Mondrian, however, turned away from "plastic" experiences of Nature, and put his ultimate trust in transcending the world of things: "Art is only a 'substitute' as long as the beauty of life is deficient. It will disappear in proportion as life gains in equilibrium." At that point, metaphorical windows no longer would be needed. The easel painting in the studio-room "will disappear as soon as we can transfer its plastic beauty to the space around us through the organization of the room into color areas." As a result, "the culture of relationships will lead to the universal relationship, which will also abolish every form completely. . . . We will live in realized art." At least in the hypothetical realm of mental constructs, classical achievements and Renaissance syntheses could join forces at a juncture where reality and utopia no longer could be set apart.

Fulfilled in *Composition in Black and White and Red*, the legend of geometry would eventually bestow on life a comprehensive—and indeed ideal—system of harmonious relationships free of art itself. At last, perfection could be measured in the midst of man's living experience of his dream of dreams.

Notes

Introduction:
Within Eternity's Reach

1. Frederick Hartt, *Michelangelo* (New York, 1965), 102.
2. From his *Commentary on the Symposium*, as translated in Erwin Panofsky's *Idea: A Concept in Art Theory* (New York, 1968), 137, 139; and from *The Letters of Marsilio Ficino*, vol.3 (London, 1975–78), 30.
3. *The Book of the Courtier*, tr. C. Singleton (New York, 1959), 342. References are to this edition (*The Courtier*), with page number indicated in the text. See André Chastel, *Marsile Ficin et l'Art* (Geneva, 1967), 57.
4. See David Summers, *Michelangelo and the Language of Art* (Princeton, N.J., 1981), 10.
5. See Eugenio Garin, *La cultura del Rinascimento* (Bari, 1967), 5–10.
6. André Chastel, *The Myth of the Renaissance, 1420–1520* (Geneva, 1969), 216.
7. *The Archaeology of the Frivolous* (Pittsburgh, 1980), 8. See also M.H. Abrams, *The Mirror and the Lamp* (New York, 1971), 31.
8. See A. Campana, "The Origin of the Word Humanist," in *Journal of the Warburg and Courtauld Institutes* 9 (1946), 60–73; G. Billanovich, "Auctorista, humanista, orator" in *Rivista di cultura classica e medievale* 7 (1965), 143–63; Michael Baxandall, *Giotto and the Orators: Humanist Observers of Painting in Italy and the Discovery of Pictorial Composition, 1350–1450* (Oxford, 1971), 1–3; Konrad Burdach, *Reformation, Renaissance, Humanismus* (Berlin, 1926), 91–92.
9. On this subject, see Erwin Panofsky, *Meaning in the Visual Arts* (New York, 1955), and *Studies in Iconology* (New York, 1972).
10. Paul Valéry, *Moi* (Princeton, N.J., 1975), 32.
11. *The Graeco-Roman Tradition* (New York, 1973), 1–2. It is beyond the scope of this study to sort out Roman from Greek influences in the case of either Florentine or Roman Humanism. Such a topic certainly deserves an independent research.
12. *Painting and Experience in Fifteenth-Century Italy: A Primer in the Social History of Pictorial Style* (Oxford, 1972), in the Preface.
13. *The Philosophy of History* (London, 1852), ix.

1. Michelangelo's *Creation of Adam*
and the Analogy of Perfection

1. *On Painting*, tr. John Spencer (New Haven, 1976), 98. References are to this edition (*O.P.*), with page number indicated in the text. For a critical edition of Alberti's works, see *Opere volgari*, a cura di Cecil Grayson (Bari, 1960–66–73).
2. Reference in John Pope-Hennessy, *Italian High Renaissance and Baroque Sculpture* (London, 1963), 61. On the subject, see E.H. Gombrich, "A Classical Topos in the Introduction to Alberti's *Della Pittura*," in *Journal of the Warburg and Courtauld Institutes* 20 (1957), 173; and Mary D. Garrard, "The Liberal Arts and Michelangelo's First Project for the Tomb of Julius II (with a Coda on Raphael's 'School of Athens')," in *Viator* 15 (1984), 335–76.

3. Mikhail Bakhtin, *The Dialogic Imagination* (Austin, Texas, 1981), 17, points out that "it would be impossible to change, to re-think, to re-evaluate anything" in the epic world.

4. See Charles Hauret, *Beginnings. Genesis and Modern Science* (Dubuque, Iowa, 1964), 56; James Anderson, *Reflections on the Analogy of Being* (The Hague,1967), 5.

5. *Oration on the Dignity of Man*, in *The Renaissance Philosophy of Man*, ed. E. Cassirer, P.O. Kristeller, and J.H. Randall (Chicago, 1967), 223. References to Pico's text (*Oration*) are to this edition, with page number indicated in the text.

6. *A Platonick Discourse upon Love*, ed. E.G. Gardner (Boston, 1914), 26.

7. See Charles Trinkaus, *The Scope of Renaissance Humanism* (Ann Arbor, Mich., 1983), 345.

8. *The Letters of Marsilio Ficino*, vol.1, 114.

9. *The Birth of Tragedy* and *The Case of Wagner*, tr. W. Kaufman (New York, 1967), 109.

2. The Geometry of Perfection:
L.B. Alberti and the Treatise as a Symbolic Form

1. On the subject, see G.N.G. Orsini, *Organic Unity in Ancient and Later Poetics* (Carbondale, Ill., 1975), 26; Laszlo Versenyi, *Socratic Humanism* (New Haven, Conn., 1963), 11–12; John M. Warbeke, *The Searching Mind of Greece* (New York, 1934), 117–18.

2. Mario Untersteiner, *The Sophists* (New York, 1954), 87–88, speaks of "uncontrolled epistemological individualism."

3. Charles Trinkaus, "Humanism and Sophism," in his *The Scope of Renaissance Humanism*, 173–74. For possible connections (direct or via Cicero) between the humanists and the sophists, see Werner Jaeger, *Paideia. The Ideals of Greek Culture*, vol.1 (New York, 1945); P.O. Kristeller, *Renaissance Thought: The Classic, Scholastic and Humanist Strains* (New York, 1961); J.E. Siegel, *Rhetoric and Philosophy in Renaissance Humanism* (Princeton, N.J., 1968).

4. *Literature as System* (Princeton, N.J., 1971), 285. Although ocular metaphors have substantially declined in modern times, Richard Rorty, *Philosophy and the Mirror of Nature* (Princeton, N.J., 1979), 13, concedes that they have articulated "the story of the domination of the mind."

5. *I Commentarii*, in *Lorenzo Ghibertis Denkwurdigkeiten*, vol.1, ed. J. Von Schlosser (Berlin, 1912), 55; *The Analogy of Names and the Concept of Being* (Pittsburgh, 1953), 25.

6. See Carlo Ragghianti, *Filippo Brunelleschi. Un uomo. Un universo* (Florence, 1977), 183; Samuel Edgerton, *The Renaissance Rediscovery of Linear Perspective* (New York, 1975), 24. On the symbolism of linear perspective and the theory of human proportions, see Erwin Panofsky, *Meaning in the Visual Arts*, 56; and his "Die Perspektive als 'symbolische Form,'" in *Vorträge der Bibliothek Warburg* 4 (1924–25), 258–330.

7. Antonio Manetti, *The Life of Brunelleschi* (University Park, Pa., 1970), 44.

8. The poem is included in *Brunelleschi in Perspective*, ed. I. Hyman (Englewood Cliffs, N.J., 1974), 33.

9. *The Life of Brunelleschi*, 52–54.

10. *De prospectiva pingendi*, a cura di Nicco Fasola (Florence, 1942), 128. Translation by the author.

11. Erwin Panofsky, *The Codex Huygens and Leonardo da Vinci's Art Theory* (London, 1940), 160.

12. Joan Gadol, *Leon Battista Alberti: Universal Man of the Renaissance* (Chicago, 1971), 28, states that Alberti, as a painter, was not concerned "with questions of what an object, or what reality, is in itself. He was bound to reality qua appearance or

phenomenon, and here he proceeded with the momentous assumption that appearances conform to the rules of simple, plane geometry. Visual phenomena, be they objects to be painted or the visual rays by which they are seen, are all treated in *Della pittura* as sensible instances of mathematical ideas." In terms of the philosophical problem subject-object, Ernst Cassirer, in *The Individual and the Cosmos in Renaissance Philosophy* (Philadelphia, 1972), 141, concludes that an equilibrium between the two "was attained neither by supernaturalistic metaphysics nor by the scientific and artistic observation of nature."

13. Ancient statuary provided ample illustrations for such a notion. See Charles De Tolnay, "Michelangelo a Firenze" in *Atti del Convegno di Studi Michelangioleschi* (Rome, 1966), 9; Paolo Portoghesi, "Michelangelo e l'eredità classica," in ibid., 346.

14. *Ten Books on Architecture* (*De re aedificatoria*, 1452), tr. J. Leoni (London, 1731), book x, ch.5, 240. On the concept of organic unity, see G.N.G. Orsini, *Organic Unity in Ancient and Later Poetics*.

15. Pico della Mirandola, *A Platonick Discourse upon Love*, 26.

16. *The Writings of Albrecht Dürer*, tr. W.M. Conway (New York, 1958), 166, 179.

17. In his essay on Dürer and antiquity, *Meaning in the Visual Arts*, 266, Panofsky adds: "Thus the style of classical antiquity might be characterized as 'naturalistic idealism.' Without this qualification the concept of 'idealism' would characterize not only the 'classical' style which, by 'ennobling' what Goethe calls 'common nature,' hopes to do justice to nature as such, but also such styles as do not attempt to do justice to nature at all."

18. *On the Family*, translated by Renée Watkins as *The Family in Renaissance Florence* (Columbia, S.C., 1969), 191, 60–61. References are to this edition (*O.F.*), with page number indicated in the text.

19. As translated by B.G. Kohl and R.G. Witt, in *The Earthly Republic* (Philadelphia, 1978), 144–45.

20. "Her land has the same position in Hellas that her city has in the land; it lies in the center of a center, inclining toward the sea. . . . A third center, in succession to those rises like a tower from the middle of the city; it is the ancient Polis, now the Acropolis . . . as in the case of a shield where circles fall within circles, there is a fifth, fairest of all, which constitutes the central boss, if indeed Hellas lies in the middle of the whole earth." A propitious harmony is thus established between natural and human artifacts: "On all sides there is a variety in the Cyclades and Sporades which lie off the coast around Attica as if the sea had deliberately placed them at the city's disposal to be her suburbs. They always seem to form a constellation and their own beauty and perfection of pattern have turned out to be the city's beauty and perfection of pattern," as translated by J.H. Oliver in *The Civilizing Power* (Philadelphia, 1968), 46–47.

21. Bruni, *Panegyric to the City of Florence*, in *The Earthly Republic*, 139.

22. Bruni, ibid., 141, 169.

23. See G.C. Argan, *The Renaissance City* (New York, 1969), 23–24, and his *Storia dell'arte come storia della città* (Rome, 1983), 104, 114–15.

24. Giannozzo Manetti, *De hominis excellentia et dignitate*, in *Filosofi italiani del Quattrocento*, ed. E. Garin (Florence, 1942), 238. Translation by the author.

25. Erwin Panofsky, *Idea: A Concept in Art Theory*, 50.

26. Ernst Cassirer, *The Individual and the Cosmos in Renaissance Philosophy*, 152–53. Joan Gadol, *Leon Battista Alberti: Universal Man of the Early Renaissance*, 22, generalizes as follows: "Painters' perspective opened not merely a new phase in the practice and theory of the visual arts but a new age in which reality came to be viewed and understood in mathematical terms."

27. *Filarete's Treatise on Architecture*, vol.1, tr. John Spencer (New Haven, 1965), 305.

28. As translated by Panofsky in "*Nebulae in Pariete*: Notes on Erasmus' Eulogy of

Dürer," in *Journal of the Warburg and Courtauld Institutes* 14 (1951), 40. See also Ruth W. Kennedy, "Apelles Redivivus," in *Essays in Memory of Karl Lehmann*, ed. L.R. Sandler (New York, 1964), 160–70.

29. *A Discourse on Remodeling the Government of Florence*, in *Machiavelli: The Chief Works and Others*, tr. Allan Gilbert, vol.1 (Durham, N.C., 1965), 113–14.

30. B.A. Van Groningen, *In the Grip of the Past* (Leiden, 1953), 49–50.

31. See Francis W. Kent, *Household and Lineage in Renaissance Florence* (Princeton, N.J., 1977), 286.

32. *Missive*, reg.19, cc61v-62r, quoted from Daniela De Rosa, *Coluccio Salutati: Il cancelliere e il pensiero politico* (Florence, 1980), 32–33. Translation by the author.

33. Iris Origo, *The Merchant of Prato* (London, 1967), 13.

34. *De vita solitaria*, in *Francesco Petrarca: Prose* (Milan, 1955), 132. Translation by the author.

35. David Marsh, *The Quattrocento Dialogue: Classical Tradition and Humanist Innovation* (Cambridge, 1980), 98.

36. See Lauro Martines, *Power and Imagination: City-States in Renaissance Italy* (New York, 1979).

37. Delio Cantimori, "Rhetoric and Politics in Italian Humanism," in *Journal of the Warburg and Courtauld Institutes* 1 (1937–38), 85–86.

38. Erwin Panofsky, "Die Perspektive als 'simbolische Form,'" 260. Already in 1915, Heinrich Wölfflin had noted that "the principle of closed form of itself presumes the conception of the picture as a unity. Only when the sum of the forms is felt as one whole can this whole be thought as ordered by law, and it is then indifferent whether a tectonic middle is worked out or a free order reigns," in his *Principles of Art History* (New York, 1950), 155.

39. Leonardo Bruni, *Panegyric to the City of Florence*, 137. Pauline Moffitt Watts, in *Nicolas Copernicus. A Fifteenth-Century Vision of Man* (Leiden, 1982), 144, quotes Cusanus, who wrote that the mind "measures all things . . . symbolically, by the method of comparison" (*De mente*).

40. Michel Stassinopoulos, "Devoirs civiques et éthiques dans la Cité antique," in *The Living Heritage of Greek Antiquity* (The Hague, 1967), 147.

41. Typical of humanist ideology, a similar attitude is expressed by Poggio Bracciolini in *On Avarice*, in *The Earthly Republic*, 251–52.

42. See Bruni's *Praemissio quaedam ad evidentiam novae translationis Politicorum Aristotelis*, in *Filosofi italiani del Quattrocento*, 116–18. Bruni's *Cicero Novus*, Hans Baron writes, taught that the "primary task of man is service for the community; and exposure of the spirit to action stimulates his highest energy," in *Cicero and the Roman Civic Spirit in the Middle Ages and the Early Renaissance* (Manchester, 1938), 22.

43. Mikhail Bakhtin, *Problems of Dostoevsky's Poetics* (Minneapolis, 1984), 110–11, 279–80, 284.

44. *The Birth of Tragedy* and *The Case of Wagner*, 95–96, 98, 109.

45. See Lewis Mumford, "Utopia, the City and the Machine," in *Daedalus* 94 (1965), 275.

46. From *Epistole familiari e senili*, in *Il pensiero pedagogico dell'Umanesimo* ed. E. Garin (Florence, 1958), 40. Translation by the author.

47. In *Letters from Petrarch*, tr. M. Bishop (Bloomington, Ind., 1966), 198, 68.

48. Antonio Manetti, *The Life of Brunelleschi*, 42, wrote: "He propounded and realized what painters today call perspective, since it forms part of that science which, in effect, consists of setting down properly and rationally the reductions and enlargements of near and distant objects as perceived by the eye of man: buildings, plains, mountains, places of every sort and location, with figures and objects in correct proportion to the distance in which they are shown. He originated the rule that is essential to whatever has been accomplished since his time in that area. We do

not know whether centuries ago the ancient painters—who in that period of fine sculptors are believed to have been good masters—knew about perspective or employed it rationally. If indeed they employed it by rule (I did not previously call it a science without reason) as he did later, whoever could have imparted it to him had been dead for centuries and no written records about it have been discovered, or if they have been, have not been comprehended. Through industry and intelligence he either rediscovered or invented it."

49. See Joan Gadol, *Leon Battista Alberti. Universal Man of the Early Renaissance*, 120–21; see also G.N.G. Orsini, *Organic Unity in Ancient and Later Poetics*, 20–21; Manfredo Tafuri, *Teoria e storia dell'architettura* (Bari, 1968), 27; Franco Borsi, *Leon Battista Alberti* (Milan, 1975), 80–81; E. Baldwin Smith, *Architectural Symbolism of Imperial Rome and the Middle Ages* (Princeton, N.J., 1956).

50. *Letters from Petrarch*, 302.

51. See E.H. Gombrich, "The Renaissance Conception of Artistic Progress and Its Consequences," in *Norm and Form* (London, 1971), T.S. Eliot, "Tradition and Individual Talent" in *The Sacred Wood* (London, 1960).

52. *Liber de vita Christi ac omnium pontificum* (1479), in *Prosatori latini del Quattrocento* a cura di Eugenio Garin (Milan, 1964), 696.

53. In *Opere volgari*, vol.3, 193, 177. Translation by the author. Franco Borsi, *Leon Battista Alberti*, 12, notes that the evolution of Alberti's conception of the vernacular extended from a "functional justification to a structural conviction in its validity."

54. Giacomo Devoto, *Profilo di storia linguistica italiana* (Florence, 1964), 77.

55. *De iciarchia*, in *Opere volgari*, vol.2, 265, as translated by David Marsh, in *The Quattrocento Dialogue: Classical Tradition and Humanist Innovation*, 90.

56. Raffaele Spongano, *Un capitolo di storia della nostra prosa d'arte* (Florence, 1941), 10; Creighton Gilbert, "Antique Frameworks for Renaissance Art Theory: Alberti and Pino," in *Marsyas* 3 (1943–45), 93.

57. See Michael Baxandall, *Painting and Experience in Fifteenth-Century Italy*, 56; *Giotto and the Orators*, 26, 130; John Spencer, "Ut Rhetorica Pictura. A Study in Quattrocento Theory of Painting," in *Journal of the Warburg and Courtauld Institutes* 20 (1957), 33; David Summers, "Contrapposto: Style and Meaning in Renaissance Art," in *Art Bulletin* 59 (1977), 344–45.

58. See Luigi Coletti, *La Camera degli Sposi del Mantegna a Mantova* (Milan, 1959), 19; Michael Levey, *Painting at Court* (New York, 1971), 76; Giovanni Paccagnini, *Il Palazzo Ducale di Mantova* (Turin, 1969), 66.

59. *The Question Concerning Technology and Other Essays*, tr. William Lovitt (New York, 1977), 128–33.

60. Panofsky, "Die Perspektive als 'symbolische Form'," 287; G.C. Argan, "Origins of Perspective Theory in the Fifteenth Century," in *Journal of the Warburg and Courtauld Institutes* 9 (1946), 100.

61. "Giovanni Pico della Mirandola. Part II," in *Journal of the History of Ideas* 3 (1942), 320. In Cusanus' words, "when indeed the human mind, the high likeness of God, participates as it is able in the fecundity of the creative nature, it puts forth from itself as the image of the omnipotent form rational entities in the likeness of real beings." See Charles Trinkaus's discussion of this passage in *The Scope of Renaissance Humanism*, 177.

62. In his study of Machiavelli's *virtù*, Joseph Mazzeo considers such a quality as "mystic, poetic and indefinite," in "Machiavelli: the Artist as a Statesman," in *University of Toronto Quarterly* 31 (1962), 274. In her translation of Alberti's *Della famiglia*, Renée Watkins states: "Virtue (*virtù*) is a key word for Alberti as for Machiavelli, but with a different meaning. It is consistently linked in *Della famiglia* to an ideal of ethical unity among men, service from each to all. Though Alberti certainly meant his *virtù* to correspond to the Greek *arete* and the Latin *virtus*, it is loose and more pragmatic than the connotation of those words in Plato and Cicero"

(18). With regard to the more general context of the fifteenth century, George Holmes, *The Florentine Enlightenment* (New York, 1969), 143, writes that "the concept of *virtù* presents difficulties for the modern reader because it is a concept transferred in a semimetaphorical manner from the sphere of individual behavior, an example of the microcosm/macrocosm style of thought which came easily to Renaissance minds but is apt to seem to us as unjustifiable personification. It is perhaps impossible to define it more closely than by saying that it refers to the moral health of a society." See also Laszlo Versenyi, *Socratic Humanism*, 83.

63. See James Anderson, *The Bond of Being: An Essay on Analogy and Existence*, 322–23; Martin Foss, *Symbol and Metaphor in Human Experience* (Princeton, 1949), 56.

64. Harold Bloom, *The Breaking of the Vessels* (Chicago, 1982), 13.

65. See G.E.R. Lloyd, *Polarity and Analogy* (Cambridge, Mass., 1966), especially the Conclusion, 421–40; J.A. Stewart, *The Myths of Plato* (Fontwell, 1960), 213.

66. See Carroll W. Westfall, "Painting and the Liberal Arts," in *Journal of the History of Ideas* 30 (1969), 492–93; L.H. Heydenreich and W. Lotz, *Architecture in Italy 1400–1600* (Harmondsworth, 1974), 38. In "Alberti and Vitruvius," in his *Studies in Early Christian, Medieval, and Renaissance Art* (New York, 1969), 327, Richard Krautheimer writes that "where Vitruvius composes a manual for the practicing architect . . . Alberti sets down a program."

67. Marsilio Ficino, *Platonic Theology* (3, 2), as translated by J.L. Burroughs, in *Journal of the History of Ideas* 5 (1944), 227–39.

68. From Walter Pater's comments on Pico della Mirandola's philosophy, in *The Renaissance* (London, 1912), 47.

3. In Adam's Likeness:
Creation as a Constant Sacrament of Praise

1. In *Filosofi italiani del Quattrocento*, 231. Translation by the author.

2. Thomas Greene, "The Flexibility of the Self in Renaissance Literature," in *The Disciplines of Criticism* ed. P. Demetz, T. Greene, L. Nelson Jr. (New Haven, 1968), 243.

3. See A. Marmorstein, *The Old Rabbinic Doctrine of God. Essays in Anthropomorphism* (London, 1937), 22; Robin Scroggs, *The Last Adam: A Study in Pauline Anthropology* (Philadelphia, 1966), 4; Gershom Scholem, *On the Kabbalah and Its Symbolism* (New York, 1978), 112–14.

4. Rudolph Bultmann, *Primitive Christianity in Its Contemporary Setting* (New York, 1972), 107, writes: "The city was not a product of human ingenuity or a social contract. It had been there before the individual and was higher than he. Its constitution was not the result of a balancing out of conflicting claims on the part of its members. Rather, it was of divine origin."

5. Joan Gadol, *Leon Battista Alberti: Universal Man of the Early Renaissance*, 90.

6. *The Analogy of Names and the Concept of Being*, 10–11. David Burrell, *Analogy and Philosophical Language* (New Haven, 1973), 9, notes: "The most common picture we have of the structure of analogous predication is the mathematical proportion, a:b:c:d. It was suggested by Aristotle (for the term he adopted, 'analogous,' means 'proportional'), often used as an illustration by Aquinas, and erected into a quite canonical form by Aquinas's voluminous commentator, Cajetan." See also James Anderson, *Reflections on the Analogy of Being*, 1.

7. "The Flexibility of the Self in Renaissance Literature," 243.

8. For Bakhtin, *The Dialogic Imagination*, 388, the testing of a novelistic character represents the "most fundamental organizing idea in the novel." Within novelistic boundaries, the trials of existence transforms man in ways that are unpredictable, at

least in light of classical standards foreign to *seeking* and *finding* any 'otherness' "; see also Georg Lukács, *The Theory of the Novel* (Cambridge, 1971), 30.

9. Erwin Panofsky, "Artist, Scientist, Genius: Notes on the 'Renaissance-Dammerung,' " in *The Renaissance: Six Essays*, ed. Wallace K. Ferguson et al. (New York, 1964), 128. Moreover, the Middle Ages "accepted and developed rather than studied and restored the heritage of the past," in Panofsky's "The History of Art as a Humanistic Discipline" in *The Meaning of the Humanities*, ed. T.M. Greene (Princeton, 1938), 94. And E.R. Curtius: "In our view paganism and Christianity are two separate realms, for which there is no common denominator. The Middle Ages thinks differently. 'Veteres' is applied to both the Christian and pagan authors of the past," in *European Literature and the Latin Middle Ages* (New York, 1963), 254.

10. *The Life and Art of Albrecht Dürer* (Princeton, 1955), 261. In *Early Netherlandish Painting*, vol.1 (Cambridge, 1966), 16, Panofsky writes that in Gothic art figures do not look "or act 'out of the picture' in order to invite the participation of the beholder, whereas Leon Battista Alberti admires and recommends precisely this. The action, too, unfolds in a direction parallel to the representational plane, passing across our field of vision rather than advancing or receding within it."

11. See Vito R. Giustiniani, "Umanesimo: la parola e la cosa," in *Studia Humanitatis: Ernesto Grassi*, ed. E. Hora and E. Kessler (Munich, 1973), 25.

12. *The Coronation Oration*, in E.H. Wilkins, *Studies in the Life and Works of Petrarch* (Cambridge, 1955), 303–7.

13. See *Filarete's Treatise on Architecture*, vol.1, 306; Frederick Hartt, *Donatello: Prophet of Modern Vision* (New York, 1972), 323; Rudolph Wittkower, *Architectural Principles in the Age of Humanism* (New York, 1971), 34–39.

14. Erwin Panofsky uses the term "pseudomorphosis," in *Studies in Iconology* (New York, 1962), 71.

15. *Letters from Petrarch*, 202–3.

16. *Oratio super Fabio Quintiliano et Sylvis*, in *Prosatori latini del Quattrocento*, 804.

17. From Valla's letters, in E.E. Emerton's *Humanism and Tyranny* (Cambridge, 1925), 292.

18. Petrarch, *Letters from Petrarch*, 301–2.

19. *Theogenius*, in *Opere volgari*, vol.2, 74. Translation by the author.

20. *The Letters of Machiavelli*, tr. A. Gilbert (New York, 1961), 142.

21. Emanuel Winternitz, "Quattrocento Science in the Gubbio Study," in *The Metropolitan Museum of Art Bulletin* 1 (1942), 104. On Federigo's *studiolo* at Urbino, see Arnaldo Bruschi, *Bramante architetto* (Bari, 1969), 75–88. See also André Chastel, *The Myth of the Renaissance, 1420–1520*, 167; E.R. Curtius, *European Literature and the Latin Middle Ages*, 178; O.B. Hardison, "The Orator and the Poet: the Dilemma of Humanist Literature" in *The Journal of Medieval and Renaissance Studies* 1 (1971), 44.

22. On the subject of pictorial perspectives, see Kenneth Clark, "Architectural Backgrounds in Fifteenth-Century Italian Painting," in *The Arts* 1 (1946–47), 13; Giulio Carlo Argan, *Storia dell'arte come storia della città*, 122, 248.

23. Frances Yates, *The Art of Memory* (London, 1966), xi, 3. See also, Hugh Kenner, *The Pound Era* (Berkeley, 1971); Gaston Bachelard, *The Poetics of Space* (Boston, 1969).

24. See Manfredo Tafuri, *L'architettura dell'Umanesimo* (Bari, 1969), 54–55; Carroll W. Westfall, "Society, Beauty, and the Humanist Architect in Alberti's *De re aedificatoria*," in *Studies in the Renaissance* 16 (1971), 44; Richard Krautheimer, "The Tragic and Comic Scene of the Renaissance," in his *Studies in Early Christian, Medieval, and Renaissance Art*, 355–56.

25. *Letters from Petrarch*, 32, 36. Often, such a simultaneity stimulated imaginative reconstructions that overwhelmed historical accuracy. Petrarch's description of the city in the *Africa* "is much too magnificent for Republican Rome, encompassing

many buildings of the Imperial age," in Angelo Mazzocco's "The Antiquarianism of Francesco Petrarca," in *The Journal of Medieval and Renaissance Studies* 7 (1977), 208.

26. *Letters from Petrarch*, 89. See Ernst H.W. Wilkins, *Life of Petrarch* (Chicago,1961), 28. John O'Malley, *Praise and Blame in Renaissance Rome* (Durham, N.C., 1979), 242–43, writes at the end of his study: "Rome was not a commercial or industrial city. It was a city whose chief assets were the memories and monuments of its past and the hopes that account for the revival of Rome in the Renaissance and that contributed to the mystique that sustained it once revived. Rome was exemplary center, font of ancient culture, special depository of the apostolic message, see of blessed Peter. Its mystique was at the very heart of its reality."

27. And what Henry James saw was a place with a "heavily charged historic consciousness," in *Italian Hours* (Boston, 1909), 367.

28. Hugh Kenner, *The Pound Era*, 31; Francis W. Kent, *Household and Lineage in Renaissance Florence*, 285–88.

29. Richard Krautheimer, "Alberti's Templum Etruscum," in his *Studies in Early Christian, Medieval, and Renaissance Art*, 337; André Chastel, "The Arts during the Renaissance" in *The Renaissance: Essays in Interpretation*, ed. André Chastel and Cecil Grayson (London, 1982), 231; Thomas Greene, "Resurrecting Rome: the Double Task of the Humanist Imagination," in *Rome in the Renaissance: The City and the Myth*, ed. P.A. Ramsay (Binghamton, N.Y., 1982), 41–52.

30. *The Autobiographies of Edward Gibbon* (London, 1896), 267, 284, 302.

31. *Wisdom and Experience* (New York, 1949), 238.

32. Michael Levey, *Early Renaissance* (Baltimore, 1967), 128.

33. See André Chastel, *Marsil Ficin et l'Art*, 59; and Piero Sanpaolesi, "Le prospettive architettoniche di Urbino, di Filadelfia, e di Berlino," in *Bollettino d'arte* 34 (1949), 322.

34. See Marvin B. Becker, "Toward a Renaissance Historiography in Florence," in *Renaissance Studies in Honor of Hans Baron*, ed. A. Molho and J. Tedeschi (Florence, 1971), 144–45.

35. *The Letters of Marsilio Ficino*, vol.2 (London, 1978), 37. See Rudolph Wittkower, "Chance, Time and Virtue" in *Journal of the Warburg and Courtauld Institutes* 1 (1937–38), 313; Erwin Panofsky, *Studies in Iconology*, 71; M.C. Pecheux, "Milton and Kairos," in *Milton Studies* 12 (1979), 197.

36. *Petrarch and His World* (Bloomington, Ind., 1966), 161; J.B. Trapp, "The Poet Laureate: Rome, *Renovatio*, and *Translatio Imperii*," in *Rome in the Renaissance: The City and the Myth*, 103; E.H. Wilkins, *The Life of Petrarch*, 28.

37. *Letters from Petrarch*, 209.

38. In David Thompson's *Petrarch, A Humanist Among Princes: An Anthology of Petrarch's Letters and of Selections from His Other Works* (New York, 1971), 117–20.

39. *Panathenaicus*, in *The Civilizing Power*, 89; "On Those Who Died in the War," in *The World's Famous Orations*, vol.1 (New York, 1906), 26.

40. Hans Baron, *From Petrarch to Leonardo Bruni* (Chicago, 1968), 166.

41. *Historians and Historiography in the Italian Renaissance* (Chicago, 1981), 3. See also John W. O'Malley, *Praise and Blame in Renaissance Rome*, 40; R.C. Collingwood, *The Idea of History* (Oxford, 1977), 44–45.

42. John Spencer, in the Introduction to *Filarete's Treatise on Architecture*, vol.1, xxxvi.

43. See Carroll W. Westfall, *In This Most Perfect Paradise* (University Park, Pa., 1974); Eugenio Battisti, *Rinascimento e Barocco* (Turin, 1960), 72–77; Charles Burroughs, "A Planned Myth and a Myth of Planning: Nicolas V and Rome," in *Rome in the Renaissance: The City and the Myth*, 200.

44. In *Prosatori latini del Quattrocento*, 754. See also Numa Denis Fustel De Coulanges, *The Ancient City: A Classic Study of the Religious and Civil Institutions of*

Ancient Greece and Rome (Baltimore, 1980), 126; R.C. Collingwood, *The Idea of History*, 44.

45. S.J. Freedberg, *Painting of the High Renaissance in Rome and Florence* (Cambridge, 1961), 90.

46. *Memoirs of a Renaissance Pope. The Commentaries of Pius II*, tr. F.A. Gragg (London, 1960), 102.

47. On the exemplary character of the papal biography, which rivaled mundane counterparts, see Massimo Miglio, *Storiografia pontificia del Quattrocento* (Bologna, 1975), 15; Gioacchino Paparelli, *Enea Silvio Piccolomini* (Bari, 1950), 313, suggests that even the more private *Commentarii* present the image that the pope wanted to leave of himself.

48. See Werner L. Gundersheimer, *Ferrara. The Style of a Renaissance Despotism* (Princeton, N.J., 1973), 269; Eugenio Garin, "La Cité ideale de la Renaissance italienne," in *Les Utopies à la Renaissance: Colloque International* (Brussels, 1963), 23; Sven Armens, *Archetypes of the Family in Literature* (Seattle, 1966), 54.

49. *Memoirs of a Renaissance Pope: The Commentaries of Pius II*, 375.

50. See Eugenio Garin, *Portraits of the Quattrocento* (New York, 1952), 51; John M. McManomon, "The Ideal Renaissance Pope: Funeral Oratory from the Papal Court," in *Archivium Historiae Pontificiae* 14 (1976), 61.

51. *Renaissance Concepts of Man and Other Essays* (New York, 1972), 26.

52. *Panegyric to the City of Florence*, in *The Earthly Republic*, 138,175.

53. See Julian Haynes, *The Origin of Consciousness in the Breakdown of the Bicameral Mind* (Boston, 1976), 30.

54. *The Letters of Marsilio Ficino*, vol.2, 37.

55. B.A. Van Groningen, *In The Grip of the Past*, 98; Joseph Campbell, *The Hero of a Thousand Faces* (Princeton, 1972), 319–27; Philip R. Hardie, *Virgil's Aeneid: Cosmos and Imperium* (Oxford, 1968), 253.

56. *The Letters of Marsilio Ficino*, vol.1, 67. See Ernst Curtius, *European Literature and the Latin Middle Ages*, 98–101; Ruggero Ruggieri, "Estetica medievale II. I 'Topoi,'" in *Cultura neolatina* 2 (1942), 160.

57. *Human, All-Too-Human* (New York,1964), 153–54.

58. *The Letters of Marsilio Ficino*, vol.1, 98.

59. Ludwig Edelstein, *The Idea of Progress in Classical Antiquity* (Baltimore, 1967), 179, points out that, in a Hellenistic spirit, the Delphic maxim "Know thyself" emphasized man's kinship with the Godhead, which entitled him to shape reality. And the performance of such a task was recognized as the "truly human obligation."

60. Ernst Cassirer, "Giovanni Pico della Mirandola. Part II," 326.

61. *Disputationes camaldulenses*, in *Prosatori latini del Quattrocento*, 734. See also Giovanni Gentile, *Il pensiero italiano del Rinascimento* (Florence, 1940), 75–76.

4. *Aemulatio*'s Last Beginning: *David* and the Epiphany of Culture

1. Charles Seymour, Jr., *Michelangelo's David: A Search for Identity* (New York, 1974), 51.

2. See Frederick Hartt, *Michelangelo: Sculpture* (New York, 1972), 50.

3. See David Summers, *Michelangelo and the Language of Art*, 454.

4. Georg Misch, *A History of Autobiography in Antiquity*, vol.1 (London, 1950), 62.

5. Kenneth Burke, *A Grammar of Motives*, 42.

6. Giorgio Bárberi-Squarotti, "Il Machiavelli tra il 'sublime' della contemplazione intellettuale e il 'comico' della prassi," in *Lettere italiane* 21/2 (1969), 147; and "Il

Principe o il trionfo della letteratura," in *Letteratura e critica: Studi in onore di Natalino Sapegno*, vol.2 (Rome, 1975), 291.

7. *De laboribus Herculis*, vol.1.8.10, ed. B.L. Ullmann (Zurich, 1951), as translated by Nancy Struever, in *The Language of History in the Renaissance: Rhetoric and Historical Consciousness in Florentine Humanism* (Princeton, 1970), 62–63.

8. See Felix Gilbert, *Machiavelli and Guicciardini: Politics and History in Sixteenth-Century Florence* (Princeton, N.J., 1965), 221.

9. "On Those Who Died in the War," 26.

10. See Rudolph Wittkower, *Architectural Principles in the Age of Humanism*, 38.

11. *I Commentarii*, 11.

12. Donald Wilcox, *The Development of Florentine Humanist Historiography in the Fifteenth Century* (Cambridge, 1965), 204.

13. *Commentari della vita e gesti dell'illustrissimo Federico Duca d'Urbino*, a cura di Walter Tommasoli (Urbino, 1966), 39. Translation by author.

14. *Liber de vita Christi ac omnium pontificum*, in *Prosatori latini del Quattrocento*, 694–96.

15. See Nancy Struever, *The Language of History in the Renaissance: Rhetoric and Historical Consciousness in Florentine Humanism*, 67; and Felix Gilbert, *Machiavelli and Guicciardini: Politics and History in Sixteenth-Century Florence*, 225.

16. *De viris illustribus*, in *Francesco Petrarca: Prose*, 234.

17. *Epistolae*, II, ed. Mehs (Florence, 1741), 112.

18. See his *Metahistory: The Historical Imagination in Nineteenth-Century Europe* (Baltimore, 1973). See also W.B. Gallie, *Philosophy and the Historical Understanding* (New York, 1964).

19. Petrarch, *De viris illustribus*, 222. See Leonardo Bruni, *History of Florence*, in Renée Watkins, *Humanism and Liberty: Writings on Freedom from Fifteenth-Century Florence* (Columbia, S.C., 1978), 33–34.

20. *Elegantiarum libri*, in *Prosatori latini del Quattrocento*, 594–96. See André Chastel, *The Myth of the Renaissance, 1420–1520*, 200.

21. *Oratio super Fabio Quintiliano et Statii Sylvis*, in *Prosatori latini del Quattrocento*, 882. See Aristides' *Panathenaicus*, in *The Civilizing Power*, 83.

22. *Letters from Petrarch*, 302; *Rerum memorandarum libri*, in *Francesco Petrarca: Prose*, 281. *De liberorum educatione*, in W.H. Woodward, *Vittorino da Feltre and Other Humanist Educators* (Cambridge, 1912), 105.

23. *Disputationes camaldulenses*, in *Prosatori latini del Quattrocento*, 730.

24. *L'arte della seta in Firenze: Trattato del secolo xv* (Florence, 1868), 234.

25. Eckhard Kessler, "Petrarch's Contribution to Renaissance Historiography," in *Studies in the Classical Tradition* 1 (1978), 129–49; T.E. Mommsen, *Medieval and Renaissance Studies* (Ithaca, N.Y., 1959), 104–5; Renato Poggioli, "The Oaten Flute," in *Harvard Library Bulletin* 11/2 (1957), 184.

26. See Bernard Lewis, *History—Remembered, Recovered, Invented* (Princeton, N.J., 1975), 11–13; Emery Neff, *The Poetry of History* (New York, 1961), 4.

27. *La ciencia de la cultura* (Madrid, 1964), 43; *Fables of Identity* (New York, 1963), 54–55.

28. *Disputationes camaldulenses*, in *Prosatori latini del Quattrocento*, 782. See Roberto Cardini, in the Introduction to Landino's *Scritti critici e teorici*, vol.1 (Rome, 1974), xxiii.

29. In *The Panegyric of Isocrates*, in *Greek Orations: Lysias, Isocrates, Demosthenes, Aeschines, Hyperides*, ed. W.R. Connor (Ann Arbor, Mich., 1966), 32.

30. Lidia Storoni Mazzolani, *The Idea of the City in Roman Thought: From Walled City to Spiritual Commonwealth* (London, 1970), 21.

31. S.J. Freedberg, *Painting of the High Renaissance in Rome and Florence* vol.1, 89–90. See also C. Cochrane, *Christianity and Classical Culture* (New York, 1957), 207.

32. E. Rojo Perez, in his Prologue to Eugenio D'Ors' *La ciencia de la cultura*, 13–15.

33. *Wisdom and Experience*, 241.

34. *Opera omnia*, ed. P.O. Kristeller (Turin, 1959), I, 2, 944. Translation by the author. Naldo Naldi described Lorenzo de' Medici "as all golden; with a golden virtue exuding from his heart," quoted from Gustavo Costa, *La leggenda dei secoli d'oro nella letteratura italiana* (Bari, 1972), 245.

35. *Renaissance Princes, Popes, and Prelates: The Vespasiano Memoirs*, tr. W. and E. Waters (New York, 1963), 356. See A.M. Brown, "The Humanist Portrait of Cosimo de' Medici, Pater Patriae," in *Journal of the Warburg and Courtauld Institutes* 24 (1961), 186–221; E.H. Gombrich, *Norm and Form*, 29; W.K. Ferguson, "Humanist Views of the Renaissance," in *American Historical Review* 45 (1939), 25.

36. *Commentary on the Commedia*, in *The Three Crowns of Florence: Humanist Assessments of Dante, Petrarch, and Boccaccio*, ed. D. Thompson and A. Nagel (New York, 1972), 117–18.

37. See J.W. O'Malley, "Fulfillment of the Christian Golden Age under Pope Julius II: Text of a Discourse of Giles of Viterbo, 1507," in *Traditio* 25 (1969), 265–338; see also his "Man's Dignity, God's Love, and the Destiny of Rome: A Text of Giles of Viterbo," in *Viator* 3 (1972), 389–416.

38. Erwin Panofsky, *Meaning in the Visual Arts*, 137.

39. Richard A. Goldthwaite, *Private Wealth in Renaissance Florence: A Study of Four Families* (Princeton, 1968), 258.

40. On the subject, see Robert Nisbet, *History of the Idea of Progress* (New York, 1980), 87.

41. R.C. Collingwood, *The Idea of History*, 44.

42. See Ludwig Edelstein, *The Idea of Progress in Classical Antiquity*, 29; Rodolfo Mondolfo, *La comprensione del soggetto umano nell'antichità classica* (Florence, 1958), Part 4, chapter 3.

43. Karl Löwith, *Meaning in History* (Chicago, 1949), 4–5; C. Cochrane, *Christianity and Classical Culture*, 63–73; Karl Joachim Weintraub, *The Value of the Individual: Self and Circumstance in Autobiography* (Chicago, 1978), 99; R.A. Markus, *Saeculum: History and Society in the Theology of St. Augustine* (Cambridge, 1970), 190; Michael C. Putnam, *Artifices of Eternity: Horace's Fourth Book of Odes* (Ithaca, N.Y., 1986), 309–10, 326.

44. See Carlo Ragghianti, *L'arte bizantina e romanica* (Rome, 1968), especially pp.589–654.

45. Spengler, *The Decline of the West*, vol.1 (New York, 1929), 31; Berdyaev, *The Meaning of History* (New York, 1962), 181–84. The negative connotation of civilization must be qualified with regard to context and critics. Often, the term stands for culture, and it is in this sense that Kenneth Clark has used it in his popular television series, *Civilization*.

46. R.C. Collingwood, *The Idea of History*, 44; Loren Partridge and Randolph Starn, *A Renaissance Likeness: Art and Culture in Raphael's Julius II* (Berkeley, Calif., 1980), 108–116.

47. *History of Ancient Art*, vol.4 (New York, 1968), 313. See also Kenneth Clark, *The Nude* (New York, 1956), 84.

48. *The Survival of the Pagan Gods* (Princeton, N.J., 1972), 320.

49. *In Our Image and Likeness: Humanity and Divinity in Italian Humanist Thought*, vol.1 (London, 1970), xxiii.

50. See Georg Lukács' remarks on literature, *The Theory of the Novel*, 33–34.

51. See Janet Smarr, "Petrarch: A Virgil Without a Rome," in *Rome in the Renaissance. The City and the Myth*, 133.

52. *The Dialogic Imagination*, 147.

53. See Miriam Eliav-Feldon, *Realistic Utopias* (Oxford, 1982), 1.

54. "Mediterranean Inspirations," in *Moi*, 34.

55. *Miscellaneous Studies* (London, 1910), 249; Friedrich Schiller, *On the Aesthetic*

Education of Man, tr. E.M. Wilkinson and L.A. Willoughby (Oxford, 1967), 193. Like the gods in Greek sculpture, Adam and David enjoy a "blessed repose" and an "everlasting youth," in G.W.F. Hegel, *The Philosophy of Fine Arts*, vol.3 (London, 1920), 124–25. "For the first time, and for all times," Herbert Read claims, Greek artists "became conscious of the ideal Man. What is not generally recognized is that, in the process, they made possible the structure of thought which we call Humanism," in *Icon and Idea* (Cambridge, 1955), 74. See also Roland Barthes, "The World as Object," in *A Barthes Reader*, ed. S. Sontag (New York, 1980), 7.

5. Rebirth as Synthesis
in *The Courtier* and *The School of Athens*

1. *Plays and Controversies* (London, 1927), 434; *On the Boiler* (Dublin, 1924), 26; "Poetry and Tradition," in *The Collected Works of W.B. Yeats*, vol.8 (London, 1908), 99–102.

2. See Wayne A. Rebhorn, *Courtly Performances: Masking and Festivities in Castiglione's Book of the Courtier* (Detroit, 1978), 60, 89. Richard Lanham, *The Motives of Eloquence: Literary Rhetoric in the Renaissance* (New Haven, Conn., 1976), 145, writes: "*The Courtier* becomes, considered as history, almost a 'faction,' a fiction from real life, halfway between life and art. Past and present, self and city, poetic and historic reality, all work together."

3. W.H. Auden, *The Enchafed Flood* (New York, 1950), 94–95, 110–11.

4. See Werner Jaeger, *Paideia: The Ideals of Greek Culture*, vol.1 (New York, 1945), xvii, 416.

5. See G. Martore, *La méthode en lexicologie* (Paris, 1953); the critic also uses the term *mots-témoins*. Leo Spitzer, *Linguistics and Literary History* (Princeton, 1970), 21–22. Charles Trinkaus, "Themes for a Renaissance Anthropology," in *The Renaissance: Essays in Interpretation*, 83–84.

6. "Michelangelo on Effort and Rapidity in Art," in *Journal of the Warburg and Courtauld Institutes* 17 (1954), 309. Richard A. Lanham, *The Motives of Eloquence: Literary Rhetoric in the Renaissance*, 152, writes that *sprezzatura* "declares, brags about, successful enselfment, a permanent incorporation in, addition to, the self." More recently, Lanham has added: "*Sprezzatura* was a new word for a new conception of identity, that paradoxically natural unnaturalness, sense of effortless effort, of instinctive artifice," in *Literacy and the Survival of Humanism* (New Haven, Conn., 1983), 36. On associative and lexical fields, see Stephen Ullmann, *Language and Style* (Oxford, 1964), 222.

7. See Attila Faj, "Vico as Philosopher of *Metabasis*," in *Giambattista Vico's Science of Humanity*, ed. G. Tagliacozzo and D.P. Verene (Baltimore, 1976), 87–109.

8. See Nancy Struever, "Vico, Valla, and the Logic of Humanist Inquiry," in ibid., 180, 183–84.

9. John M. McManomon, "The Ideal Renaissance Pope: Funeral Oratory from the Papal Court," in ibid., 33.

10. *Letters from Petrarch*, 199.

11. Thomas Greene, "Petrarch and the Humanist Hermeneutic," in *Italian Literature: Roots and Branches*, ed. G. Rimanelli and K.J. Atchity (New Haven, Conn., 1976), 210–12.

12. Thomas Greene, "The Flexibility of the Self in Renaissance Literature," in *The Disciplines of Criticism*, 251.

13. *The Rhetoric of Romanticism* (New York, 1984), 273, 281. See also Charles Hauret, *Beginnings: Genesis and Modern Science*, 72; and Jean de Fraine, *The Bible and the Origin of Man* (New York, 1962), 34.

14. *On the Aesthetic Education of Man*, 75–77, 59–61, 217–19.

15. *The Rhetoric of Romanticism*, 265.

16. See John O'Malley, "The Vatican Library and the School of Athens: a Text of Battista Casali, 1508," in *The Journal of Medieval and Renaissance Studies* 7 (1977), 271–72; John Shearman, "The Vatican Stanze: Function and Decorations," in *Proceedings of the British Academy* 57 (1972), 13–17.

17. *Classical and Christian Ideas of World Harmony* (Baltimore, 1963), 7, 13–14; Rudolph Wittkower, "The Changing Concept of Proportion," in *Daedalus* 89 (1960), 200. Writing on Plato's aesthetics, Walter Pater comments that, in education, "all will begin and end in 'music,' in the promotion of qualities to which no truer name can be given than symmetry, aesthetic fitness, tone. Philosophy itself, indeed, as he conceives it, is but the sympathetic appreciation of a kind of music in the very nature of things," in *Plato and Platonism* (London, 1912), 268.

18. Manetti, *The Life of Brunelleschi*, 51.

19. See Emanuel Winternitz, "Quattrocento Science in the Gubbio Study," in *The Metropolitan Museum of Art Bulletin* 1 (1942), 109. See also Eva Tea, *La proporzione nelle arti figurative* (Milan, 1945), 10.

20. See Ernest MacClain, *The Pythagorean Plato: Prelude to the Song Itself* (Stony Brook, N.Y., 1978), 3.

21. J.M. Warbeke, *The Searching Mind of Greece*, 28–29, points out that "the fact that the sepals, petals, stamens, and pistils of a flower are arranged on the scheme of 4,4,8,4 might suggest an antecedent plan or design. The number four would give a 'clue' to the operation of whatever intelligible cause may govern such a form." Without it, our class would be less definite. Pythagoras, Philolaus, and modern man would agree that "the mathematics of any given piece of reality is a very significant part of its interpretation."

22. *Plato and Platonism*, 52. See Francis Conford's comments in his edition of *The Republic of Plato* (New York, 1975), 249; Walter Burkert, *Lore and Science in Ancient Pythagoreanism*, tr. Edwin L. Minar, Jr.(Cambridge, Mass., 1972), 372; Bertrand Russell, *History of Western Philosophy* (London, 1961), 54–55.

23. *The Renaissance Philosophy of Man*, 105. See Charles Trinkaus, *The Scope of Renaissance Humanism*, 441, 358.

24. In *The Scope of Renaissance Humanism*, 352, 355; Trinkaus, *In Our Image and Likeness: Humanity and Divinity in Italian Humanist Thought*, vol.1, 126–28, 142, 306.

25. On the subject, see Richard Rorty, *Philosophy and the Mirror of Nature*, 318.

26. See Rudolph Wittkower, *Architectural Principles of the Age of Humanism*, 125; Mary D. Garrard, "The Liberal Arts and Michelangelo's First Project for the Tomb of Julius II (with a Coda on Raphael's 'School of Athens')," 371; Erwin Panofsky, *Galileo as a Critic of the Arts* (The Hague, 1954), 1–4.

27. *The Letters of Marsilio Ficino*, vol.3, 38. Such aesthetic qualities, Walter Pater would add, "transform themselves" into "terms of ethics," and "moral taste" fit for Plato's City of the Perfect, in *Plato and Platonism*, 271–72.

28. *Art and Thought in the Hellenistic Age: The Greek World-View, 350–50 B.C.* (London, 1979), 120.

29. *The Idea of Perfection in the Western World* (Princeton, N.J., 1946), 26, 97–98.

30. *La cultura del Rinascimento*, 8, 60; see also Jean Seznec, *The Survival of the Pagan Gods*, 146–47.

31. As translated in Charles Trinkaus's *The Scope of Renaissance Humanism*, 180.

32. As translated by Pauline Moffitt Watts, *Nicolas Copernicus: A Fifteenth-Century Vision of Man*, 133.

33. With regard to the development from classical to Christian, Kenneth Clark, *The Art of Humanism*, 140, outlines a similar evolution in the art of Mantegna: "In his later work the classical subjects become more poignant and personal, culminating in that haunting masterpiece *The Dead Christ* in the Brera, and we see that in the end Mantegna has found in Christianity a feeling of ultimate values which Rome,

even the grave and magnificent Rome of his imagination, could not give him." To illustrate that shift, it suffices to compare the Louvre *Martyrdom of St. Sebastian* (1480) to the Ca' d'Oro version (1490).

34. See Etienne Gilson, *The Spirit of Medieval Philosophy* (New York, 1978), 21–23.

35. See P.O. Kristeller's Introduction to the translation of the *Oration*, 216–21.

36. Charles L. Stinger, "Roma Triumphans: Triumphs in the Thought and Ceremonies of Renaissance Rome," in *Medievalia et Humanistica* 10 (1980), 189; C. Cochrane, *Christianity and Classical Culture*, 29.

37. *Miscellaneous Studies*, 57.

6. *Homo Artifex*:
The Analogue of Creativity

1. *The Rhetoric of Religion* (Boston, 1961), 3. See also Rosalie Colie, "The Rhetoric of Transcendence," in *Philological Quarterly* 43 (1964), 169.

2. In David Thompson, *Petrarch, A Humanist Among Princes: An Anthology of Petrarch's Letters and of Selections from His Other Works*, 121.

3. Konrad Burdach, *Reformation, Renaissance, Humanismus*, chapter 1, 1–84.

4. "Étymologie et ethymologia (Motivation et retromotivation)" in *Poétique* 3 (1972), 409, 406, 413; see also Antonino Pagliaro, *Altri saggi di critica semantica* (Messina, 1961), 322.

5. *Reflections* (New York, 1978), 323.

6. Charles Trinkaus's *The Scope of Renaissance Humanism*, 366, quotes the Neapolitan humanist Giovanni Pontano: "Wherever speech is greater and more frequent, there is a richer supply of all those things in which life is lacking (since need is given as a companion to all men at their birth). Through speech life itself is made far more adaptable as well as more capable both of acquiring virtue and of attaining happiness."

7. See Leo Spitzer, *Linguistics and Literary History*, 21–22. On *aletheia*, see Ernesto Grassi, *Heidegger and the Question of Renaissance Humanism* (Binghamton, N.Y., 1983), 64–76; Martin Heidegger, *Early Greek Thinking*, D. Krell and F. Capuzzi (New York, 1975), 102–23; *Poetry, Language, Thought*, tr. A. Hofstadter (New York, 1971), 36; Clayton Koelb, *The Incredulous Reader: Literature and the Function of Disbelief* (Ithaca, N.Y., 1984), 34–36.

8. *Marsilio Ficino. The Philebus Commentary* ed. and tr. Michael J. Allen (Berkeley, Calif., 1975), 364.

9. *The Letters of Marsilio Ficino*, vol.1, 113.

10. Ibid., vol.1, 101; vol.3, 24.

11. See Louis Ginzberg, *The Legend of the Jews*, vol.1 (Philadelphia, 1937), 49.

12. *The Letters of Marsilio Ficino*, vol.3, 31.

13. Lorenzo Valla, *Elegantiarum libri*, in *Prosatori latini del Quattrocento*, 595.

14. André Chastel, *Marsile Ficin et l'art*, 133; Erwin Panofsky, *Renaissance and Renascences in Western Art* (New York, 1972), 188.

15. *Opere di Dante degli Alighieri . . . col Comento di Cristoforo Landini* (Vinegia, 1484), Preface fol.a, as translated in M.H. Abrams, *The Mirror and the Lamp*, 273. See also Martin Kemp, "From 'Mimesis to Fantasia': the Quattrocento Vocabulary of Creation, Inspiration, and Genius in the Visual Arts," in *Viator* 8 (1977), 385; E.N. Tigerstedt, "The Poet as Creator: Origins of a Metaphor," in *Comparative Literature Studies* 5 (1968), 475; David Summers, *Michelangelo and the Language of Art*, 473 (note 38) and 495 (note 99); Milton C. Nahm, *The Artist as Creator* (Baltimore, 1956), 54–55, adds that emphasis on the autonomy of the mind's inventive powers made of "the artist the analogue to God."

16. *Beginnings* (Baltimore, 1978), 83. Eric Partridge adds that *author* relates to the past participle *auctus* of the verb *augere*, which defines *author* as an *increaser* and a *founder*, in *Origin: A Short Etymological Dictionary of Modern English* (New York, 1958), 32.

17. Michael Baxandall, *Giotto and the Orators*, 16–17.

18. See P.O. Kristeller's essay on "The Modern System of the Arts" in *Renaissance Thought II: Papers on Humanism and the Arts* (New York, 1965), 163–227; David Summers, *Michelangelo and the Language of Art*, 35; Milton C. Nahm, "The Theological Background of the Theory of the Artist as Creator," in *Journal of the History of Ideas* 8 (1947), 365–66.

19. *The Letters of Marsilio Ficino*, vol.1, 190.

20. See David Peterson, *Hebrews and Perfection: An Examination of the Concept of Perfection in the "Epistle to the Hebrews"* (Cambridge, 1982), especially 21–22.

21. Martin Foss, *The Idea of Perfection in the Western World*, 30.

22. *Heidegger and the Question of Renaissance Humanism*, 15.

23. See Richard Lanham, *The Motives of Eloquence. Literary Rhetoric in the Renaissance*, 2.

24. I borrow the term from Clayton Koelb, *The Incredulous Reader: Literature and the Function of Disbelief*, 35–36.

7. The Legend of Geometry Fulfilled:
Piero della Francesca and Piet Mondrian

1. *Anatomy of Criticism*, 351.

2. "Tradition and Individual Talent," in *The Sacred Wood*, 49.

3. *The Diaries of Paul Klee, 1898–1918*, ed. Felix Klee (Berkeley, Calif., 1964), 229.

4. See André Malraux, *The Voices of Silence* (Princeton, N.J., 1978), 69.

5. *Abstraction and Empathy*, tr. Michael Bullock (New York, 1953), 3.

6. *De prospectiva pingendi*, 100.

7. Unless indicated otherwise, all quotations are from his essay, "Plastic Art and Pure Plastic Art," in R.L. Herbert, *Modern Artists on Art* (Englewood Cliffs, N.J., 1964), 114–30.

8. *Piero della Francesca* (Florence, 1950), 14. For more recent comments, see G.C. Argan, *Salvezza e caduta nell'arte moderna* (Milan, 1964), 135–36. A pioneering essay on the roots of modern abstraction is Kenneth Clark's "Uccello and Abstract Art," in his *The Art of Humanism*, 43–78.

9. See Roberto Longhi, *Piero della Francesca* (Florence, 1975), 30.

10. *The Letters of Marsilio Ficino*, vol.1, 91.

11. *The Renaissance*, 216.

12. See Joan Gadol, *Leon Battista Alberti: Universal Man of the Early Renaissance*, 28–29; John White, *The Birth and Rebirth of Pictorial Space* (London, 1957), 190; Cesare Brandi, *Il Tempio Malatestiano* (Turin,1956), 25.

13. Sonnet written (c. 1425) by Giovanni di Gherardo da Prato called Acquettini, in *Brunelleschi in Perspective*, 32.

14. In *Filarete's Treatise on Architecture* vol.1, 305.

15. *Ragionamenti sulle arti figurative* (Milan,1942), 143–44; *Dal cubismo al classicismo* (Florence, 1972), 208.

16. See E. Sindona, "Introduzione alla poetica di Paolo Uccello: Relazioni tra prospettiva e pensiero teorico," in *L'Arte* (1972), 12.

17. See Lionello Venturi, "Paolo Uccello," in ibid., 1 (1930), 78.

18. W. Tatarkiewicz, *A History of Six Ideas: An Essay in Aesthetics* (Warsaw, 1980), 235.

19. *A Platonick Discourse upon Love*, 30; *Filarete's Treatise on Architecture*, vol.1, 296; *Divina proportione* (Vienna, 1889), 17, 43, translation by the author; *The Letters of Marsilio Ficino*, vol.3, 29.

20. See André Chastel, *Marsil Ficin et l'Art*, 61; Michael Baxandall, *Painting and Experience in Fifteenth-Century Italy*, 108.

21. *Plato and Platonism*, 272–73.

22. *Kandinsky: Complete Writings on Art*, vol.2, ed. K.C. Lindsay and P. Vergo (Boston,1982), 759.

23. *Velázquez, Goya, the Dehumanization of Art, and Other Essays*, tr. Alexis Brown (New York, 1972), 110.

24. *Creative Intuition in Art and Poetry* (New York, 1968), 159.

Index of Names